DRAWING RESEARCH AND DEVELOPMENT

Edited by David Thistlewood

Consultant Editors
Sheila Paine and Elsbeth Court

Longman
in association with the
National Society for Education
in Art and Design

WITHDRAWN

14 SEP 01

WEST SUSSEX INSTITUTE OF
HIGHER EDUCATION LIBRARY

WS 1087321 X

AUTHOR
———

TITLE
DRAWING

CLASS No
741.2

APR 94

LONGMAN

NSEAD

Longman Group UK Limited
*Longman House, Burnt Mill, Harlow, Essex CM20 27E, England
and Associated Companies throughout the World.*

© Longman Group UK Limited 1992

*All rights reserved. No part of this publication may be reproduced, stored in a retrieval
system, or transmitted in any form or by any means, electronic, mechanical,
photocopying, recording, or otherwise, without either the prior written permission of the
Publishers or a licence permitting restricted copying issued by the Copyright Licensing
Agency Ltd, 90 Tottenham Court Road, London WIP 9HE.*

First published 1992
ISBN 0 582 07419 3

Set in 10/12pt Plantin (Linotron 202)
Produced by Longman Singapore Publishers (Pte) Ltd
Printed in Singapore

British Library Cataloguing in Publication Data
Drawing Research and Development. – (Art & Design Education Series)
I. Thistlewood, David II. Series 741.2
ISBN 0-582-07419-3

Library of Congress Cataloging-in-Publication Data
Drawing research and development/edited by David Thistlewood:
consultant editors, Sheila Paine and Elsbeth Court.
p. cm. — (Art and design education series)
Includes bibliographical references and index.
ISBN 0-582-07419-3
1. Drawing–Research.
2. Drawing–Technique.
3. Children as artists.
I. Thistlewood, David.
II. Series.
NC720. D69 1992 92-16634
741–dc20 CIP

Contents

W. SUSSEX INSTITUTE
OF
HIGHER EDUCATION
LIBRARY

Acknowledgements

This volume originated in the proceedings of a conference entitled
Drawing Art and Development, organised by the NSEAD at the British
Museum in 1989.

Drawing Art and Development Planning Committee
SHEILA PAINE (Chair); Institute of Education, University of London
ELSBETH COURT; International Society for Education through Art
JOHN MATTHEWS; Goldsmiths' College, University of London
JOHN STEERS; General Secretary, NSEAD
ANNE INGALL; Financial and Administrative Assistant, NSEAD.

Acknowledgements for individual figures appear at the end of the
relevant chapters.

COVER: Schematic heads and bodies from Erhart Schön *Underweysung
der Proportion* (Nuremberg, 1538).

Illustrations

v

W. SUSSEX INSTITUTE
OF
HIGHER EDUCATION
LIBRARY

Introduction

In July 1989, the National Society for Education in Art and Design (NSEAD) sponsored a conference at the British Museum in London entitled *Drawing Art and Development*. Its purpose was to provide a focus for current research into drawing as a phenomenon which has the widest possible constituency. The Museum holds one of the world's finest collections of drawings, and this imbued the conference, symbolically as well as practically, with a closeness to the history and the artefacts of fine drawing achievement.

The conference planners were aware of the extraordinary diversity of research activities in the field of drawing which have been taking place mainly (though not only) in Europe, North America and Australia over several decades. Fundamentally, the study of drawing is about relationships between kinds of imagery and kinds of experience, whether individual or social, and about how these relationships are related to the manifestations of art and design. It thus has potential for aiding the understanding of human and cultural development.

Surveying the field as a whole, certain issues and concerns demand attention, including: notions of representation and sources of imagery, questions of whether expressions are internal (personal) or external (cultural); associations between child and adult art; the role of drawing in cognition; the processes of learning in drawing; optimal ways to facilitate or nurture growth in and through drawing; relationships between drawing and intelligence; and the significance, for normative theories, of the anomalous drawings of a precocious genius or an extraordinary *savant*.

The study of drawing has been illuminated by research in such areas as these. But the remarkable diversity of professional backgrounds and intentions has given rise to many different interpretations of the concepts involved and the discoveries made, to such an extent that mutual support and the sharing of ideas has often been difficult.

Drawing Art and Development therefore sought to bring together, for formal presentation and informal discussion, as many different kinds of professional researchers, teachers and practitioners as possible whose common focus is the phenomenon of drawing. The conference attracted diverse participants from many countries and numerous challenging research contributions, a selection of which is presented in this publication. Many other contributions of quality and repute, which deserve the hospitality of a larger volume than this, have had to be omitted. But the content here has been selected to reflect the character of the conference generally and to highlight some of the significant matching as well as contrasting correspondences identified between specific research programmes, their methods and their ideas.

The content has also been presented in a sequence which, it is hoped, illustrates something of the great pervasion of drawing beyond what is strictly recognised as art education. The focus at first narrows upon

drawing as cultural induction and development, including the development of intelligence and perceptivity. It subsequently widens into philosophical realms, and engages aspects of drawing that fuel creativity in designing at large. Finally (and to complete a virtuous circle) the focus reconverges in order to consider the special significance of observational work as one of the foundation disciplines of drawing, and a chief means of developing the creative percipience first given expression in the drawings of early childhood.

In a synoptic opening chapter, Sheila Paine describes the extent of the field of study in terms of the differing intentions of drawing research, and the diverse research methods employed. She explores underlying causes of some of the many different perceptions of the concepts of drawing – drawing as art, drawing as development, drawing as skill, and the processes of both learning to draw and learning about drawing. She argues for a shared reevaluation of interpretations of these concepts as the beginning of closer working relationships between all researchers in the field, to link new discoveries and identify the most valuable foci for future collaborative investigations.

Brent Wilson is well known for occasionally-controversial theories on development in drawing. In Chapter Two he considers the conception of children's drawing as being determined by association with adult art. He proposes a direct link between the emergence of the concept of child art and Courbet's alleged 'invention' of Modern art in the mid-nineteenth century. He recognises important differences between the uses of children's drawings by psychologists, teachers and artists, and he focuses on the assumption of a similar vision and response to the world which children and mature Modern artists allegedly share. Wilson questions the eventual status of children's art in a Post-Modernist era. He argues persuasively that a new relationship between children and contemporary art, which may be facilitated within education, may free children from the constraints imposed by identifying their work solely with Modernist attitudes and ideas.

Chapter Three also deals with the earliest years of development in drawing. Here John Matthews uses longitudinal case studies to illuminate the nature of drawing activity at its beginning in early childhood and in the immediately ensuing years. He challenges the accepted convention of early drawing as haphazard and without meaning, arguing that even very young children operate according to principles which they learn, that they express feeling in their drawing, and give evidence of their acquisition of aesthetic experience. Matthews suggests that young children learn according to principles that are intrasensory – graphic, gestural and verbal – and also interpersonal, that is, encouraged by other children as well as teachers and parents.

In the study of development in drawing, working with anomalous cases has a strong recent history with roots in psychiatry and the diagnostic or therapeutic use of drawings. This ranges from Luquet's work with asylum patients in France some seventy years ago to Selfe's unique study in England in the late 1970s of the 'artistically' accomplished autistic child Nadia. This approach continues to offer a rich vein

of discovery, with the possibility that anomalous development may shed light on normality.

For some years Neil O'Connor and Beata Hermelin have been working in Britain on the drawings of the autistic. Their contribution in Chapter Four operates from assumptions of intention and developmental phases which are significantly different from those of other writers in this volume. However, their quest is a central one: how do graphic skills arise? Their research compares the abilities of mathematically and artistically 'gifted' adolescents and similar adolescents with low and high intelligence quotients, in order to determine that graphic ability is not dependent upon intelligence. They raise important questions concerning the relationship between reproduction and invention in artistic production, and about whether drawing is a separate domain of intelligence.

The perils of adopting a research position which is implicitly monocultural are well known. Three contributions to this volume remind us of drawing as a manifestation of culture. They are also reminders of the special need to analyse and understand inter-cultural and cross-cultural influences that determine significant differences in aspects of that manifestation. In Chapter Five Elsbeth Court uses an extensive survey of three different groups of Kenyan children in their homesteads and classrooms to reveal the effects of interacting social influences upon their drawings. Drawing performance is seen to be modified by the acquisition of traditional and school conventions, as well as by personal growth. Access to imagery and image-making facilitates the recording and transmission of ethnic cultures, which have ramifications for such concepts as personal identity, shared experience and nationhood.

Taha Elatta reflects on the effects upon Sudanese life of two dominant cultures, the Islamic and the African, through an analysis of surface design images on three-dimensional indigenous artefacts. Chapter Six is his report on work that is still in progress, aimed at creating a resource for art teaching from the categorisation of regional imagery that will ultimately develop into a comprehensive taxonomy. Here the issue of development in drawing refers not so much to individuals as to cultural change. A closely related concept – historical change – is featured in a broadly based study of children's drawings in three northern hemisphere cultures. Johan Ligtvoet and Brent Wilson examine children's portrayals of trees rendered from the imagination. Their study, reported in Chapter Seven, illuminates degrees of conventionality in children's drawing, in the sense that pupils' changing schemata for trees are attributed to variations of teaching, pupils' access to picture books, and other historical changes over the fifty year span represented in the sampling of graphic evidence.

Leslie Perry attempts, in Chapter Eight, the difficult tasks of defining the concepts of drawing in its representational and creative forms, as an essential contributor to the development of language skills and expression, and as one of the most potent factors in the shaping of cultural traditions. He expresses a topical concern for the function of drawing in

design, arguing that it is, ideally, instrumental in the evolution of designs and not merely supportive.

Two further contributions bring the discussion on drawing into the arena of higher education. Here the older student's ability to progress is conditioned by previous development during school experience, and the tutor's approach to teaching must take this into account. In Chapter Nine Steven Garner examines the position of drawing at this stage, in the important contemporary context of design, extending the view of drawing in design which Perry has presented philosophically. Garner describes the attitudes to design drawing of a number of designers and designer-teachers, and how these affect what the students do and what they understand as the relationship between drawing and design. Seymour Simmons seeks to evolve a new philosophical position by comparing fundamentally different drawing rationales. He considers, in Chapter Ten, what was expected in terms of drawing outcomes when philosophical rationalism determined cultural production, when empirical analysis, particularly of the natural world, was predominant, and when experimental scientific methodology seemed an ideal model for all knowledge acquisition. He shows how all of these are both superseded by and subsumed within a semiotic approach to drawing in higher education, in recognition of the contemporary value afforded to 'linguistic' analogies and eclectic symbolism.

For art educators and especially art teachers in many countries, drawing has been something requiring defence within the curriculum, either because of an unjustified apparent 'superfluousness' to the facilitation of valued learning of all kinds, or paradoxically because it is seen as useful in learning but trivial in itself. From his standpoint of close involvement with art educational practices, Robert Clement sets out an essentially British view of the prime functions of drawing in the curriculum. In Chapter Eleven he presents drawing as the means of observation, investigation and invention, and as an educational medium in symbolisation and expression, with examples from his own classroom experience of specific teaching methods. His arguments begin from the child's activity, and create a practical view of drawing's role in the development of thinking.

Nancy Smith's views in Chapter Twelve are not dissimilar, attending as they do to fostering dynamic, aesthetic and representational aspects of drawing activity, much of which, she argues, has yet to be given adequate attention and value in American schools. Her clearly constructed theoretical discussion includes development of the aesthetic rendering of line, shape and texture. To investigate her theory, she uses evidence of informal studies based upon classroom observations of children engaged in 'responsive' observational drawing, besides analysing their graphic products. With this posthumously-published essay, Nancy Smith concludes a fine and, sadly, too brief career in American art education.

John Willats' research into drawing development is concerned with the underlying topological and projective geometries of children's drawing at various ages. He uses the evidence of lateral studies (his own

and others') together with some individual examples to argue that children's drawing conventions do not compare to the usual criteria of adult works. This is a profound critique of the theory – still extant – of child art as an imperfect exercising of skills that usually reach perfection in physical and mental maturity.

This collection of research findings illustrates that the processes and paths of development in drawing are far more complex than previously reported. Development begins earlier and combines multiple systems of knowledge. Resulting 'growth' may be defined as understanding of drawing repertoires, as development attributed to the dynamic interaction of several influences, as being more than maturation – that is, intrasensory, interpersonal, and stimulating the individual's attention towards social contexts.

In much previous research there has been a tendency to focus on literal, actual, or conventional representation as the 'goal' of drawing in education. It will be obvious that several presentations here challenge this perspective. Also reconsidered are notions of development in drawing as predictable, sequential stages. This mirrors the fact that Post-Modern outlooks on culture are challenging expectations of what it is relevant to portray in art. The new eclecticism in mature art may be at last creating true points of contact with the creativity of the young. Multivalent and multicultural aspects of children's drawings may provide sounder theoretical connections with adult art than the often spurious common ground that was posited in Modernism.

This of course has ramifications for representation. If all cultures and states of mind are equally valid in the present artistic climate – if our chief convention is that we have no dominant conventions – then what are the chief cultural principles towards which teachers must guide their pupils? The answer in Britain has been to build into the National Curriculum in Art the disciplines of observational drawing: children draw what they, as unique percipient individuals, sense and observe. In the final chapter (the sole contribution to this volume that was not part of the conference), David Thistlewood considers the central importance of observational drawing in the National Curriculum, and also suggests that its emergence was anticipated, rehearsed and strengthened in the presentations and debates of *Drawing Art and Development*.

ELSBETH COURT
SHEILA PAINE
DAVID THISTLEWOOD

Chapter One

SHEILA PAINE Conflicting Paradigms of Vision in Drawing Development Research

> Drawing! God knows it's simple enough – making things out of lines.
> I've seen far better drawings – done by children of seven and eight than by all the academicians [1].

Real research, like real art, can be a very private, even isolated pursuit. The laboratory, the studio, the library and the other research locations (not forgetting the mind itself) are places of deep concentration where external events become excluded in order to focus on immediate investigations, their discoveries and conclusions. The researcher, like the artist, becomes immersed in the 'language', symbols, structures, strategies and media particular to the current investigation, temporarily eschewing many of their exterior equivalents in life beyond the task pursued. Periodic returns to the external reality are necessary to re-examine phenomena for their pertinence to the work in progress, but the real creative investigation continues in isolation, determining deeper and more crucial attitudes even when, on the visible surface, the research design itself (or the initial artistic intention) seems immutable.

This isolation, so vital as it is to the protection of the inner vision of the researcher as to the artist, has come to be unfortunately replicated (it seems to me) in the outer structure of relevant research generally. A plethora of sophisticated new communication systems has collectively failed to improve contacts and increase understanding, other than in limited ways. Here we all are, trying to understand some of the same things about drawing, its nature, purposes and potential, and for all those parallel studies we seek out whenever we can, much of value which could helpfully affect the design and development of current studies of all kinds, remains unknown, unnoticed or misunderstood.

One reason for this is the diverse phenomenon of drawing itself. Because it is perceived to have very diverse intentions and to express very different aspects of human endeavour, the study of drawing has attracted researchers from widely different backgrounds. This ought to be an incomparable asset to all concerned, with so many differently trained minds and eyes studying the same type of artefact. But these researchers move in different arenas, responding to different disciplinary paradigms and employing different 'languages'. Mutual understanding has thus been difficult to achieve, even when the desire to share ideas and discoveries has been strong.

The particular study of development in drawing has always offered us potentially special insights into some of the most important issues in

education and in art as well as into the realm of human behaviour: into the learning process; into the very nature of drawing and art as emergent capacities; into their dynamic and inter-active role in human development; into socio-cultural change; and into the creative determinants of that process. The field of researchers into development in drawing therefore widely includes:

Psychologists

Keen to relate drawing to behaviour, to analyse it in relation to the development of intelligence or personality, and frequently interpreting it as representational in intention and either therapeutic or even possibly damaging in action.

Artists

Concerned with feeling, cultural meaning, tradition and innovation, dynamism and symbolism, seeing drawing holistically, as expressive more than as representational, and as an intense though not actually (in Freudian terms) neurotic activity.

Teacher-educators

Variously envisaging drawing as therapy, as expressive and creative activity or as instrumental in support of other curricular study, in the learning of academic skill and about art, wanting to have the means to justify it in the classroom in one or more of these manifestations and/or to use it as evidence of successful learning; engineers and architects: seeing drawing as providing a visual vocabulary of structural and geometric logic and interested in the analysis of the 'language' so-created.

Designers

Concerned with the development of ideas through drawing for the function and style of artefacts.

Art historians

Examining drawing for its contemporary reference to and associations with the form, subject-matter and iconology of art.

Philosophers

Wishing to define the concept of drawing for its significance in relation to other concepts such as of the mind, the aesthetic, creativity and the imagination.

Sociologists and anthropologists

Focusing on the cultural and environmental influences upon drawing and the implications of these for human groups in terms of cognition, cultural expression and social change.

This is in some ways a contentiously itemised listing and not offered as any more than a broad description of some of the major concerns. Its point is to show that researchers concerned with drawing are richly different in their vision of it and in what they feel they can learn from it. The list is non-evaluative and has no hierarchy.

The research methods adopted by this diverse group unsurprisingly

are diverse too and epitomise the views held. In the first instance there is the way in which the drawings themselves are obtained, selected and viewed; they may be commissioned by researchers or retrieved from work normally produced, a difference which may be reflected in the items eventually obtained as well as linked to the researchers' expectations. Whichever of these collection methods is employed, there is the difference too between lateral investigation by selection of one or more items from many individuals in groups, or longitudinal study of many items from usually smaller numbers of individuals.

In an open-ended and cumulative rather than a more positively anticipatory approach, drawings may be viewed as individually significant 'milestones' which are only assumed to say something about the 'road'. In all this, the researcher may operate at a distance either in time or through intermediaries, or be actively and closely involved, for example as a teacher. All these strategies carry their own consequences for research outcomes, which may be affected by the remoteness or the intervention of researchers in the activity of drawing, and modified by contextual circumstances or by recognition of personal as opposed to general factors. The effect of a Subject's awareness of the interest of a researcher in his or her drawings, while they are being made, can become a crucial determinant in those drawings too.

Researchers use the material so acquired very differently. A major difference stems from the idea of drawings as open to the techniques of analysis (identifying details of imagery or of form as separately significant from their contexts) and conversely a holistic view (of any drawing as more than the sum of its parts). Pro-scientific researchers may argue that the latter position is unacceptable because it is statistically impenetrable; their quest is likely to be for hard-edged conclusions, usually expressed statistically or at least as phenomenal positive-negative statements. Art-oriented researchers on the other hand may say that fine analysis is rarely tenable, given the complex and creative nature of the activity and the interdependence of the ideas which parts of any drawing may in combination express; they may consequently argue for the validity of soft-edged conclusions where trends, traits and intuitive judgments, seldom amenable to precise description, are nevertheless seen as important.

There are indeed many different perceptions of the nature of valid research. The most extreme differences exist as between the researcher-theorist and the researcher-practitioner, that is to say between the 'laboratory' researcher and the 'action' (for example, classroom-based) researcher. The former are often accused of lacking understanding of their research Subjects and the latter of lacking clinical precision, awareness of theory and of recent 'discoveries'. Such accusations are not without foundation but should never be allowed to serve – as they often do – as workable generalities and reasons for ignoring the work of one faction by the other. It is from occasions unconstrained by habitual thinking that the unexpected and the newly valuable sometimes emerge.

The study of development in and through drawing has emerged from a considerable legacy of historical beliefs and practices, some of which,

3

though no longer held or practised, continue to condition that study. We still seem to be influenced by the mediaeval view of the activities of children as trivially playful because essentially not adult. The emergence of the concept of child art some hundred years ago has done little to dent this view; that is why Eric Gill's comment on the superior quality of some children's drawing was so provocative [1]. Educators may recognise the autonomy and the independent visual language of children's drawing but the general social belief continues almost as strongly as ever – that it is only reputable when aspiring to emulate what are perceived (not necessarily correctly) as adult models and methods. It is good to see questions being raised by some contemporary psychologists about the complacent and common assumption that the notion of 'adult-style representations' is a 'secure base' from which to explore children's drawings [2].

A view begins to emerge that a child's behaviour can have its own rules and meanings *which are not necessarily inferior or irrelevant to those of later development*. Contemporary art also shows that the representation of a purely visual reality is not something by which one might necessarily judge or measure the intelligence of the contemporary artist. Such judgments may only be relevant if appraised in the context of an individual's motivation. Neither can they be made unrelated to (at least) an awareness of the beliefs surrounding contemporary art within any culture, since no image is conceived in isolation from others, even if the maker may seem unaware of influences effecting what is created.

Just as views of childhood from the past leave their after-image on the minds of contemporary researchers, so too have views of the nature of drawing as a central phenomenon of art itself. The concept of the Classical, the idea that there are ideal forms of art and hence of drawing, to which those who draw aspire in their every mark, is widespread, whether in its Western or Oriental forms. For the former, Harold Osborne suggests that this implies either attempting to measure up to standards of finite excellence set by the art of the Greeks and Romans, or to the best of its kind in any period, with:

> adherence to recognised canons of form and conscious craftsmanship, or even the more obvious types of symmetry and proportion, in contrast with personal emotion and alogical inspiration [3].

It is not hard to see the former of these two positions as deeply influential upon much of the scientific scrutiny of drawing which has taken place in the past century, especially because the premise upon which it is founded affords a more comfortable base for such scrutiny than the field of behaviour and feeling. But the antithetical concept of early and middle twentieth century modern art initially described as Expressionist, has also influenced the initiation of behavioural and personality-centred investigations. Broadly speaking, in this view the drawing expresses the personality or embodies the feeling(s) of the artist. It is where analytical and quantitative scientifically applied methods of research have become implicitly challenged by these abstract concepts, that the difficulties for research have increased.

4

A principal problem for the researcher into drawing, therefore, is the assumption of the nature and significance of drawing which is inherent in the design of the research method. Some things are immeasurable and lend themselves more to descriptive than to quantitative investigation. If you believe development in drawing to be about acquiring techniques to draw what you see [4], it is reasonable to try to correlate age, stage and intellect. If you perceive it as a reflection of a previously formed inner design, or you see it as actually formed by and formative to experience (Peter Fuller's notion of good drawing as 'transitional'), then there are no fixed technical phenomena whereby such things may be precisely evaluated. The researcher must face up to the uncertainties of interpretation, where 'intuition, speculation, hunch and intelligent guess are all involved' [5]. But the real problem lies not in any one of these awkward but potentially revealing processes, but in the extent to which most drawing represents aspects of all three positions.

The history of the interpretation of development itself has also been formative upon the study of development in drawing. It begins, one might argue, with the extraordinary fantasy of the development of one imaginary child, 'Emile', by the eighteenth-century French philosopher Rousseau. The activity of drawing was not to be accorded very much significance in Emile's development, but it would be used to develop 'exactness of eye and flexibility of hand' in the search for the truth about nature. Rousseau's views were conceived within a broad linear-sequential framework of development, seen as a ripening process, where drawing like any other activity was the manifestation of a particular stage of fruition. It was important, too, as instrumental in the development of the senses, a process which could be facilitated but not hurried, since an individual must be 'ready' to proceed to a further stage. Rousseau did go so far as to imagine the kind of development in drawing itself which would naturally ensue from observation and the example of his imaginary pupil:

> I will have our drawings framed [and] arrange them in order
> round the room, each drawing repeated some twenty or thirty
> times, thus showing the author's progress in each specimen,
> from the time when the house is merely a rude square, till its
> front view, its side view, its proportions, its light and shade are
> all exactly portrayed [6].

It seems fairly obvious that the influence of Rousseau's developmental and methodological theory, its emphasis on stages and readiness for each one, together with his limited understanding of the drawing process, has persisted far beyond its credibility, bearing in mind his own inadequate early education and his failure as a tutor and parent. Curiously his insistence on the importance of the development of the senses apparently did not extend to his vision of drawing development (with its constant emphases on geometry, proportion, accuracy and the avoidance of fantasy).

Some hundred years later the German educational philosopher Froebel gave drawing greater significance than either Rousseau or other previous educational theorists. Believing in the notion of development

from within, in response to creative self-activating initiatives, he envis-aged drawing as one of the natural processes of that response. Drawing was asserted to develop 'according to the inherent laws of life ... furnishing the soul with clear concepts, true thoughts and beautiful ideas' [7]. Echoing Rousseau, this idealistic view was paradoxically accompanied by some fairly rigid prescriptions on the part of Froebel (and of Pestalozzi) for the teaching of drawing and an endorsement of Rousseau's four stages of development.

Rousseau's rigidly sequential description of development seems to have been perpetuated into the twentieth century as a structural base upon which contemporary 'stage' theory has been grafted. The (amplified and newly described) stages are commonly seen as invariable in order, and each dependent upon the attainment of the preceding ones. James Sully (assisted by Ebenezer Cooke) is usually accredited with first applying this in any truly systematic way to drawing [8], and to influencing some of the major European drawing researchers who followed. We know that working with real rather than imagined child case-studies, Sully (England 1895) [9], Luquet (France 1913) [10], and Eng (Norway 1931) [11] contributed to a new longitudinalist approach to the study of behaviour and development through the medium of drawing. This individual-specific research method has existed ever since (albeit intermittently practised) alongside the work of those researchers who have preferred the often more accessible lateral investigations, such as that represented in Cyril Burt's controversial and subsequently much-discredited *Mental and Scholastic Tests* [12] and in the Florence Goodenough *Draw A Man Tests* [13].

Burt and Goodenough adopted the prevailing view of staged develop-ment [14] and the basis of the stages which Sully had devised to describe development in drawing. The intelligence tests they each formulated have, in their frequent use, influenced the attitudes of several genera-tions of psychologists and teachers (including art teachers) since the nineteen-twenties. The notion of rigid sequencing is a neat and comfort-able one; any direct questioning of the vision of development in drawing which it represents has been little heeded. In 1943, in discussing the use made by Burt of the theory of the developing schema, Herbert Read was conversely arguing 'My own observations do not support such a neat evolutionary theory' and describing a more complex developmental process whereby there exist:

> two different styles of representation, one for [the child's] own
> personal satisfaction, the other for the satisfaction of other
> people [15].

Burt's and Goodenough's influence on schools – and the schools' and the researchers' employment of their tests – continued unabated, reinforced in 1947 by some largely supportive ideas contained in Lowenfeld's highly influential work on drawing and education [16].

The researcher with the greatest long-term influence in this evolution of the theory (I would suggest) has been Luquet, since he is the most often quoted. It is not unreasonable to envisage his two major works on drawing (1913 and 1926) as having determined the form of both

Piaget's evolutionary, and extremely influential, staged model of development and Bruner's cognitive growth model, both of which were conceived as unalterable sequence models, characteristically similar to Luquet's own. For example, in the case of the former, and as recently as 1969, Piaget and Inhelder wrote:

> In his celebrated study on children's drawings, Luquet
> proposed stages and interpretations which are still valid today.

They went on to describe two contrary opinions about drawing development, arguing confidently that 'Luquet seems to have settled the dispute conclusively' [17]. Again Read is among the few to have tackled the implications of Luquet's proposals; he notes that Luquet recognised at eight years a stage in which children draw in two different modes, but comments:

> What Luquet, for a later stage of development calls a *'duplicité de types'*, is in my view present from the beginning, and this fact has a fundamental bearing on the psychological basis of the child's activity [18].

Luquet's perception of development in drawing was evolved from studies of the mentally ill and of his own daughter (from three to only nine years). There are recognised problems and pitfalls in inferring the normal from examples of the anomalous. There are well-known problems too in evolving a theory largely from one case-study (especially one so close to the researcher). Every evening, from the age of three, Simonne was encouraged to spend time drawing at the corner of her father's desk. She is credited with the occasional petulant protests ('Don't keep on expecting me to do the same thing') which convey the dominance of the watching adult. One may question to some extent, Luquet's later influence on researchers and theorists in relation to the apparent credibility of his research situation; one may reasonably wonder whether other models developed according to other principles or from different kinds of observations might be at least as valid.

Yet the fascinating alternative propositions supplied by other twentieth-century researchers and theorists (in the field of psychology and emanating from North America as much as from Europe) for models of the process of development do not seem to have taken root. The (i) transitional model (development as continuous, incremental and cumulative); (ii) the staged-transitional model (in which the sequence of attainment is invariant but development is not impeded because any one stage has not been mastered); and (iii) the spiral models in which progress is achieved through the constant reinvestigation of earlier experiences (but at new levels and with new skills) [19] afford some exciting speculation on their validity in the context of art. The notions of accumulation, parallelism, reinvestigation and the whole idea of development as multilinear, multifaceted and of unpredictable pace, speak to a world of mental flexibility and diversity that artists and other creative practitioners of all kinds can empathetically recognise.

I have elsewhere suggested that the actual 'pathway' of development may not be the same for all individuals and based this suggestion on the evidence of a number of case studies [20]. At one end of the spectrum,

there seem to be examples of logical, linear and systematic progression, but at the other of children who appear to have acquired and lost and sometimes rediscovered drawing skills, accelerating and decelerating through their own sequences of stages. Where in individual cases the stage theory seems most applicable, it is still advisable to be wary of inherent assumptions. For example, Piaget postulated a general, growing ability from ten years to think flexibly and to explore propositions; yet in a characteristic *tour de force* Eng's Subject, Margaret, was drawing *God carrying a Soul up to Heaven* at 4 years, 8 months. And whereas Lowenfeld describes at post ten years a gradual decrease in imaginative thinking, Fein's 'Heidi', like many, was increasingly involved in adolescence with imaginative concepts of symbolism and feeling.

Even within stage theory, we need to recognise the possibility of variation in the alleged content of the stages themselves, just as we also need to remain alert to Subjects who may obligingly distort that content to fulfil the expectations of their development that they intuit we have. That in turn reinforces the caution necessary in the choice of methods for acquiring evidence. I feel bound to argue at this point that longitudinal studies of individuals can offer potentially more useful and less distorted evidence of development in drawing than many lateral studies of categorised groups (although they do not replace those). They can be derived from the natural production of drawings and are the consequences of individual experience. Such studies, when of individuals with exceptional drawing facility (whatever their other strengths or weaknesses) and especially of those who develop into practising artists, already reveal much of value for the wider study of drawing development [21].

Discussion of the process and the 'pathways' of development presumes notions of what is seen as desirable development and of the position or condition from which it begins. What did Gill see as 'better' in young children's drawings compared to those of adults? Are they, as Cizek and some more recent art educators would argue, more expressive, more innocent, less-influenced and less repressed than later productions? Or are children' s drawings in need of:

> a truer eye, a surer hand—the graceful outline and light touch of the draughtsman (Rousseau);
> genuine artistic activity which they will only achieve at fifteen years (Burt);
> 'not only the rules of drawing' but 'a greater understanding of the laws of nature' (Nicolaides) [22];
> superior visual perception and greater executive skill (O'Connor) [23];
> the avoidance of that obsession with stereotypic drawing which heralds or maybe contributes to 'developmental disablement' (Henley) [24].

The most favoured description has, of course, been of a much analysed journey towards the alleged universal objective of 'accurate' representation, though many artists and others interested in perceptual theory

recognise that, by the nature of the eye-brain-personality relationship, there can be no such thing.

Recent research reveals that early 'scribble' can have meaning [25] and that first images (however apparently incoherent) can determine the themes and preoccupations of a lifetime [26]. Thus drawings do not necessarily accrue greater value (in terms of human experience and as evidence) as their makers become older; they only use different techniques, express different ideas or reinvestigate the same ideas differently. They may come to display the conventions of their culture (such as the Western techniques of occlusion or perspective) and an increasing understanding of certain structures in space; but the capacity to grasp and represent some essentials of experience (feeling and intuitive knowing as well as quite explicit situations) is often apparent in many of the earliest works that children produce.

Given that analytical research methods have predominated, the choice of phenomena to deem significant in drawings, to quantify and to explain, has always been potentially contentious. The approach has been largely object-centred and the most widely investigated has been the drawing of the human figure on the assumption that (as suggested by Dale Harris in 1963 [27]) it is the most frequently portrayed object in children's drawings. That claim may be generally valid in Western culture but the examples of the autistic investigated by Selfe [28] and O'Connor [29], for instance, and of children from other cultures by such as Court [30], where other objects have primacy, should warn us to perceive this approach with caution. This is not to argue that the human form as object is an irrelevance; Osterreith and Cambier's most plausible study of male and female drawings [31] goes further than most in exploring not only construction but also movement, mood and character, recognising that the way children construct human figures and represent their details, reflects expressive intentions as well as structural knowing.

When the links between drawing and emotion or personality have superseded the more pervasive interest in determining intelligence, analytical research has sometimes focused on expressive rather than object phenomena, recognising those aspects of drawing as art with which artists themselves are generally more concerned. But in seeking evidence for the psychological condition or personality of the Subject, personality theorists have tended to retain too great a dependence upon object phenomena, rather than to those more genuinely expressive characteristics which are about the drawing as a drawing. Koppitz's 1968 Test [32] combines mental development indicators with emotional 'quality signs'. However, the indicators of the latter display an arbitrariness of choice, expressing the researchers' prejudices about human behaviour and also about the activity of drawing, more than any real psychological or artistic logic. Thus:

> transparent features of a drawing, poor integration of a
> picture's parts, shading, gross asymmetry of limbs, slanting or
> tiny figures [and] special features [such as] tiny head, crossed
> eyes, long or short arms, clouds or rain. . . .

9

all earn the researchers' implicit disapproval, though these only describe devices which are known to be legitimate artistic means to the portrayal of response to feeling.

A focus on the content of a drawing and especially the use of lateral studies techniques can seem to lead to notions of what is average performance at different ages and to consequent expectations of children which, as has been suggested, they often obligingly fulfil. It is not necessarily a popular idea, particularly where it impinges on age structured educational systems, to suggest that differences in the pace of development between individuals (concealed by lateral research methods) are significant and revealing. For many individuals – perhaps most – there seem to be surges of development in drawing at different ages as well as periods of stasis, with causes in emotional, social and environmental circumstances. Only longitudinal studies (though used in association with findings from lateral ones) can address this area of investigation.

Some changes of focus in this complex research field seem to be suggested by the often conflicting descriptions of theory and practice which have been raised here, for instance to explore:

1 The decrease as well as the increase of complexity in drawing sequences, bearing in mind that the refinement of the essence of an idea and its expression can be as (or more) laudable a statement of it as anything complicated.
2 The capacity to portray relationships between objects in a drawing (such as through movement or symbolically), as perhaps more important an issue in the study of development and of art, than the ability (or even the wish) to report form and proportion in single or multiple objects.
3 The parallel phenomenon of the use of imaginative skills alongside other more representational ones at any period of development.
4 Spontaneous drawing, as reflecting what children are interested in, rather than what we may expect them to be interested in or what they do for us.
5 The valuable facility to use and discard exterior conventions according to individual need at different times (a process of development described by Brent Wilson [33]).
6 Materials and their consequences for drawing development (the autistic 'Nadia' had very firm preferences [34]).
7 The motivational and developmental issues inherent in Luquet's and Read's observations of parallel intentions.
8 The study of pace of development in drawing, recognising individual differences and their external causes.

Conclusions

The complexity of the concepts of development and of drawing and the diversity of research backgrounds have sustained an isolation between potentially inter-valuable facets of research. I have no doubt failed to disguise my own viewing position (as an artist/art educator) on this fascinating arena of investigation. It appears to me that, like a number of

individuals drawing on location together, we all have somewhat different perspectives on the same subject matter. A greater sharing of those different facets of perception could be mutually illuminating.

The study of children's drawing, as well as the study of the nature of drawing as art, challenges a number of common assumptions which have hitherto guided research. Some culturally conventional techniques of drawing such as occlusion, perspective, 'accuracy' in representation, increasing complexity, and so forth, are inadequate as evidence of development although they may tell us of the extent to which certain cultural skills have been adopted. Neither is it sufficient to presume that the human figure is the most significant subject matter (to development) of children's drawing, or that any drawing which has been commissioned (as opposed to spontaneously created) is necessarily legitimate in the context of development. As to the process of development in drawing itself, it appears eclectic and frequently erratic, accelerative or regressive according to external influences or inner motivation and rarely wholly (if at all) linear.

Children's drawings often seem to display *in their own terms* many of the concepts usually associated only with mature adult performance: control of the media, subtlety, economy or complexity of expression (in images or ideas underpinning them), and great imagination. When we fail to see these capacities, it may be because we look for their adult and cultural forms rather than their natural equivalents from the younger mind and hand.

Stage theory (and especially the description of supposed stages) has particularly predetermined our perception of what children are aiming to do in drawing. Admission of the possibility of a multiplicity of developmental models, frees us to read the evidence of early drawings rather differently. Motives for drawing in certain ways may vary from time to time; structural knowledge may frequently be subordinated to other expressive intentions; individual expression may 'wax or wane' in relationship to cultural learning; and intelligence may reveal itself through the flexibility of thinking shown in the iconology of successive drawings, rather than in the formal portrayal of their object-contents.

If there is a discernible commonality in all this, it must be about the extent to which drawing, for any individual, develops as an expressive and reciprocating agent for the intellect. While the (dislocated) body of research has yielded much of value, it has often seemed to fly in the face of what drawing naturally is: 'visual thinking', dynamic, individualistic, and expressive from the beginning. Renewed questioning of stage theory in this context, and of the whole image of sequential development in drawing to which educators (including many art educators) have adhered for so long, can only be desirable and welcome. The opportunity for those skilled in drawing and its teaching to join with those skilled in the study of human behaviour, in evaluating some alternative models of development, would offer many rich ramifications indeed for the interests of all the differently motivated researchers in this field.

Notes and References

1 GILL E. (1941), 'Abolish art and teach drawing', *Athene*, March, p. 22.
2 COSTALL A. (1985), 'How meaning covers the traces' in FREEMAN N. H. and M. V. COX (eds) (1985), *Visual Order* (Cambridge University Press), p. 18.
3 OSBORNE H. (ed) (1987), *The Oxford Companion to Art* (Oxford University Press), p. 246.
4 FULLER P. (1985), *Rocks and Flesh* (Norwich School of Art Gallery), pp. 6–7.
5 Fuller calls this the 'objective fallacy' but it is a good description of the motivation behind some kinds of drawing and a strong determinant of the pattern of development, even if the drawings themselves may not be judged wholly to fulfil the intention.
6 ROUSSEAU J. (1762), *Emile* (London, Dent and Sons, 1982), p. 109.
7 FLETCHER S. and J. WELTON (1912), *Froebel's Chief Writings on Education* (London, Edward Arnold), p. 226.
8 MACDONALD S. (1970), *The History and Philosophy of Art Education* (London, London University Press), pp. 325–329.
9 SULLY J. (1895), *Studies of Childhood*, (London, Longman, Green and Co.).
10 LUQUET G. (1913), *Les Dessins d' un Enfant* (Paris, Librairie Felix Alcan). See also LUQUET G. (1927 [77]), *Le Dessin Enfantin* (Paris, Delachaux et Niestle).
11 ENG H. (1931 [70]), *The Psychology of Children's Drawings* (London, Routledge and Kegan Paul).
12 BURT C. (1921), *Mental and Scholastic Tests* (London, R. S. King and Son).
13 GOODENOUGH F. (1926), *Measurement of Intelligence by Drawings* (New York, World Books).
14 According to Burt, 'from one unique phase to another through a series of transformations', unfolding 'the line of mental progress'; BURT (n.12) p. 347.
15 READ H. (1943 [70]), *Education through Art* (London, Faber), p. 124.
16 LOWENFELD V. (1947 [58]), *Creative and Mental Growth* (New York, Macmillan).
17 PIAGET J. and B. INHELDER (1969), *The Psychology of the Child* (London, Routledge and Kegan Paul).
18 READ (n.15) p. 123.
19 MURRAY T. R. (1979), *Comparing Theories of Child Development* (California, Wadsworth Publishing Co.).
20 PAINE S. (1983), Progress and paradox in drawing, in DYSON A. (ed) *Art Education: Heritage and Prospect* (London, Heinemann).
21 PAINE S. (1987), 'The childhood and adolescent drawings of Henri de Toulouse-Lautrec', *Journal of Art and Design Education*, 6, 3. See also PAINE S. (1988), 'Letting the impressions stream in', contrib. exhib. cat. *Michael Rothenstein* (London, Angela Flowers Gallery).
22 NICOLAIDES K. (1972), *The Natural Way to Draw* (London, André Deutsch).
23 O'CONNOR N. (n.d.) 'Spatial representation in mathematically and in artistically gifted children', (unpubl. MRC Developmental Project, Institute of Education, London University).
24 HENLEY D. (1989), 'Stereotypes in children's art', *American Journal of Art Therapy*, 27 May.
25 MATTHEWS J. (1984), 'Children drawing: are young children really scribbling?', *Journal of Early Child Development and Care*, 18, pp. 1–39.
26 PAINE S. (1985), 'Development in drawing in the childhood and adolescence of individuals' (unpubl. PhD thesis, University of London).
27 HARRIS D. (1963), *Children's Drawings as Measures of Intellectual Maturity* (New York, Harcourt, Brace and Jahanovich).

28 SELFE L. (1977), *Nadia – a Case of Extraordinary Drawing Ability in an Autistic Child* (London and New York Academic Press).

29 O'CONNOR N. and B. HERMELIN (1987), 'Visual memory programmes; their use by idiot-savant artists and controls', *British Journal of Psychology*, 78, pp. 307–23.

30 COURT E. (1989), 'Drawing on culture: the influence of culture on children's drawing performance in rural Kenya', *Journal of Art and Design Education*, 8, 1.

31 OSTERREITH P. and A. CAMBIER (1976), *Les Deux Personnages* (Brussels, Editest).

32 KOPPITZ E. (1968), *Psychological Evaluation of Children's Human Figure Drawing* (New York, Grune and Stratton).

33 WILSON B. and M. WILSON (1977), 'An iconoclastic view of imagery sources in the drawings of young people', *Art Education*, 30, 1.

34 See SELFE (n.28).

Chapter Two

BRENT WILSON Primitivism, the Avant-Garde and the Art of Little Children

We have yet to uncover the drawings of a young child of ancient Egypt or Greece, but can be certain that, through the ages, whenever adults have made art, little children have watched and then made their own naïve versions of drawings, paintings and sculpture. The frozen tundra of the Soviet Union has, for example, provided us with the drawings of young Onfim who, at some time between the years 1224 and 1238, drew pictures of battles on birchbark tablets that had been prepared for his school lessons. Then there is Johannes, a young Dutch boy, who drew figures in his school textbook in the early sixteenth century. At nearly the same time, in about 1520, the Italian artist Gian Francesco Coroto painted a portrait of a young boy holding a drawing of a human figure – perhaps his self-portrait. Jean Heoard, tutor to Louis XIII, saved the drawings of the young prince from the age of four. Pieter Jansz Saenredam depicts young boys drawing on the walls of Dutch churches in 1641 and 1644. Of course, the closer we approach the present time the more we are likely to discover surviving artefacts of children's drawing [1].

We are left to wonder what adults thought of juvenile efforts at drawing in previous times. It is doubtful whether they took much notice. In all likelihood the art-like products of children were notable only when they were seen to contain evidence of giftedness, like the image of a sheep scratched on a smooth rock by the young shepherd boy, Giotto, that, according to Vasari [2], so astounded Cimabue that the artist immediately asked for permission to have the boy as his apprentice. The story may be apocryphal but it tells an essential truth. The drawings of children became important only when they began to look like those of the adult artist.

But today many people, especially art teachers and parents, speak easily of child art. The point at which adults began to think of the drawings of children as art should probably count as a discovery, but not of something new. Rather it was a discovery of features and qualities that had perhaps always been present but ignored in children's drawings. It was not so much that children's drawings changed, but that adults' perceptions of them changed. But when did children's drawing cease to be merely the by-products of graphic play and begin to count as art? Why did such a categoric and definitive shift occur?

It is difficult for those who have lived in the century of the Expressionists, Fauvists and Cubists – in a time that worships the naïve and the *so-called* primitive in art – to realise how utterly different these

traits are from the Raphaelesque ideal that characterised the early nineteenth century. At that time Thackeray could criticise David's Neo-Classical paintings as stiff and childish. In the twentieth century the childish, or at least the child-like, is an admirable trait in the work of artists. Klee and Dubuffet owe their reputations in part to the child-like. I will trace the evolution of beliefs that signalled this shift in attitude towards the naïve and the primitive.

Like the presumed Norse discovery of America, which made no difference to Columbus when rediscovering and exploring the 'new' continent, child art had its first discoverer. In 1848, the posthumously published book, *Reflections et Menus Propos d'un Peintre Genevois* by Rudolphe Töpffer, Swiss schoolmaster, caricaturist, and illustrator of children's stories, contained two chapters devoted to child art [3]. Almost no one noticed. Because of his training as an artist and his schoolteacher's insights into the drawings of children, he could raise questions about the little manikins or rudimentary figures drawn by children. More importantly, he wondered if the apprentice painter was less an artist than the young child who had received no formal instruction in art. Indeed, Töpffer made the astonishing statement that there is less difference between Michelangelo 'the untutored child artist' and Michelangelo 'the-immortal', than between Michelangelo 'the immortal' and Michelangelo 'the-apprentice' [4]. To Töpffer the child's spontaneous graphic inventions were seen as closer to the creative expressions of great artists than were the slick works of those whose art displayed mere conventional skill.

Töpffer's radical ideas did not, however, go entirely unnoticed. According to Schapiro, Gautier in his *L'Art Moderne* was, 'enchanted by Töpffer's assertion of the superiority of children's art' [5]. And in the opinion of Schapiro [6] Töpffer's ideas also influenced Champfleury, and it was through him rather than Gautier that child art came to be linked with Modernism and to the idea that the child could create art. In writing about the work of Courbet in 1855, Champfleury echoed Töpffer, to say of the painter 'between Courbet as a child and Courbet as a master, there was no Courbet *apprenti*' [7]. Champfleury and his colleague Courbet each in his own way championed popular and naïve images.

In his enormous painting of 1854–55, *L'Atelier du Peintre* (or *The Painter's Studio, Real Allegory, resolving a phase of Seven Years in my Artistic Life*), Courbet presents a cross section of humanity (Fig. 1). To the left are commonfolk, poverty, wealth and wretchedness; in the centre is the artist himself at work on a painting while a model and a little boy observe; and on the right are Courbet's friends and colleagues from the artistic and literary world, Baudelaire and Champfleury notable among them. Courbet has painted what Werner Hofmann has called a '*tableau clef*'. Hofmann claims that in the painting:

> the century's development is for an instant arrested and a
> balance struck; the whole first half of the century is gathered
> together in it in concentrated form, while the second half is
> already foreshadowed [8].

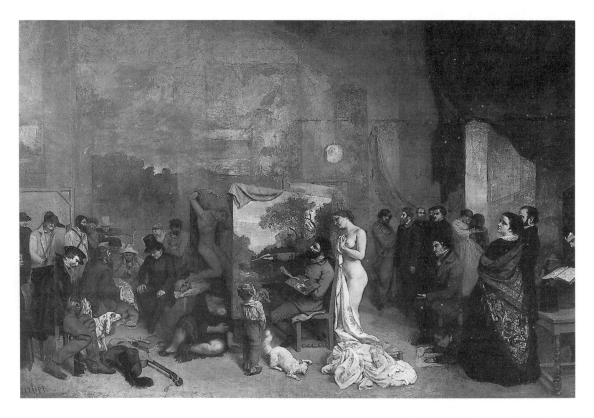

1 GUSTAVE COURBET:
L' Atelier du Peintre;
1854-55; oil on canvas
360 x 600 cm; Louvre,
Paris.

Among its many meanings is an allegory of the ages of man. There is the infant nourished by its mother, and then the two young boys, the one at the easel with the artist, transfixed, it seems, by the painter's power to create visions of reality from mere paint, and the second shown drawing at the feet of the pensive gentleman. This is Champfleury who drew Courbet's attention to the naïve art of the folk, and perhaps also to the creative power of the child. In this monumental painting, in which Alan Bowness claims Courbet invented modern art [9], we glimpse (through the triangle formed by Courbet, Champfleury, and the child) the first chronicle in paint of childhood creativity. In this premier dramatic production of Modernism, the child has been cast in the role of artist, placed among artists, and given nearly equal billing. It was through this painting that a radical view of creativity and the supposed inventive force of children's drawing entered, if not the consciousness, at least the sub-consciousness, of the artistic avant-garde. But in this the avant-garde was far ahead of the main body. There is no evidence that natural philosophers and pedagogues, later to study child art, took any notice whatsoever.

The discovery that led to scientific exploration and pedagogical colonisation of the world of child art took another whole generation. In Milan in the winter of 1883–34, Corrado Ricci, the Italian poet and philosopher, took refuge under a portico to escape a sudden shower. While waiting for the rain to subside he observed drawings children had

16

scrawled spontaneously on the walls. Those drawings high on the wall by older children he thought crude, those lower genuinely creative, and he resolved to conduct a study of the art of little children. In 1887 Ricci published *L'Arte dei Bambini* [10], a full generation after Töpffer's two chapters on the art of the child and Courbet's *The Studio*. Still, it was the first book to be devoted entirely to the art of little children.

Ricci was not alone in his discovery of child art. In 1885 the Austrian art student, Franz Cizek, observed children drawing on a wall opposite his room in Vienna [11]. He gave children paint, encouraged their efforts, eventually established art classes for them, and became known as the father of child art. And there were more discoverers, such as the American Earl Barnes who, in 1893 – unaware of the work of Ricci – published his own study of children's drawings [12]. When he learned of Ricci's book he had a portion of it translated and published in the United States so that differences between his research and Ricci's could be noted, and so that he would escape the charge of plagiarism that he feared someone might level at him.

Barnes should not have been concerned with plagiarism. He and a sizeable number of colleagues, frequently unknown to one another, were affected by the spirit of their time as they all enthusiastically discovered the dimensions of child art. In the space of the dozen years before the turn of the century, psychologists, philosophers, educators, and art educators had published an enormous number of important studies of child art. The drawings that had not been art were well on their way to becoming so.

Discoveries have both utilitarian and ideological values. For the psychologists, the graphic images of children provided a way to study the 'contents of children's minds'. Pedagogues saw graphic images as a language parallel to the written and the verbal, that would provide the child with a means for conveying information, while artists saw in children's images a confirmation of their beliefs about the true nature of art and artistic creativity. It is this third strand of child art that I should like to follow.

In Vienna, Franz Cizek was in close touch with the group of artists and architects (particularly Otto Wagner, Olbrich, Moser, and Gustav Klimt) who in 1896 broke away from the *Akademiker* and founded the *Sezession*. Viola tells of the response of these artists to the art of Cizek's children:

> There was great rejoicing! Some went so far as to say that these
> were the foundations of the new art education. Why go back to
> the Chinese, Japanese, ancient Egyptians, Babylonians, and
> Negroes? Here was that which they sought [13].

The images of children did indeed appear to possess much that artists were striving for in their own art. Consequently, artists used the art of the child along with naïve, tribal, and various other forms of exotic art to confirm their artistic ideologies. Let me point to some of the crucial relationships between the art of the child and Modernist beliefs. Modernism was characterised by the desire for the new, the novel, the

yet-to-be seen. This yearning had its roots in Romanticism which Jacques Barzun has characterised as the:

> great revolution which drew the intellect of Europe from the
> expectation and desire of fixity into the desire and expectation
> of change [14].

And Romanticism, according to Wiedmann:

> made everything fluid. It was the triumph of motion over stasis,
> of process over permanence, of force and flux over solid form
> and substance [15].

This novelty of imagery was found in artefacts from remote times and places, in the artefacts of tribal peoples, and also in the art of children and peasants. It could be a mistake to think that these children's images had important effects on groups of artists, the expressionists in particular. It was more a case of the expressionists seeing in the art of so-called 'primitive' peoples and children the expressive qualities that they had already begun to achieve in their own work. True enough, in an article he contributed to the 'almanac' *Der Blaue Reiter* (probably the first journal to publish children's art for artistic reasons) [16], Auguste Macke praised the art of children and aborigines 'who have their own form, strong as the form of thunder!' And in a letter to Macke, his fellow artist Franz Marc proclaimed:

> We must be brave and turn our backs on almost everything that
> until now good Europeans like ourselves have thought precious
> and indispensable. Our ideas and ideals must be clad in
> hairshirts, they must be fed on locusts and wild honey, not on
> history, if we are ever to escape the exhaustion of our European
> bad taste [17].

And Paul Klee reacted favourably, if somewhat defensively, to the comparisons made between his works and the art of children:

> Child's play! Those gentlemen, the critics, often say that my
> pictures resemble the scribbles and messes of children. I hope
> they do! The pictures that my little boy Felix paints are often
> better than mine because mine have often been filtered through
> the brain [18].

But it was the idea that children and aboriginal peoples were unconstrained by societal conventions, that because of their naïve state they were somehow in closer touch with cosmic and primal forces, that enabled them to tap the wellspring of creative energy better than artists whose sensitivities had been dulled by academic artistic conventions. Kandinsky wrote of the cosmic and spiritual forces that could be sensed and expressed when free from convention. And children who had not had the time to be enslaved by convention were, along with primitive peoples, the possessors of clear channels to the primal forces of creativity. In Kandinsky's own words:

> We shall appreciate that the inner sound is intensified when it is
> separated from conventional practical meanings. That is why
> children's drawings have such a powerful effect upon
> independent-thinking, unprejudiced observers. Children are
> not worried about conventional and practical meanings, since

they look at the world with unspoiled eyes and are able to
experience things as they are, effortlessly . . . Thus, without
exception, every child's drawing reveals the inner sound of
objects.

Kandinsky goes on to decry adult efforts to instruct children in their
artistic endeavours and concludes:

Now the gifted child not only ignores externals but has the
power to express the internal so directly that it is revealed with
exceptional force (as they say, 'so that it speaks!') [19].

In effect, if this unconventional, untrammelled, unfiltered creative
expression that children and the supposedly naïve possessed, were
regained by artists, it would be the means by which they would be able
to express the essence of objects rather than their external appearances.
The simplicity, directness, and apparent abstractedness of children's
images reinforced the idea that children saw and expressed reality with a
universal wholeness that the modern artist could only hope to emulate.
Moreover, it might be supposed that the essence, the universal whole-
ness, that was presumedly found in children's expressions would lead art
towards a universal similarity.

Artists, however, ignored that possibility and saw the attempt to avoid
conventions in art, at the very least, as the beginning of a perpetual
avant-garde, a period in which each artist must engage in the process, as
Robert Motherwell said, of 'inventing yourself from scratch' [20]. The
ultimate end of this obligation for self-invention can be imagined as a
state where even the avant-garde has been disbanded in favour of count-
less individuals, each creating a style different from the styles of every
other artist. And thus modern art and the child art that clung to its coat-
tails coexisted in a context of mutual beliefs:

1 Art came from individual intrinsic sources.
2 Art was to express a feeling about something rather than depict its
 exterior appearance.
3 Form and abstraction were the new ideals – the artist and the child
 saw the world as light, colour and mass.
4 The art of children and tribal peoples provided models of primal and
 unfettered creativity for modern artists to emulate.
5 Former (Western) artistic conventions were to be avoided, as every
 artist and every child had the obligation to invent individual styles of
 art.
6 Through the harnessing of individual creative energies art could
 remain in a perpetual state of renewal, Modernism could last forever,
 there would be a perennial avant-garde.
7 In this ideal Modernist state, artistic growth would come not through
 formal instruction but through nature and the organic unfolding of
 intrinsic creative energy.

These were the beliefs that fuelled the forces of Modern art. And these
were the beliefs that governed the practices of art education for both the
artist and the child. Cizek spoke wistfully of an island in the sea where he
could have his garden of God, the Eden where children's art could be
nurtured from natural roots, where the universal spontaneity of the child

19

would be smoothly transformed into the unique creativity of the artist with no fear of conventional contamination. This was the Modernist view of art and art education.

Now we have entered a Post-Modernist era. Regardless of what we call this new time, its *Zeitgeist* is exemplified by our less voracious appetite for the primal and the primitive, our de-emphasising of originality, and a great inquisitiveness regarding the social construction of art. Modernism made possible the discovery of child art; will the passing of the Modernist era lead to a disassembling of child art?

I should like to discuss a paradigm shift of the variety characterised in Thomas Kuhn's *The Structure of Scientific Revolutions* [21]. It is a revolution, albeit a very small one in an obscure corner of the art world, and one in which I played a role. In 1977, Marjorie Wilson and I published an article in which we illustrated that virtually every image drawn from memory by teenagers could be traced not to intrinsic or individual sources, but to the popular media, to 'how to draw' books, and to other imagery from the teenage subculture. Its publication [22] brought forth an enormous outcry from art educators and others. For example, Rudolf Arnheim, the paradigm defender of *Gestalt* theory, said that we were engaged in 'the exhumation of the mummies of nineteenth-century art drill'. For Arnheim our suggestion that children's graphic images had their origin in the images of others was not a mere academic question. At stake was 'the very health of the human mind' [23].

It was clear to us that our reporting of some interesting facts about the sources of imagery in art (which incidentally corresponded nicely with Gombrich's notion of schema and correction used by artists [24]) had collided with Modernist notions of artistic creativity. We were convinced that what we said about teenagers was just as true for all young children. A series of studies followed in which we illustrated repeatedly that children's imagery is not universally the same, that it is subject to the influences of time, place, and art.

We charted the decline of the two-eyed profile that was prevalent in the drawings of children prior to the turn of the century. The two-eyed profile had entered children's imagery as a form of intellectual realism – where children's propensity to draw what they knew rather than what they saw became the accepted way to draw people. Once set, the image was copied by generations of children whose virtually only source of imagery was the drawings of other children, and it met its demise with the advent of inexpensive printing methods that led to the Sunday comics that provided children with a multitude of possibilities for ways to draw people [25].

We illustrated that rather than producing the most imaginative and varied images, children with few influences from popular sources actually produced the most restricted kinds of images. Cizek, Lowenfeld and the other fathers of child art were wrong. The children in an Egyptian village drew with an extremely restricted graphic vocabulary. Their human figures, for example, were almost always composed of two major head types, three major body types and simple, standard ways for drawing arms and legs [26].

I illustrated how children carry graphic configurations from one country to another. Ricci's sample of children's drawings collected in Milan in the 1880s have the same curious way of mounting arms that is found in the drawings of Italian immigrant children in California collected by Goodenough in the 1920s. The graphic 'vocabulary' of children's drawings seems nearly as regular as that of their verbal language [27]. Cultural differences extended to syntax as well. Children in Egypt and Japan structure their drawings very differently. Egyptian children frequently compose their drawings symmetrically with a central figure and two flanking figures; Japanese children use planes, occlusion, and cropping [28].

Children cannot ignore the stylistic and expressive features of the works of art they experience. When asked to draw what happened next after the incident depicted in Munch's *The Cry*, even five-year-old children who were not yet adept at drawing human figures modelled the lines in their drawings after those that undulate throughout Munch's work [29].

While some art educators still maintain that children's drawings are the same throughout the world, even five-year-old children in the United States can distinguish between drawings made by their peers and those made by Egyptian children. Moreover, they think that the drawings made by their peers are better, more like their own, and more desirable to emulate than drawings made by Egyptian children. In other words little children are able to detect differences in children's drawings that adult educators for over a century maintained were not there [30].

These studies were undertaken soon after Pop artists began to use 'culture as nature' [31]. This research parallelled a renewed interest in the social and narrative dimensions of art, and because it broke with Modernist beliefs about child art, originality, expression, and creativity it might be seen within the Post-Modern *Zeitgeist*.

What then are the prospects for child art, this product of Modernism, now that we have entered a Post-Modern era? It is of course important to remember that 'modern' is still the dominant component in the term which characterises our new age. Nevertheless, in this emerging era, abstract and non-objective art coexist with art that is based on literal ideas, subject matter, appropriations, parody, and narrative. For most artists the drive to reduce art to its barest formal essentials has lost its appeal. Among many the desire to join the avant-garde seems notably lacking; others believe that the avant-garde no longer exists. Individuality and creativity still hold some of their former attraction, but rather than avoiding past artistic conventions and styles, artists unashamedly scour the history of art in a deliberate effort to appropriate whatever appears useful [32].

The desire of artists to appropriate their images from tribal sources, however, has declined steadily since the first decades of this century [33] and our attraction to the exotic and the tribal seems to have taken a decidedly un-Modern turn. Currently there is an effort under way to reconsider tribal artefacts as ritual objects rather than the dislocated sanitised works of art into which we have made them [34]. Abstract form

that was seen as the very essence of art in the Modernist era is now seen as just one of a dozen or so major features of the content of art so that now works of art are seen less and less as aesthetic objects and increasingly as societal texts to be read semiotically.

We have even come to the point where the philosopher of art, Arthur Danto [35], and the art historian Hans Belting [36] can speak seriously of our having reached the end of the history of art – a time when all the continents of art so eagerly discovered (or invented) by the avant-garde have now been colonised, when future centuries, like the last century are already in place. Art according to Danto, will of course go on, but only in the sense that we will continue to develop that finite number of artistic continents that we already know. The endless new worlds of art to which primitivism, children, and the avant-garde were to lead seem now to have acquired the illusionary quality of a mirage. With the recognition that many of the ideas that undergirded Modernism were more ideology than universal truth comes the realisation that most of the ideas that elevated children's drawings and paintings to the status of art have also lost their potency and veracity.

So what does the future hold for child art? Will the idea that children produce art dissolve along with Modernist ideology? The minor shock-wave that rumbled through art education with our 'iconoclastic' observations has largely subsided. Our series of studies of the sources of children's art-like images have been accepted without the consternation caused by the initial publication. And perhaps now children are seen as less creative in their art than they once were. We have shown just how dependent children are upon culture for the images that they employ in their out-of-school art, but there has still been little recognition of just how much the school-art images of children are the products of the adults that teach them.

Some art educators, those who have been seen as the most gifted teachers, have been those who have most successfully used children as little art-making machines. The standard mode of operation of the best of them has been to set a visually rich topic – the circus, the animals at the zoo, the parade – and to provide children with large pieces of paper, wide brushes, and juicy paint. Children are encouraged to work large and to show as many things as they can. Given the subject, the crudeness of the tools and materials, the rawness of primary colours, and the encouragement to be spontaneous, coupled with children's own natural biases (towards simplicity, right-angle orientation of shapes, avoidance of overlapping lines and shapes; their tendency to present objects from the most characteristic view, to fill formats and to balance one figure with another) it is no wonder that the results look creative and so much like modern art. I hope art teachers continue to motivate children to do these marvellous things, but I also hope that teachers will realise that they exert almost total control over the images of children, and that the apparent expressiveness of the products is almost entirely of teachers' own doing. Children are no more or less artistically creative than adults.

What will be the status of child art in the Post-Modern era – in an era in which form, spontaneity, and even novelty are seen to be no more

important in art than idea, symbol, narrative, representation, wit, irony, parody? I should like to suggest one possible answer. The children who drew on Cizek's fence have their counterparts today in the children who produce great stacks of drawings, not because teachers tell them to but because they themselves want to. These are the children who produce pictures that many art teachers still see as little more than crass imitations of the worst features of popular culture – super-heroes, hot rods, and fashion models.

Art teachers have either ignored these spontaneously generated images or they have taken them to be signs that 'insidious' social and cultural forces have destroyed the natural creativity of children. But one of the things that fascinates me most about children's images produced out of school is the fact that they display much of the wit and humour, the interest in narration, the parody and satire that are to be found in the works of some Post-Modern artists. Just as it was possible to see a correspondence between the art of the child and the Modern artist, it is possible now to see a correspondence between the art of the child and the Post-Modern artist. But this correspondence is probably not sufficient to allow most children to maintain their Modern-era standing as artists.

In our Post-Modern time, child art already seems to have lost some of its status as art. It is less frequently seen to have an affinity with the things that artists try to do. It is less often displayed in the main galleries of museums alongside the work of artists. Some of the research on which I have commented could be interpreted to show that the child is the most conventional rather than the most creative producer of art. Will it be of any consequence if, because of these insights, the art-like products of children lose some of their status?

Perhaps through our Post-Modern lens we will be able to see that the dream of children as creative artists was mere Modernist ideology. More and more, we see how absurd it was to believe that children could be kept in a perennial state of pre-conventional creativity, through which they would finally and forever subvert the conventions of art and of society. The Modernist notions of originality and creativity that were attached to child art may have kept many children from receiving the kind of art education that might have helped them to develop as artists. They certainly deprived them of the opportunity to learn about and to understand the works of artists.

Artistic creativity of societal and historical significance almost always emerges when artists are unable to convey their ideas through conventional artistic styles. Artistic convention is as important as artistic invention and, for both the artist and the child, convention, not necessity, is the mother of invention. Our Post-Modern conception of child art will perhaps allow us to begin to attend to the teaching of conventional things about art that will enable some children to go beyond the art of today.

With the Post-Modern dissembly of child art, the little child is no longer seen as leading the way to artistic paradise. Indeed, there may be some irony in the fact that while Paul Klee's painting reflects the things

he learned from observing the drawings of children, now the paintings of Paul Klee may be presented as models from which children might learn [37]. The dissembly of child art, at least as we have known it in the Modern period, may actually lead to a Post-Modern art education that is more theoretically sound than its Modernist parent – an art education in which children are taught to see the relationship between their works (that may or may not be art) and artists' works of art.

Notes and References

1 See WILSON B. (1987), 'Histories of children's styles of art: possibilities and prospects' in WILSON B. and H. HOFFA (eds) *The History of Art Education; Proceedings from the Penn State Conference* (Reston VA, National Art Education Association), pp. 177–84.

2 VASARI G. (1894), *Vasari's Lives of the Most Eminent Painters, Sculptors and Architects*, trans. J. FOSTER, (London, George Bell), p. 94.

3 SCHAPIRO M. (1979), 'Courbet and popular imagery, an essay on realism and naivete' in SCHAPIRO M. (1979), *Modern Art: 19th and 20th Centuries* (New York, George Braziller), p. 61.

4 *Ibid.*

5 *Ibid.* p. 62.

6 *Ibid.* p. 63.

7 *Ibid.* p. 82.

8 HOFMANN W. (1977), 'The painter's studio: its place in nineteenth century art', in CHU P. t-D. (ed) (1977), *Courbet in Perspective* (Engelwood Cliffs NJ, Prentice-Hall), pp. 110–20.

9 BOWNESS A. (1972), *Courbet's 'Atelier du Peintre'* (50th Charlton Lecture on Art, University of Newcastle upon Tyne).

10 RICCI C. (1887), *L'Arte dei Bambini* (Bologna, Nicola Zanichelli).

11 VIOLA W. (1936), *Child Art and Franz Cizek* (Vienna, Austrian Junior Red Cross).

12 BARNES E. (1893), 'A study of children's drawings', *Pedagogical Seminary*, 2, pp. 451–63.

13 VIOLA (n.11) pp. 12–13.

14 BARZUN J. (1949), quoted in WIEDMANN A. K. (1979), *Romantic Roots in Modern Art* (Surrey, Gresham), p. 243.

15 *Ibid.* p. 12.

16 MIESEL V. H. (1970), *Voices of German Expressionism* (Engelwood Cliffs NJ, Prentice-Hall), p. 44.

17 WIEDMANN (n.14) p. 223.

18 *Ibid.* p. 224.

19 MIESEL (n.16) p. 59.

20 BRENSON M. (1983), 'Artists grapple with the new realities', *New York Times*, May 15th, Arts and Leisure suppl., p. 1.

21 KUHN T. S. (1970), *The Structure of Scientific Revolutions* (Chicago University Press).

22 WILSON B. and M. WILSON (1977), 'An iconoclastic view of the imagery sources in the drawings of young people', *Art Education*, 30, 1, pp. 4–12.

23 ARNHEIM R. (1978), 'Expressions', *Art Education*, 31, 3, pp. 37–8.

24 GOMBRICH E. H. (1965), *Art and Illusion* (New York, Bollingen Foundation).

25 WILSON B. and M. WILSON (1981), 'The case of the disappearing two-eyed profile; or how little children influence the drawings of little children', *Review of Research in Visual Arts Education*, 15, pp. 1–18.

26 WILSON B. and M. WILSON (1984), 'Children's drawings in Egypt: cultural style acquisition as graphic development', *Visual Arts Research*, 10, 1, pp. 13–26.
27 WILSON (1987) (n.1).
28 WILSON B. and M. WILSON (1987), 'Pictorial composition and narrative structure: themes and the creation of meaning in the drawings of Egyptian and Japanese children', *Visual Arts Research*, X, 1, pp. 10–21.
29 These data are from an unpublished study in which children from kindergarten through to grade five were asked to tell what the story in Munch's *The Cry* might be, and then to draw what happens next. Although no reference was made to style in the instructions, even the five-year-olds replicated aspects of Munch's style.
30 Drawings by Egyptian and American children were paired and matched for developmental level, pose, complexity and pattern. Children were asked to indicate which drawing they thought to be the best, the one most like a drawing that they themselves had done, the one they would wish to have drawn, and the one drawn by an American child.
31 HUGHES R. (1980), *The Shock of the New* (London, BBC), p. 324 *et seq.*
32 Of course the paradigm modern artists like Manet and Picasso always knew that art came from art and were the best of borrowers.
33 Despite the efforts of William Rubin at the Museum of Modern Art, New York (through the exhibition *Primitivism in 20th Century Art: Affinity of the Tribal and Modern*) to revive interest in the primitive and thus to bolster one of the principal tenets of Modernism – that there is an inextricable link between the 'primitive' and Modern art.
34 MCEVILLEY T. (1984), Doctor lawyer Indian chief: " 'Primitivism' in 20th Century Art" at the Museum of Modern Art in 1984, *Artforum* XXIII, 3, pp. 54–61.
35 DANTO A. C. (1986), *The Philosophical Disenfranchisement of Art* (New York, Columbia University Press).
36 BELTING H. (1987), *The End of the History of Art?* (Chicago University Press).
37 WILSON B., A. HURWITZ and M. WILSON (1987), *Teaching Drawing from Art* (Worcester MA, Davis).

Acknowledgements

The Louvre (Musées Nationaux), Paris for Fig. 1, Gustave Courbet, *L'Atelier du Peintre.*

Chapter Three

JOHN MATTHEWS The Genesis of Aesthetic Sensibility

The beginnings of drawing are often considered the results of meaningless, reflexive, sensorimotor markings. In many accounts, both old and new, early mark-making has been considered a false trail which the infant abandons when he or she learns to adopt a culture-conventional graphic symbol system. One common notion about the acquisition of drawing derives from a classic study by Luquet [1], according to which development only occurs as the child learns to control fortuitous likenesses appearing in chance formations of marks. Other studies [2] have described the child as abstracting from sensorimotor markings a small repertoire or formal vocabulary of drawing structures which he or she later uses in combinations to form the first designs and depictions. Whilst this acknowledged the importance of early mark-making in physical, emotional and aesthetic terms, it was considered the apprenticeship for later configuration. The impression gained from many studies is that the earliest mark-making is a meaningless prelude to the assumed goal of drawing development – the representation of objects.

Some recent experimental work continues to describe development in terms of the kinds of representational thinking through which children move before they are able to encode projective relations in their drawings [3]. Valuable as this work is in sorting out the task-demands and the conceptualisations involved when children try to draw an object set before them, it already assumes an hierarchy of drawing systems. In this hierarchy the foremost drawing experience is discounted altogether as mere 'scribbling'. Later development is considered almost always in terms of how the child manages to escape the 'tyranny' of a supposedly rigid, inflexible drawing schemata [4] to the position in which he or she is able to encode the optical array as seen from a single station-point.

Unquestioned assumptions about the definition of drawing have concealed the significance of children's earliest use of graphic media and created a misleading description of drawing acquisition. This has had lasting repercussions in education. Other recent research [5], however, shows that the beginning of drawing – far from being the result of haphazard, accidental scribbling – is in fact, a highly intentioned act which is given both organisation and meaning by the infant.

This new research into children's drawing forms part of a revolution in our understanding of their development. In the earlier half of the twentieth century, development tended to be described in terms of deficits – what the child was thought unable to understand at a given age, as measured against a pre-envisaged end point, namely a hypothetical plateau of maturity. In addition, such end states were typically Western ethnocentric in character.

From the 1950s however, a major change has occurred in our under-standing of child development. The work of Piaget showed that the child's thinking was neither random nor mechanistic but organized and dynamic. He mapped the progress of development through a series of stages, which required the child to make repeated and radical reorgani-sations of preceding levels of understanding. I depart from Piaget's initial conception of development as a progression through an hierar-chical series of 'stages'. Nevertheless, the model envisaged by Piaget, in which the development of knowledge is thought to be the result of the child's dynamic, self-initiated interactions with the environment, remains germane.

In studies of the beginnings of cognition very young infants have been shown to be endowed with internal programmes of enquiry which drive them on an intensely active search of the environment for the very stimuli required for further development. Bower [6] showed that even the neonate had startling capacities and could no longer be considered as the famous *tabula-rasa*. Experiments suggested that the neonate entered the world already equipped with rudimentary conceptions about objects and events. Other studies revealed that the infant was born with propensities to engage in interpersonal relations. Winnicott [7] postu-lated a transitional area of creative interaction formed between mother and infant. The work of Stern [8] and Trevarthen [9] illuminated the organisation of this interaction between infant and care-giver. Together, this research has revealed that newborns and young infants play an active role in the generation of culture.

In view of these discoveries it would be strange if, as many studies claim, graphic representation appears comparatively late in infancy (at around three years of age) when the child is thought to produce the first drawings of recognisable objects. This is in stark contrast to what we find in all other aspects of cognition. For example, the child's first words are now considered a part of a continuum which begins with the neonate's first sounds. No one would nowadays suggest that the infant's vocalisation has no meaning until the first true words are uttered, yet an analogous claim is frequently made about drawing acquisition.

Research solely orientated to view-specific information is blind to the syntax of the beginnings of drawing. A paradigm in which drawing is defined solely as the unambiguous depiction of projective relations cannot accommodate the earliest mark-making as part of a continuum which, like language, is characterised by semantic and structural organi-sation at every level. Nor can it capture the purposes children themselves spontaneously attribute to drawing. It fails to show the issues which might concern *them*, the children, irrespective of whether these concerns fit an adult psychologist's conception of graphic representa-tion.

The study

Supposing very young children have their own priorities about the kind of information to be encoded in drawing? I have attempted to develop

naturalistically sensitive techniques which would illuminate children's own meanings when engaged in this activity. Most experimental work alters fundamentally – with the very first question – the nature of drawing for the very young. It recontextualises drawing by presenting the child with a task of another person, and so divorces drawing from its context in children's emergent symbolisation as a whole.

This chapter is derived from information that has not been collected in conventional experimental settings [10]. Day-to-day records were made of thousands of observations; recorded longhand in journals, in colour-slide sequences, on film, audiotape and video. Micro-analysis of video recordings helped reveal the structure and organisation of early mark making. The research reveals children discovering and using a small number of structural rules or principles. These structural principles have the capacity to encode forms and relations within the environment, as well as convey emotions. This development is a prolonged and extremely complex journey, in which the child investigates and re-investigates, over and over again, in different contexts and at different ages, structural and symbolic potentialities available at the beginning of infancy.

For the purpose of this chapter I have selected two video sequences for analysis. The first was recorded in the nursery class and was edited to show Jason's drawing development from 3 years: 10 months: 23 days, to 4 years: 0 months: 4 days. During this short period, Jason passed very quickly through many approaches to the denotational and transformational values of marks, lines, shapes and colours [11]. The video clearly illustrates the general pattern of development which emerged from the data on all the children. It is also convincing evidence that the child's drawing production is biologically driven. Jason was not forced to draw. It was an enthusiastic, self-initiated and self-motivated process which cannot be accounted for in terms of imitation from cultural exemplars, or by motor skills development.

In watching the very young involved in their drawing, one is witnessing an unfolding programme of symbolisation. This does not occur in a social or cultural vacuum – as, for example, a great pioneer of child art, Franz Cizek, believed. The video recordings show the origins of the two-dimensional forms used by Jason, and even more strikingly the interpersonal context for the child's acquisition of graphic symbol systems.

Analysis of the video recording of Jason

Jason is sitting with other children at a table in the nursery. He has a piece of paper measuring 29 × 25 centimetres and there is a box of felt-tip pens before him. He uses a black felt-tip pen to describe a closed-shape, and then, inside this he draws a similar, smaller closed shape, whose boundary line is concentric with the larger closure. He then encloses this within a rectangular form, the lines of which run parallel to the edges of the paper.

He has discovered the structural principle of *closure* and this has led

him to produce a shape which will be extremely important for its structural and representational possibilities. This is the *closed shape* [12]. The other structural principle discovered here is *parallel* or *concentric grouping*. In addition to these structures, he also produces a form which, like the others, is to play a key role in drawing production *perpendicular attachment*. He attaches or relates lines to each other at perpendicular junctions. He can also attach lines at, approximately, right angles to baselines. He uses the perimeter of a closed shape (which he has made just seconds before) as such a baseline. Starting at a point along this boundary line, he sweeps a line up and away from it, and then returns it to connect once more with this baseline, at an approximately perpendicular junction. Jason can also generate variations of perpendiculars to make a *U-shape-on-baseline* (Fig. 2).

2 JASON: first drawing at 3 years: 10 months: 23 days.

Within the first forty seconds of what is perhaps his first drawing ever, Jason produces structural principles fundamental to drawing. Consider the major ones. The perpendicular attachment can specify *connectivity* and also maximum differentiation in terms of linear direction. It utilises the opposition or convergence of two vectors. It specifies a *corner*.

The closed shape will be used to specify a spatial relation which infants may discover before their first birthday, and which continues to remain profoundly significant to them during their early years, undergoing many new interpretations as they grow. This is the *inside/outside* relationship. The closed shape will then go on to represent coherent, bounded volumes in their entirety, or be used to denote the individual aspects or *faces* of volumetric solids. This particular type of spatial

concern is essentially topological in character. With this repertoire Jason can generate entire families of hybrid forms. These structural principles will serve all his drawing.

Now he freely plays with variations of these forms. He has interiorised the necessary action programmes involved in the production sufficiently to allow their release for lucid use. It is the interaction between the child's response to the structural demands of drawing, and this more fluid, relaxed play with these structures, which allows permutations – and therefore graphic development – to occur. In play, the child is able to disassemble, or uncouple, the components of action programmes and either use them singly or rearrange them into new groups of action. What is learnt in the free variation of form is then carried back to subsequent attempts to construct new forms [13].

Jason displays another structural option. He superimposes, over the drawing produced so far, a *continuous rotation*. At one point he looks over his shoulder to see what is happening across the room, whilst continuing to draw the rotation. However, whilst this dynamic structure is partly driven by haptic, proprioceptive and kinaesthetic information, it is guided and organised by visual information – Jason looks back to his rotation to ensure that the pen is still on course. He even gives a little burst of speed when he regains visual contact.

As with other dynamic structures, such rotations afford the young child both representational and expressive possibilities – representational in the sense that their derivative, the *closed shape*, can specify volumes or faces of objects; expressive in that such a structure can convey or transmit mood and emotion.

A few seconds later, Jason dissects the perimeter of this rotational shape with little dashes and a continuous zigzag. Though Jason uses the words 'railway train' to describe this, it may be that he perceives an isomorphic relationship between signifier (marks on paper) and the signified (railway lines or tracks). Other graphic representations employed by children do not map onto objects in direct correspondence, but have more complex or subtle relationships with the world. Also, as will be described later, children use drawing to specify not only the form of objects but also the form of events. The dissection of a boundary is an important structure and one which will lead to further variations of right-angle attachment.

Three weeks later, Jason has modified and combined the action scripts described above so that he is able to produce new forms: *travelling* or *oscillating zigzags* spiral inwards and outwards; cell units (derived from U-shapes-on-baselines) can be attached one to another, or nested within each other; differentiations can be made between these by constructing them with either smooth, wavy, or zigzag lines. Jason is synthesising forms in new ways. He has produced an image which he says is 'a monster'.

An intense feedback loop of interaction is formed between Jason and Marc, who sit next to each other. This social setting tends to require them to describe their actions and their drawings to each other. In a mutually reciprocal process in which it is impossible to say who is influ-

encing whom, both boys' drawing actions gradually evolve – over the course of a few seconds – to dynamic, skidding movements of the pen across the paper; movements which are accompanied by emphatic vocalisations. The boys harmonise and resonate for moments together, their rising and falling drones synchronised with the tempo of their rapid drawing actions.

This reveals very young children to be alternating between distinctive modes of representation; some of which specify the configuration of objects, and some of which record their movements in time as well as space. I have termed these latter types of representation *action representation* [14]. Research which has assumed the child's intention in drawing is always or solely to picture has completely overlooked action representation, besides other important graphic systems. While in this particular example it is not possible to state with certainty the 'denotational' values [15], both boys show a concern with both the shape and movement of 'monsters'.

Immediately after producing his drawing, Jason starts another. This time, parallel grouped lines are attached to a closed shape to specify connectivity between distinct forms. Jason's new 'monster' is a complex closed shape whose character is modified by a zigzagging boundary, and whose radial lines are attached at a variety of junctions notional and actual. However, while Jason is drawing this, Marc is producing its developmental forerunner – the closed shape with attached lines, or core and radial unit [16]. Marc excitedly taps Jason on the shoulder and says to him that it is 'a spider'.

Twenty days later Jason, now 4 years: 0 months: 4 days old, uses a closed shape plus attached parallel lines to represent a human figure – the controversial 'tadpole' as it is often called (Fig. 3). He is delighted with this achievement and gives a little backward jump in his seat as he says, 'a man'.

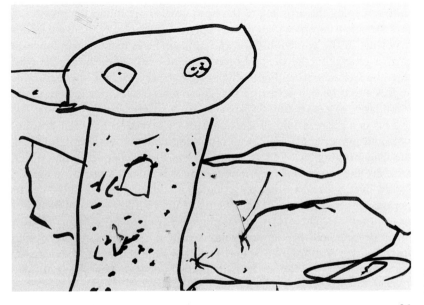

3 JASON: drawing at 4 years: 0 months: 4 days.

In the drawings of the very young, the denotational values of lines are sometimes indeterminate and amorphous. Drawing production is a continuous episode in which the child sometimes changes the values of the lines from moment to moment. An example of this occurs a moment later when Jason attaches a line at a right-angle to a line which represents one of the legs. Initially, Jason allows the thickness of the line itself to stand for the volume of the arm. However, a new idea seems to occur to him. He goes on to make a further stipulation about this form by adding another line to the end of the arm and, by making a U-turn with the pen, returns the arm line to its base – the line denoting the leg. The line describing the arm no longer specifies a rod or stick-like form, but is essentially an elongated U-shape-on-baseline specifying a tubular volume 'saliently extended' along one dimension, to use John Willats's phrase [17].

Jason then modifies the form of the other arm line. He has some interesting and poignant difficulties here. He continues the line off the edge of the paper and on to the newspaper which covers the table. He notices this and experimentally moves the drawing paper slightly, breaking and then reconnecting the line. He has realised what has happened and is wondering what to do about it.

This reveals another aspect of the child's accommodation to the constraints of a drawing medium. To explore the range of possibilities this medium offers, the child has to discover the laws which regulate it. Exactly how far adults enable the child to define the limits and possibilities of the medium is a question of crucial importance for education. A return will be made to this issue, when consideration is made of the kind and quality of interaction and provision arranged by a mother to support her two-year-old child's painting experience. Implicated here is a model of development and learning about which there is considerable misunderstanding.

Jason also, in forming this arm line, makes a U-turn in another direction, returning the arm line to the head unit. He is still in the process of interiorising a complex plan of movements – but actually these are minor problems in the enormous conceptual leaps he is making. He makes a further change to the denotational value of lines, when he in-fills with dots the space between lines which originally represented the legs. This suggests that he has perceived that these lines could equally denote the boundaries of a body unit.

This is a process John Willats calls the 'interaction between production and perception'. This is a continuing dialogue between child and drawing production. The selection of the formal opportunities which arise are the result of the symbolic salience the child attaches to certain forms over others at particular times in development. There occur periods of sensitivity to certain kinds of information over others. As I have noted elsewhere [18] development is not to be thought of as a linear progression through an hierarchically tiered series of stages, with the primitive and 'inferior' stages gradually replaced by more advanced and 'superior' ones. Rather, at every phase in development, the symbolic

systems used by the child are legitimate and powerful systems capable of capturing the kind of information the child feels essential [19].

Discussion

It seems that the child's generation of these forms in the two-dimensional landscape of drawing actually alerts his or her attention to those very forms in the environment (including the environment of pictorial imagery). Drawing actually initiates and guides the child's further detection of structure.

There are further important implications for teaching. The child – according to this model of development – is only able to emulate cultural or natural forms in so far as he or she has already independently initiated their generation. So this development cannot be accounted for in terms of copying from cultural exemplars, nor can it be described solely in terms of motor development. What one sees here are quantum leaps in cognitive development, in which Jason is moving through a series of distinctive changes in the values he attributes to lines, line orientations and line junctions. That is, development is to be described in terms of the changing representational and expressive potentialities he discovers within graphic structures he himself spontaneously generates.

Analysis of the video recording of Hannah

The second video recording is of a younger child, Hannah, aged 2 years: 2 months: 28 days, drawing with brush and paint. She is drawing at a table, alongside her mother, her early painting occurring within a shared space between care-giver and infant. One can see drawing actions originating from the natural movements of the body, defining and recording axes and vectors, occurring within a personal envelope of body space. The infant's construction of graphic meaning occurs within an unfolding event carefully and sensitively supported by her mother. Both mother and infant are engaged in an exquisitely orchestrated exchange of shared perceptions about what is taking place at the interface between action and emergent form.

Hannah is standing on a chair at a table upon which rests an A1 sheet of paper, some brushes and six pots of pigment – black, red, yellow, purple, green and blue. Hannah's mother, Linda, is seated at her left, within touching distance of her. Hannah stabs a brush loaded with red paint firmly down on the paper. She hunches her shoulders over the targeted bristles, putting her weight and pressure to bear upon the point of contact between bristles and paper. The handle of the brush oscillates slightly as a result of the displaced pressure she exerts on the irresistible, immovable point. Linda is opening her mouth in interest and surprise and, with the merest movement of her eyes, looking up to Hannah's face and back down again to the painting, focusing her central attention on and around the brush tip.

As Hannah presses the brush down, she compresses her lips and

slightly screws up her eyes in tension. She presses down for about one and a half seconds. Towards the end of this action there comes from her compressed lips a 'raspberry' sound, synchronised to the action which at this moment she stresses even further. This raspberry sound lasts just less than a second and continues while the brush is raised about 15 centimetres above the surface of the paper. About 15 seconds have elapsed as Hannah now stabs the brush down vigorously to the same point, synchronising a raspberry sound to the moment of impact and continuing it over into the pressured contact of the brush against paper. As she concludes this action and raises the brush about 15 centimetres above the surface, she looks towards Linda, who returns her glance. This was impact number three.

The fourth impact is the first of a series of four rhythmically spaced stabbing actions, each synchronised with a raspberry sound. The first of these gestures is impacted around the first small locale, but with each successive impact she reaches over the paper making a series of four spots which run along an axis extending away from her. She has increased still further the volume of the synchronised raspberry sound, carrying this sound on as she presses down on the brush for a fraction of a second.

During impact number five which occurs at a site a few more centimetres away from her, and again synchronised with a raspberry sound, Linda's open mouth transforms into a smile which develops through impact number six. After her eighth stab, Hannah makes a longer pause, looking towards Linda. Linda smiles at her, realigning her gaze towards her, and then immediately glancing back towards the field of action. The last impact is translated to a pull stroke, the movement of which Hannah visually tracks with an inclination of her head. The brush, maintaining contact with the paper, is pushed away from her and finally pulled again back towards her.

This seems to give her a new idea – to make a different marking action with a different colour. With a brush loaded with blue paint, she makes a near closed shape using a paint-pot, standing on the paper itself, as an axis around which to rotate the brush.

This behaviour is of great significance. Whereas the stabbing of the red brush was matched with raspberries, the trailing, almost enclosing, blue line is accompanied by a gentle 'shhh' sound. She is making correspondences between action and speech, and between speech and image – the beginnings, in fact, of counting [20]. In both 'counting' and colour-coding her actions, Hannah is displaying the beginnings of logico-mathematical thinking. She is, however, showing an additional, subtly different orientation to the medium. In associating impacted red dots with raspberry sounds, and a trailing blue line with 'shhh' sounds, she is matching characteristics shared between distinct sensory domains, marking action and sounds. She is discerning and matching expressive characteristics which remain constant across sensory domains. She is forming cross-modal associations which are the basis of aesthetic sensibility.

34

Discussion

A mark-making event like the one described above constitutes a development of those early interchanges between mother and infant which involve actions of the body, the face, and vocalisations [21]. Here we see rhythmical patterns of action, each partner coupled together precisely. According to Trevarthen, these acts of cognisance-sharing are possible because humans (including infants) are able to detect universal indices of intention and motivation which are signalled in the subtle changes and nuances in the synchrony of body-action, facial expression and speech. Because of this capacity, we are able to gauge and assess the inner experience – the psychological state – of one another.

Trevarthen has postulated the existence of a biologically standardised time-base for these universal indices, against which we evaluate the significance of any variation in tempo, amplitude, cadence, accentuation or stress. It is the controlled use of such variations which Hannah uses for such powerful expressive effect in her use of painting materials.

Consider this inter-subjective or 'potential space' [22] in which this event occurs. Both infant and mother are sharing a field of view which is also a field of action. This consists not only of the physical surface of the paper, the pots of paint, brushes and so on, but is also a window opening onto a variety of potential but unknown futures. They are both predicting and anticipating events. They are not playing with objects alone, but with ideas. Both infant and mother know something of each other's view-point. They each orchestrate their actions with the view-point of the other taken into consideration. In a sense, they are stepping hand-in-hand into the unknown.

Consider the kind and quality of the mother's support for her child's behaviour. It is notable that few words are spoken. Most of the communication between them consists of exchanged glances. There are different types of glance. Both parent and child seem to be able to distinguish these effortlessly. There is, for example, a questing glance made by Hannah to which her mother frequently responds with an action as well as – and sometimes instead of – a word. Their communication is deeper and more fundamental than spoken words.

Further research is needed about the structure and organization of this interpersonal, gestural and expressive language for it is part of the key to the principles of teaching interaction. Linda is a aware of Hannah's salient field of view and action, and only enters this space when absolutely necessary. She also withdraws from it as soon as possible, moving her hands out to wait at the periphery of this space and allowing Hannah quickly to resume command of the action.

When the mother assists the child's actions, her hands hover in empathy around Hannah's in a clear, defined way, respecting Hannah's field of view and her visual ability to track. In this way the infant is allowed to see what is happening and is able to take control again as soon as possible. To a certain extent, the way Linda 'scaffolds' the tasks [23] allows Hannah the illusion of complete mastery and control.

Winnicott's ideas concerning a 'transitional' area of magical illusion are not out of place here [24].

The mother is sensitive to a shared 'theatre' into which hands and objects have to make controlled entrances and exits. The mother stage-manages with great discretion, allowing Hannah's performance and concentration to continue fluidly without disruptions. Linda moves in and out of this stage unobtrusively, her actions of management and maintenance timed to coincide with Hannah's preoccupation with a brush or a pot of paint. In this way, the uninterrupted process of the painting is preserved.

Some researchers habitually conceive of drawing as problem solving. As a generality this is misleading. There are no problems here. When, as happens, Hannah's brush flies off the paper to collide with the edge of the table with a loud bang, she is not upset by this but rather regards this event with the greatest interest. Painting is for this young child an event which is only partially predictable, and in which accommodation and assimilation are in a fluid state of balance – a state perhaps unattainable in any other medium. There is an interplay here between the child's intended actions and the random perturbations which affect them. The child is not disturbed by these and, whilst continuously monitoring and correcting flight of brush, does not do this toward a fixed, internalised model or goal, but is tolerant of a wide range of variation from the projected action programme. Indeed, it is the child's perception and use of these 'accidents' which is at the heart of drawing development.

How the care-giver responds to the fluid variety of such events is of course crucial. At no time has the child been given any sense of misbe-haviour or failure. The mother observes and responds to events with no preconceptions of 'correctness'. She responds throughout with an openness – in fact she shows a marked increase of interest at unforeseen events. There are no adult preconceptions and no artificial boundaries. The child is given the opportunity of defining the painting experience.

Hannah initiates sequences of action which are lucid games requiring her mother's participation (even if this simply means watching). Hannah looks up at her mother after impacts, requesting, without speech, acknowledgement of her actions. This she receives in the form of a smile, an open mouth, or just a raised eyebrow.

It is Hannah who structures the entire event, determining the expres-sive values of the sequence, the tempo, cadence, nuance. It is she who orchestrates actions, materials and ensuing marks into a dynamic, rhyth-mical structure which has syntax, phrases, climaxes, beginning, middle and end, and even a full stop to mark its completion.

This record is valuable in terms of the information it yields about the child's conceptions of objects and events, about her internal representa-tion of her own body and the effect of her actions upon objects. The child is building up interiorised and dynamic representations that enable anticipatory descriptions to be generated of events at the interface between organism and environment. Research has suggested that object representations are a derivative of interiorised action scripts [25]. This again supports the idea that action representation, in children's symbolic

play and drawing, makes an important contribution to cognition. There is much evidence to be derived, from the sequence described above, of the interrelations between internal blueprints for actions and objects. In studying, for example, the graceful flight of her hand as it closes in on paint-pots or brushes, inferences about the child's formation of internal representation of objects and events can be made. One can see her make mid-flight corrections or adaptations of the form of her hand according to her perception of the form of objects.

However, this development cannot be couched solely in terms either of the infant's accommodation to external objects or in terms of coordination of motor-movements. Highly detailed recorded observations have shown the infant systematically seeking out the potentialities or 'affordances' [26] of graphic or mark-making materials, not only in the sense of the properties of the physical materials in themselves, but also in the sense of their expressive potential. The infant seeks within these external objects and materials the potentialities they offer in terms of manipulation. Trevarthen, in discussing the development of motor-control, has said:

> It is in the nature of motor coordination to 'explore' the
> mechanical periphery, to conduct a search for programs of
> activity that will exploit the potential of the body and of the
> objects that come in contact with it [27].

This is exactly what we see happening in the very young infant's encounter with graphic and mark-making materials. Some of the potential exploited within interaction between body and object is expressive. Actions are grouped together for reasons which cannot be accounted for in terms of object mastery alone. There is here a controlled variation in the use of action schemes; delicate fluctuations in stress, tempo, amplitude and duration. Whilst Piaget and others have concentrated research on the logical and operational aspects of motor programmes, very little study has been made of what Hauert and Mounoud term the 'kinematic' aspects of action [28]. Hannah's modulation, calibration and synchronisation of actions, including speech, is guided and organised by an orientation to media which can only be adequately characterised as expressive and aesthetic. The actions are grouped together according to creative purposes. They are organised by a particular attitude to form. This is why one must consider aesthetic sensibility as a very special aspect of cognition.

Conclusion

The research shows that two year olds not only employ mark-making for the representation of objects and events, but that in their hands this medium becomes an expressive vehicle capable of recording any subtle stresses or nuances occurring within an interpersonal setting. In synchrony with the child's discovery of the representational potentialities of marks and marking actions, he or she discovers what Nancy Smith has described (in her contribution to this volume) as 'the expressive characteristics inherent in media'. It is the child's understanding and use

of these expressive characteristics which form the basis for aesthetic sensibility. This research strongly suggests that aesthetic responses are not simply the result of the child's initiation into culture-conventional models, but are based on spontaneously generated forms of action made in early infancy. It is at this level that graphic structure acquires not only its representational potential but also its emotional values, and this is the origin of aesthetic sensibility.

The research shows that the beginnings of graphic representation are neither solely nor chiefly the result of the infant discerning configurative likenesses in what are initially the consequences of accidental sensori-motor markings. On the contrary, the infant gives meaning to drawing right from the outset of mark-making. At this time, the infant forms a coordinated group of actions which are used for investigating the potentialities of both the environment and the infant's own body. The infant learns that actions not only create effects on the physical world, they effect the psychological states of others. Together, these dynamic actions form a 'four-dimensional' language. Long before the infant has many sentences with which to describe experiences, he or she is already using this package of behaviours as a means of forming descriptions of reality.

That these drawing activities are self-initiated and self-driven does not mean that development can occur within a social vacuum or a hostile environment. On the contrary, these programmes of early symbolisation have built into them the need for interpersonal engagement. If drawing – or any other symbolic system – is to develop it needs interpersonal support of a special kind by care-givers and teachers who can identify, and are sensitive to, the child's unfolding programmes. The example of Linda's support for Hannah serves to highlight and illustrate basic principles of interaction and provision which are the same in essence at any level of education.

Notes and References

1 LUQUET G. (1927 [77]), *Le dessin enfantin* (Paris, Delachaux et Niestle).
2 For example, KELLOGG R. (1970), *Analysing Children's Art* (Palo Alto,Cal., Mayfield).
3 FREEMAN N. and M. COX (eds) (1985), *Visual Order: the Nature and Development of Pictorial Representation* (Cambridge University Press).
4 VAN SOMERS P. (1984), *Drawing and Cognition: Descriptive and Experimental Studies of Graphic Production Processes* (Cambridge University Press).
5 WOLF D. and C. FUCIGNA (1983), 'Representation before picturing'. Paper for a symposium on Drawing Development, British Psychological Society International Conference on Psychology and the Arts, Cardiff; SMITH N. (1983), *Experience and Art: Teaching Children to Paint* (New York, Teachers College Press); MATTHEWS J. (1984), 'Children drawing: are young children really scribbling?', *Early Child Development and Care* 18, pp. 1– 39; MATTHEWS J. (1988), 'The young child's early representation and drawing', in BLENKIN V. and V. KELLY (eds), *Early Childhood Education; a Developmental Curriculum* (London, Paul Chapman).
6 BOWER T. (1982), *Development in Infancy* (San Francisco, Freeman).
7 WINNICOT D. (1974), *Playing and Reality* (Harmondsworth, Penguin).
8 STERN D. (1977), *The First Relationship: Infant and Mother* (Glasgow, Fontana/Collins).

9 TREVARTHEN C. (1975), 'Early attempts at speech', in LEWIN R. (ed), *Child Alive* (London, Temple Smith); TREVARTHEN C. (1984), 'How control of movement develops', in WHITING H. (ed), *Human Motor Actions: Bernstein Reassessed* (North Holland, Elsevier Science Publishers).

10 Rather, the data derive entirely from spontaneous drawing, located within children's developing representation as a whole. The data consist of detailed longitudinal studies of 43 children. 40 were studied in a London nursery class over a two-year period, while recorded observations of the remaining 3 were made from the children's births to the ages of 8, 15, and 18 years.

11 See SMITH (n.5) and WILLATS (n.15).

12 MATTHEWS (1988) (n.5); see also MATTHEWS J. (1990), 'Expression, representation and drawing in early childhood' (unpubl. PhD, University of London).

13 WOLF D. (1984), 'Repertoire, style and format: notions worth borrowing from children's play', in SMITH P. (ed) (1984), *Play in Animals and Humans* (Oxford, Basil Blackwell).

14 MATTHEWS (1984, [88]) (n. 5).

15 WILLATS J. (1984), 'Getting the drawing to look right as well as be right: the interaction between production and perception as a mechanism for development', in CROZIER W. and A. CHAPMAN (1984), *Cognitive Processes in the Perception of Art* (Amsterdam, North Holland).

16 ATHEY C. (1980), 'Parental involvement in nursery education', *Early Childhood*, December 1980.

17 WILLATS (n.15).

18 MATTHEWS (1988) (n.5).

19 See WOLF and FUCIGNA (n.5); SMITH (n.5).

20 GELMAN R. and C. GALLISTEL (1983), 'The child's understanding of number', in DONALDSON M. *et al* (eds), *Early Childhood Development and Education* (Oxford, Basil Blackwell).

21 TREVARTHEN (1975) (n.9); STERN (n.8).

22 WINNICOT (n.7).

23 GRAY H. (1978), 'Learning to take an object from the mother', in LOCK A. (ed) (1987), *Action, Gesture and Symbol* (London, Academic Press), p. 169.

24 WINNICOT (n.7).

25 BRETHERTON I. (1984), 'Representing the social world in symbolic play: reality and fantasy', in BRETHERTON I. (ed), (1984) *Symbolic Play* (London, Academic Press).

26 GIBSON J. (1979), *The Ecological Approach to Visual Perception* (Boston, Houghton Mifflin), p. 127.

27 TREVARTHEN (1984) (n.9) p. 259.

28 MOUNOUD P. and C. A. HAUERT (1982), 'Development of sensorimotor organization in young children: grasping and lifting objects', in FORMAN G. E. (ed) (1982), *Action and Thought: From Sensorimotor Schemes to Symbolic Operations* (New York, Academic Press), pp. 3–35.

Chapter Four

NEIL O'CONNOR and BEATA HERMELIN
Idiot-Savant Artists: Intelligence-Independent Graphic Ability

Children and drawing

When children start to draw they make squiggles and random lines. Later at ages around four to six they draw objects in such a way as to reveal parts which, although known to exist, cannot be seen on the model – for example, drawing a handle on a cup even if it is not presented to the child's viewpoint. Many people have observed this fact and the phenomenon has been known since the work of Luquet [1].

It is fashionable nowadays to say that such children can be induced to draw realistically what they see, by presenting them with the right circumstances [2]. However, it is our contention that there is a tendency for children to draw what they *know* rather than what they see, and it is not unreasonable to say that the development of children's mental age is *in general* parallelled by their capacity to express themselves in drawing. But there clearly are exceptions. Just as some children are precocious readers or musicians, some are precocious artists. Sheila Paine has drawn attention to Millais and Toulouse-Lautrec whose artistic skills developed early [3]; and Howard Gardner has noted Michelangelo's precocity [4].

The phenomenon of precocious artistic development can occur independently of intelligence at any *level* of intelligence, so it is possible for the mentally handicapped to show unusual graphic ability just as it was for Millais or Toulouse-Lautrec. This raises the question of whether artistic ability (or graphic ability) must be seen as a skill which occurs independently of what we have come to describe as general intelligence; and this also reflects unsatisfactorily on the premise that children draw what they know. It is into this circle of argument that we make the experimental intervention which we report in this chapter.

If in fact graphic or artistic skills are independent of general ability, this prompts certain questions: how do such skills arise, and to what degree are they a product of abilities such as visual imagination, visual memory or outstanding motor skills? Anecdotal information suggests that some primary skills, such as visual memory, are present in some outstanding artists but not in others. Henry Moore is supposed to have been able to imagine a figure from all sides after a brief glimpse from one point of view. On the other hand, it is said that Rodin was very short-sighted. However, such anecdotes are unhelpful because they do not inform us whether the primary abilities or disabilities to which they attest were influential upon artistic output.

Study of gifted adolescent artists

Van Sommers has concluded that a high percentage of the problems artists experience in drawing may be executive [5]. Whatever an artist's level of skill, problems arise when depicting difficult subjects. To draw from observation subjects that have complicated forms might involve close and frequent visual examination, but a question arises as to whether visual analysis aids execution or whether the success of any representation might depend to a large degree on some form of motor memory. Van Sommers addressed the problem of execution as distinct from visual analysis, but we decided to investigate the degree to which visual memory and motor memory played parts in any graphic task which depended on recall. At the same time we wished to investigate the effects of intelligence in relation to these aspects of graphic tasks.

One of our studies [6] compared four groups of children, all of them normal or above normal in intelligence. One was a mathematically able group and another an artistically able group. There were control groups for each of these, comprising children who did not have the special abilities of the experimental groups but who matched them in general intelligence. All groups were of about thirteen years of age; the mathematical group and its control had IQs of 117, and the artistic group and its control had IQs of 107. In addition to the intelligence tests, all subjects were administered a verbal reasoning test which involved analogies, syllogisms, tests of semantic identity and three term series problems. None of these problems had a spatial element, and from the result they were shown to reflect the IQ levels of the four groups.

We then presented two sets of spatial problems to the different groups, (i) verbally and (ii) non-verbally. The verbally presented spatial tasks were of the kind: 'How many diagonals are there on the surface of a cube?', or 'If the mid-points of each of the sides of a square are joined together by a set of lines – what figure will result?'. As might have been expected, the mathematically able children did much better on this task than the artistically able children. In fact the mathematicians were more successful than any of the other groups, suggesting that intelligence was not the only contributory factor but that mathematical ability consists in part in being able to translate visual problems into language and vice versa.

We next presented a set of visual spatial tasks which involved no element of speech apart from very general instructions. Such tasks involved imagining the appearance of a shape from a particular viewpoint, or required memory of paired associate shapes of Persian letters. In these tasks the mathematically and artistically able children did not differ from each other despite the differences of intelligence, but both were better than their control groups in each case. Therefore the result in this task did not reflect IQ level but ability to remember non-verbalisable shapes.

There were thus two clear results. Mathematically able children converted verbal codes into spatial images better than other groups, even those gifted for art. Secondly, children in the two specifically-gifted

groups, irrespective of intelligence differences, were better on non-verbal visual memory scores than control subjects not gifted for mathematics or art. Thus the conclusion can be drawn that visual short-term memory for non-verbalisable items is to some degree IQ independent because mathematically and artistically gifted children are better than IQ matched controls in these sorts of tasks. We thus had a conclusion which seemed to suggest some degree of IQ independence in the case of spatial ability. The degree to which memory for spatial tasks for recognition or recall might vary in the artistically able gave rise to further investigation.

Visual memory and motor programmes in *idiot-savant* artists and controls

In order to pursue further the question of the role of intelligence in relation to artistic ability, we decided to make studies of *idiot-savant* artists – that is to say artists of special graphic ability but low intelligence – and also to compare such subjects with artistically gifted people of normal intelligence. Our first of such studies was based on *idiot-savant* artists and control subjects of low IQ and no particular artistic talent.

The first experiment was concerned with the success of *idiot-savant* artists who were found to have an overall intelligence level which was less than half the normal level. Five individual *idiot-savant* artists were matched for intelligence with another group of mentally handicapped people who had no special artistic ability. Both groups were given a number of tests of visual memory and were also given a Goodenough-Harris *Draw a Man* test of intelligence. This graphic measure of intelligence showed the *idiot-savant* artists (having IQs of 76 points) to be far superior to the controls (whose scores of 54 were not significantly different from their other intelligence measures). The central result of this study showed that, when matched for intelligence, a selected group of mentally handicapped people with artistic ability were far superior in a variety of graphic tasks to their controls.

The drawings of the *idiots-savants* (Figs. 4 and 5) made one wonder whether their graphic capacities were superior not only to those of the same level of intelligence, but also to a normally intelligent group. To test such a possibility we carried out another study in which we compared artistically gifted children of normal intelligence, *idiot-savant* artists, and two IQ matched control groups.

The tasks presented to these four groups were twofold. Firstly they were required to observe and recognise a series of shapes. A shape was presented to them and then, from memory, had to be identified from among other shapes of a similar nature. A second task was to reproduce graphically a design they had seen recently and for a short period. The figures presented from memory and for recognition were characteristically similar (Fig. 6).

The results of these two experiments show that when the groups were required to recognise items previously shown from among a series of similar items, (i) the determining factor was intelligence, and (ii) the

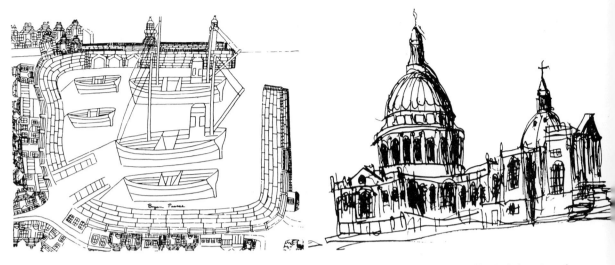

4, 5 Typical drawings by the *idiot-savant* artists.

	Target design					
Simple structured designs	�					
Simple unstructured designs						
Complex structured designs						
Complex unstructured designs						

6 Figures featuring in the first (memory and recognition) test.

normal artistic children were superior to the *idiot-savant* artists. The control groups in this case behaved similarly to their IQ-matched groups.

When, however, the second task was undertaken – drawing the similar figures from memory – the sub-normal control group performed worse than any of the other three groups (whose performances were broadly similar to each other). The scores in these cases were ratings of verisimilitude of reproduction (Fig. 7). Furthermore, when all reproduced drawings were rated for executive graphic skill as distinct from verisimilitude, the similarity of the normal artists and *idiot-savant* artists was further emphasised, their total scores being very closely similar. This rating, which was carried out blind, was meant to be a measure of graphic skill independent of capacity to reproduce a precise copy. It was based on the accuracy of line joints, smoothness of curves, strength and firmness of line, and overall 'success' of the *Gestalt*.

The conclusion from the results of this experiment would seem to be that while visual memory images seem to be more readily available to

43

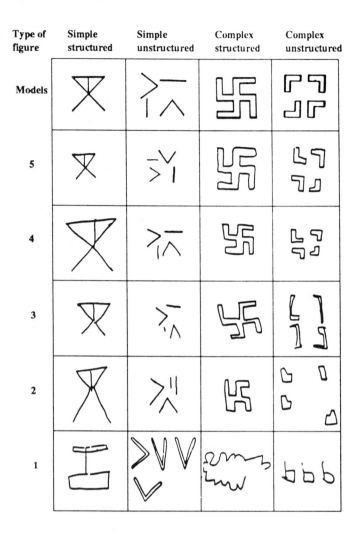

Type of figure	Simple structured	Simple unstructured	Complex structured	Complex unstructured
Models				
5				
4				
3				
2				
1				

7 Figures featuring in the second (memory and reproduction) test.

subjects with high rather than low intelligence, the efficient accessing of graphic motor programmes depends more exclusively upon artistic competence. Equally important is the result that the *idiot-savant* artist is capable of a graphic output equivalent to that of an adolescent gifted for art.

One question remains to be answered: how could it possibly be the case that – although incapable of equalling those of higher intelligence in the recognition of similarity in visually presented designs – the *idiot-savant* is nonetheless capable of drawing them with reasonable accuracy and considerable graphic skill? To further explore this problem we undertook two additional experiments.

Recognition failure and graphic success

The purpose of this experiment was to simplify the recognition task in the hope of aiding the *idiot-savant* artists to improve their recognition capacity, We then hoped to explain their success in graphic output by

44

offering them two different forms of input – one visual as in the previous experiment, and one tactile or kinaesthetic. The intention in using a kinaesthetic input was to offer something more similar to a graphic output than one coded from visual modality or from sight. The assumption would be that if the input and the output were in the same kinaesthetic modality, no re-encoding process or transfer process from sight would be involved and, therefore, output might be facilitated.

There were three groups of subjects in this experiment: (i) a group of *idiot-savant* artists chosen for their outstanding drawing ability, (ii) a group matched on the Goodenough-Harris *Draw a Man* test [7] for graphic intelligence but otherwise of normal or superior ability, and (iii) a group of mentally handicapped people matched with the *idiot-savant* artists for performance and verbal intelligence. The normal group of gifted artists and the *idiot-savant* artists scored 119 and 114 respectively on the *Draw a Man* test. The two scores were statistically identical.

We thus had three groups of subjects with eight in each group. Two groups were matched for talent, the normal and the *idiots-savants*, and two were matched for intelligence, the *idiots-savants* and the mentally handicapped controls. All subjects were given a test of visual recognition and memory in the same way as in previous studies. However, in this case only two items were presented, one first for learning and the other, after the removal of the first, for the Subject to identify it as either identical or different. Six pairs of designs were used, three the same and three different (Fig. 8).

8 Figures featuring in the 'similarity-difference' recognition test.

Once again the determining factor was intelligence. The normal artists were easily able to recognise similarity and difference whereas the two mentally handicapped groups did badly on this test. This was of course because the element of memory was involved, and the *idiot-savant* and sub-normal groups scored badly. But when no memory was involved, (for example, when a comparison was made between a visually presented and a tactile experience of trees, faces, vehicles, and so on, the subjects being required to say 'same' or 'different' on a simultaneous task) the transfer from one modality to another was similar for the *idiots-savants* and the normal artists, although the mentally handicapped people without artistic ability did worse.

However, when a similar experiment was repeated with a delay of ten seconds between the visual and the tactile kinaesthetic presentations, the mentally handicapped artists were found to be inferior to the normal controls and equivalent to the mentally handicapped control group. In other words, when a memory element was introduced once more the *idiot-savant* artists behaved like their IQ controls.

Memory reproduction after visual or tactile kinaesthetic presentation

We have thus established that while matching is not a problem for the *idiot-savant* artists, recognition memory places them in a category different from that of normal artists. In other words recognition memory is related to intelligence.

It remains, therefore, to determine again whether reproduction from memory is handicapped in the *idiot-savant* artists compared with the normal artists. To carry out this investigation we presented two kinds of material, one visually and one kinaesthetically. First the visual: each subject was shown a stimulus diagram – for example, a tree or a face – and after a short interval asked to draw as precisely as possible what had just been observed. Eight drawings were involved, and results were scored according to the number of departures from the original. The scores, when compared, showed that the *idiot-savant* artists and the normal artists – although differing – did not differ significantly, whereas the *idiot-savant* artists and their IQ-matched controls did differ.

The conclusion from this sub-study, therefore, is that the *idiot-savant* artists did not differ from the normal gifted children in their ability to draw from memory although they did differ (as previous studies had shown) in their capacity to make comparisons from memory of presented models of the same level of difficulty.

The other aspect of the reproduction task was the presentation of a trace input from which the subject was required to reproduce the object or form traced. Once more eight stimuli were involved, and the Subject traced around the raised outline with his or her preferred hand. The Subject was told each time what sort of object the stimulus represented. After the removal of the stimulus he or she was asked to draw as precisely as possible what had just been traced. The same pattern of results emerged from this tracing study as had appeared in the visual

presentation, that is to say, the *idiot-savant* artists were found to be similar to the normal children gifted for drawing, and different from their IQ-matched controls.

This set of experiments, therefore, could be summarised by saying that when tracing around one raised outline drawing of an object while viewing another, the *idiot-savant* artists were as good as artistically gifted children of above average intelligence in judging whether the two stimuli were the same or different However, when the same task had to be performed as a successive presentation where memory was involved, the *idiot-savant* artists' performance was like that of their IQ-matched controls and inferior to that of normal, artistically-gifted children.

Thirdly, regardless of whether the stimulus which had to be subsequently drawn from memory was a visual or tactile presentation, the *idiot-savant* performed like the normal gifted group and better than their IQ-matched controls. So this confirmed the results of previous experiments in a more precise way, and removed the difficulty of the judgments made in previous experiments by using a technique of similar and different presentations. Furthermore, it was shown that kinaesthetic presentation did not improve the capacity of the *idiot-savant* artists to perform their graphic reproduction tasks.

We have therefore reconfirmed several times that the *idiot-savant* artists' graphic skill rests on their superior output ability rather than on a particularly competent perceptual analysis. Of course, almost by definition, talent manifests itself as a generative productive process whereas the capacity for information analysis is one of the basic functions associated with intelligence. It is, therefore, perhaps not too surprising that *idiot-savant* artists utilise the former process more efficiently than the latter.

Art and accuracy

In the previous studies it was shown that success in copying presented material or designs was equal for the artist of normal intelligence and for the *idiot-savant*. The experiment to be reported now will show that overall accuracy of representation may have been better for the normal than for the mentally handicapped subjects, but ratings of artistic merit do not differentiate the groups. It will also show that while the accuracy of the drawing may be related to intelligence, the artistic quality of the graphic design production is not.

Various authorities on children's drawings (such as Hagen) suggest the view that, as Arnheim has pointed out, a pictorial representation is not a mechanical replica of a percept but renders its structural characteristics through the properties of a particular medium. Thus drawing ability, according to these views, does not depend primarily on any special skill in analysing visual input; rather it is a function based on canons of motor output or rules for representation of space. In some respects, therefore, our experiments have tended to support such a view.

If the capacity to draw is in fact independent of one's general level of cognitive development, as our experiments seem to show, the question

arises as to whether such independence is equal for all the various components which make up drawing skill.

In the last experiment we hinted that representational accuracy and artistic-aesthetic value can be distinguished in *idiot-savant* artists. To illustrate this take two artists, for example Stubbs and Turner. Stubbs was an expert in painting extremely lifelike and precise images of animals, clearly stressing representational accuracy, while his near contemporary, Turner, emphasised atmospheric effects with less attention to veracity of detail. That such personal predilections can be an aspect of the *idiot-savant* as well as established artists is indicated by two drawings, both by the same artist (Figs. 9 and 10). One is a conventional representation of a church copied from a postcard, and the other a highly stylised and abstracted image of a model.

9, 10 Highly stylised abstracted image of model figures in a landscape, and conventional representation of a church, exhibiting differing idioms in the work of the same *idiot-savant* artist.

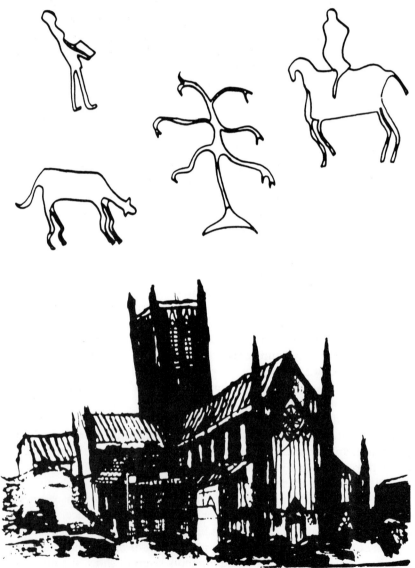

The design of this experiment – which is intended to try to discriminate between accuracy and artistic merit, and measure them in normal and mentally handicapped artists – was to make comparisons between two such groups, each asked to draw scenes presented to them in three-dimensional models set in a simple scene. The normal artists were children who represented the top two per cent of artists in a school in Croydon, and the *idiot-savant* artists had IQs of the order of 70 points.

The material presented consisted of four models mounted on a green board, as if figures in a rural scene. One item was a tree in the background, another a horseman on a horse, a third a woman carrying a tray, and the fourth a cow. These items were arranged in a particular configuration. The various conditions were (i) that a drawing should be done from memory, (ii) that the Subject should see the scene, imagine that he or she was looking at it from another point of view, and draw it from that point of view (namely from a position at right angles to the actual angle of view), (iii) that the Subject should draw the model while looking at it and not from memory, and finally (iv) that the Subject should draw from a photograph of the model.

The order of conditions was constant. Two measures were taken of the results, accuracy and artistic merit. Accuracy in each drawing was judged on the basis of the location within the display, the orientation, and the veracity or verisimilitude of each item. Each of these measured was scored out of seven and the these totals added.

The second type of measure, of artistic merit, was based on ratings made by five experienced university lecturers in art and design education. They rated each drawing out of fifteen points on the basis of liveliness and sensitivity to the object drawn, vitality and character of line and texture, the presence of a distinct personal style, the organisation and composition of the drawing, and the degree to which a compelling and interesting image was produced.

All five rated all drawings without being aware of the individuals' group membership or of the differing conditions under which the drawings were executed. Unlike the scoring of accuracy, each drawing was judged as a whole for artistic merit rather than assigning a separate score to each of the four items in the scene. The results of the study showed that, as far as accuracy was concerned, the normal young artists were superior to the *idiot-savant* artists in accuracy. The inferior score of the latter was due in large part to the condition in which the scene had to be imagined from a different angle than that actually presented. The *idiots-savants* did this badly. The main finding from this study on the nature of the drawing ability of *idiot-savant* and normal, gifted children is therefore that while representational accuracy is associated with intelligence, artistic merit is not. No difference between the groups was detected by the raters of artistic merit.

Summary

It has been established, we think, that at this level of measurement, artistic or graphic ability is independent of intelligence. Secondly, it

seems that graphic output is independent of visual memory; thirdly, that visual memory and visual comparative judgment may be related to intelligence and may therefore be less related to graphic ability than is often believed. Is clear that graphic ability is so independent of intelligence that it can occur at a very high level in people who otherwise are severely handicapped intellectually. However, one must avoid the erroneous conclusion that good artists cannot be intelligent. A further problem remains unsolved. Could one have *idiot-savant* artistic genius? Was the Douanier Rousseau such a person?

Notes and References

1 LUQUET G. (1913), *Les Dessins d'un Enfant* (Paris, Librairie Felix Alcan).
2 See FREEMAN N. H. and M. V. COX (eds) (1985), *Visual Order* (Cambridge University Press).
3 PAINE S. (1981), *Six Children Draw* (London, Academic Press).
4 GARDNER H. (1983), *Frames of Mind* (London, Heinemann).
5 VAN SOMMERS P. (1984), *Drawing and Cognition* (Cambridge University Press).
6 See also O'CONNOR N. and B. HERMELIN (1986), 'Spatial representations in mathematically and in artistically gifted children', *British Journal of Educational Psychology*, 56, pp. 150–57; O'CONNOR N. and B. HERMELIN (1987), 'Visual and graphic abilities of the *idiot-savant* artist', *Psychology of Medicine*, 17, pp. 79–90; O'CONNOR N. and B. HERMELIN (1987), 'Visual memory and motor programmes; their use by *idiot-savant* artists and controls', *British Journal of Psychology*, 78, pp. 307–23; HERMELIN B. and N. O'CONNOR (1990), 'Art and accuracy: the drawing of *idiots-savants*', *Journal of Child Psychology and Psychiatry*, 31, 2, pp. 217–28.
7 GOODENOUGH F. (1923) [D. B. HARRIS (1963)], *Children's Drawings as Measures of Intellectual Maturity* (New York, Harcourt Brace).

Chapter Five

ELSBETH COURT Researching Social Influences in the Drawings of Rural Kenyan Children

> Education ... might help to promote progress, and at the same time to preserve what is best in the traditions of the African people and assist them to create a new culture which, though its roots are still in the soil, is yet modified to meet the pressure of modern conditions.
>
> Jomo Kenyatta (1935)

These words were written during the thirties by a London University student who subsequently became the first President of Kenya. Similar notions about the dynamics of cultural change in Africa continue to inform public opinions [1]. This chapter [2] contributes new evidence to strengthen the case for the links between heritage, formal education and the generation of contemporary culture. My intentions are first to discuss the design of the study; and, second, to summarise selected findings about drawing performance and to begin theoretical consideration. The definition of culture used here is comprehensive, referring to a particular way of life:

the whole network of habits, beliefs, customs, attitudes and

forms of behaviour which hold it together as a community [3].
This subsumes works and practices of intellectual and especially artistic activity.

The situation

Like other post-colonial states, Kenya is committed to building its national identity and a modern economy. Three significant factors challenge these efforts: cultural longevity, ethnic diversity and a youthful population. 'Aesthetic' stone tools are one million years old while specific artisanal traditions, such as twined baskets and decorated gourds, have precedents which date back 2800 years [4]. Today, there are three language families, about fifty indigenous ethnic groups, as well as long-term settlement by Asians and Europeans. Half the population is under the age of fifteen. Finally, there are few natural resources and land suitable for agriculture is scarce.

Throughout Kenyan society, there is a strong belief in the efficacy of formal education for nation building. Since Independence in 1964, enrolment has expanded five-fold; Government spends one third of its total budget on education. In 1985, major reforms in curriculum were initiated in order to provide more relevant instruction for the rural

majority. A significant role in these reforms is assigned to Art and Craft, which is now an examined subject at primary level. Drawing is the first topic on the new syllabus, an indication that it is recognised as an essential and instrumental skill [5].

This increased emphasis upon drawing is a major innovation in both policy and practice. In traditional forms of the visual arts, there are few graphic images and no 'pictures', thus indigenous models are limited. Pencil drawing is an introduced medium that most children first experience in school. It has come to be closely associated with formal education, for instance in discussion, many people use the Swahili word *andika* (write), instead of *chora* (draw). For artists, the pencil is a new and inexpensive tool that offers both flexibility and permanency. Drawing already provides a means for the maintenance of local cultures, whether through transcription of existing imagery or through reportage (Fig. 11). For children, the opportunity to draw enables them to define actively their own visual culture, and also offers them a new range of basic skills. These reforms affirm the Government's belief in the unique contribution which Art and Craft can make to personal and national development. Consequently, there is a need for more explicit knowledge about the teaching of drawing.

11 MICHAEL LEKEDAA, Samburu (male, 17 years): school art poster, *8-4-4 Reform in Art and Craft Education.*

The implementation of the new syllabuses depends upon art educators who are very few in number and upon teachers who are generally keen, but have little 'training' in art (in fact, forty per cent have no training whatsoever). Since the reforms, there has been a marked increase in the publication of art education materials, most of which offer techniques for 'making art' and/or model examination questions.

The texts are weak in general discussions about art and about processes of learning in art. There is little specific information about the diverse visual cultures of East Africa. Accordingly, it not surprising to find that theory is derived from external sources.

For example, page one of the *Teachers' Handbook for Primary Art and Craft* [6] published by the Kenya Institute of Education, begins with a description of 'the stages in children's artistic development'. The source is unacknowledged, but can be traced to 'Tests of Educational Attainment (v): Drawing (Test 17)' in *Mental and scholastic tests* by Cyril Burt (1921). Of the available models for development in drawing, both art critic Herbert Read and historian Stuart Macdonald cite this one as best known and most rigid [7]. It was devised for psychological purposes, 'to open avenues to strange places in the childish mind', and was not intended for the charting of artistic progress. Yet it was adopted as such by some art educators and cited for more than half a century with little serious questioning until the last decade. It is especially significant to ask why the validity of such received theory has not been critically questioned by Kenyans, with specific reference to their distinctive artistic-visual contexts and the drawings by their schoolchildren.

Theoretical issues

> The experience of working outside one's culture points up, dramatically at times, the degree to which notions about art and attitudes to art are local rather than universal – if there are attitudes which are universal [8].

Prior to the 1980s, scholarship about drawing in non-Western cultures was stronger in anthropology, psychology (often with its fieldwork evidence interpreted at second hand) and *cross-cultural* psychology, than in either art history or art education [9]. Notable exceptions were Margaret Trowell's seminal work about art and art education in Africa, and the serious treatment of cultural influences in text books by McFee and Lark-Horovitz *et al*. During the second half of the 1980s, there was a marked increase in attention to social, intercultural and non-Western topics at conferences and in art education publications.

On the completion of my first drawings study in 1981 [10], it became clear that to proceed with the line of enquiry which the data were suggesting would require a different kind of theoretical underpinning, one which made 'culture' central to the problem. While this kind of analysis is the essence of anthropological enquiry, it is also found in the work of distinguished psychologists, such as Winnicott, Bruner and Vygotsky [11]. The latter stresses the importance of the socio-historical origins for higher psychological processes, which include drawing. He is also among the first to suggest mechanisms by which culture is internalised by each person. Many social scientists now stress the significance of social mediation, which refers to the importance of nurture (in contrast to nature) and context (in contrast to the individual). In art education research, Brent Wilson's most recent work is informed by such views [12].

53

The study

The problem was to investigate ways in which characteristics and patterns of growth are shaped by ethnicity, each with its distinctive local traditions in the visual arts, and are moderated by the experience of formal schooling, whether by mere attendance and/or tuition. Kenya is an excellent location for such comparative research because of its ethnic diversity and especial efforts in formal education. This study of cultural influences upon children's drawing performance, then, has two primary areas of theoretical enquiry. The first is about the interactive quality of learning (or development) in drawing, and posits that drawing performance is largely shaped by socio-cultural variables. The second concerns the dynamics of cultural change, with specific reference to the introduction of pencil drawing and its contribution to the definition of contemporary culture.

Methodological issues

Taking a cultural perspective begins a process of major accommodation in thinking about graphic behaviour, if not about art. It can lead to major modifications in teaching and research, with adjustments in methodology [13]. Within a particular tradition, an understanding of culture is usually implicit or 'given', but in comparative studies, whatever the subject-matter, the relativity of culture is central to the problem and thus requires specification.

In this investigation, there are at least two kinds of cultural consideration. First, the research is *cross-cultural*. It involves a comparison of the visual arts in three distinctive African cultures which, in turn, are being modified by the intervention of a fourth, national culture. Second, the problem concerns the *influences of these cultures* upon drawing performance. The key independent variable (in contrast to age or gender) is culture. This involves questions about equivalence concerning, for example, notions of drawing and how growth is manifest. Cultural or contextual 'grounding' was essential before embarking upon the selection of a purposive sample or before collecting further data.

Description of the sample

The sample was selected from three ethnic groups, which are representative of Kenya's diversity; Kamba agricultural artisans, Luo-Abasuba fisherfolk and the pastoral Samburu. These groups live in different geographic regions on land of low agricultural potential. They are distinctive in many ways, such as heritage, language (and language family), dominant mode of economic production and, most importantly for this study, visual arts and visual skills. All of the primary schools were maintained by the State and follow the national curriculum. The school enrolment ratio (that is, enrolment relative to the school-age population) was highest for the Kamba children and lowest for the Samburu, while literacy was below thirty-nine per cent for Luo and Samburu adults.

Kamba arts, often a source of trade, are found in the practice of fine craft work, which children learn from an early age. The incised gourd typifies the Kamba tradition – very neat, clear, all-over surface decoration of a useful artefact. A different purpose for art is seen in the daily personal decoration of the Samburu, in their elaborate hairstyles and variety of beaded ornaments. These popular art forms express their social identity and aesthetic sensitivity. In addition, as pastoralists, they have highly developed visual skills necessary for herding in the bush; their vocabulary is rich in phrases for natural patterns. In contrast, the Luo use art more conservatively. They signify status by the embellishment of certain artefacts such as shields and stools, and celebrate special occasions by painting murals. Most outstanding is their decoration of boats, which have both religious and economic significance.

After discussions about the project with scholars at the University of Nairobi and School of Oriental and African Studies, London, three groups and three communities for the research sites were selected. The communities were Wamba (Samburu), Wamunyu (Kamba), and Rusinga Island (Luo). A purposive sample was made with the assistance of local educators; for each group it included: ten homesteads, one nursery school and two primary schools, with collections from class levels one, three and five. The homestead visits were for collecting drawings from 'unschooled' children (from age one) and for observing domestic settings. The age range for primary school children was from five to eighteen, with much variation by age at a given class level [14].

Procedures for the requested data: drawings and individual tasks

In all situations, materials were provided for drawing; A4 paper and pencils. Requests were spoken in the mother tongue by a local research assistant and the researcher was present as a participant observer. For the primary school collection, students were requested to draw during four different sessions in their classrooms. Requests included short discussions of the topic. Three stimuli were imaginary and one was observational. These were:

 Drawing 1 **D1** Cow-Person-House
 Drawing 2 **D2** Myself eating
 Drawing 3 **D3** A table with three containers
 Drawing 4 **D4** Free choice, undirected (in colour) [15].

The procedures were pretested in Nairobi and on Rusinga Island, and a few adjustments were made. In the nursery schools, three drawings per child were collected, but the observation drawing was excluded. The homestead collection took place outdoors in family compounds, that is, the atmosphere was informal and relaxed. After a demonstration of mark-making in the earth, children (in small groups) were invited to draw on paper, first with pencils and then with crayons using a free choice stimulus.

The first round of assessment was by observation. Group comparisons (for ethnic group, school class, age, gender) were made for a particular

stimulus; there were also comparisons between stimuli. This was followed by the numerical coding of the imagery in order to provide a comprehensive survey of drawing characteristics and to carry out cross-tabulations and multivariate analyses, procedures necessary for making quantitative comparisons and for indicating the strengths of relationships. The scoring system was based upon the literature and my previous work as well as visual information gained in the current study.

Individual tasks were carried out by interview using a formatted questionnaire. The tasks were devised to assess, (i) style preference by choice of imagery on incised calabashes, *kangas* (Swahili for printed cloth wraps) and reproductions of paintings; and (ii) visual understanding of content and depth in photographs and line drawings. The responses were tabulated, and provide some insights for interpreting the drawings. In addition, I interviewed teachers and school heads about ethnic and school art, and surveyed each classroom for practical evidence of art education, for example, the kinds of wall displays.

Selected findings: early childhood

12 Drawing by AMOS OGWENO, Luo (male, 1.5 years).

13 Drawing by MUTYOTA MUSYOKI, Kamba (male, 5 years).

This refers to the youngest children, who are not enrolled in primary school [16]. The homestead collection offers exceptionally strong baseline evidence for 'the unschooled'. Only two of the eighty-eight children had previous experience with paper and none had attended nursery school. In all three ethnic groups, most children started to draw from the bottom of the paper and filled the whole page with action representations, recording their motor activity (Figs. 12 and 13). Their

work looks exceptionally neat – deliberate and arranged – indicative of their extraordinary eye-hand coordination. Most frequently, they drew repeated curvilinear and/or straight lines. Few drew shapes and even fewer named their representations. Between the groups, however, there are differences in their awareness of the surface area and of line. Many Samburu children arranged their imagery on the paper like a composition. With regard to line usage, they had the most range (dots, wiggles) and variation (thin, thick, soft, hard). For the most part, the other groups did not arrange their imagery as a whole, nor was their mark-making so varied. Nearly half of the Luos only used circular, soft lines while most of the Kamba children used straight and strong lines. These characteristics, which reflect prevailing practices of child-rearing, also suggest the rudiments of group styles.

Some trends are suggested by the small sample of nursery school children. Although teachers encouraged the use of figurative imagery, children drew both action and visual representations in outline and with few details. These were placed all over the paper surface, with little attention to vertical orientation. On their 'free choice' drawing, houses and vehicles were the most popular subjects, *not* the human figure. Art/Craft was taught regularly at one nursery (in Wamba, Samburu); the children there drew more expressively and with a wider range of imagery than those from the other preschools.

Mila

The Swahili word *mila* connotes the importance of ethnic heritage and customs for Eastern Africans. These emphasise social, primarily domestic, concerns and traditional economic activities, and they are most apparent in the selection of subject matter. What is important (like the cow and the house) is drawn frequently, placed prominently on the paper, drawn large and with much detail. With regard to their social attitudes, children tended to draw small, generalised people rather than a specific individual. Even when requested to draw a single person, as in the stimuli for **D1** and **D2**, the majority (up to eighty per cent) drew more than one human figure.

The continuing strength of traditions is observed in the predominance and persistence of certain content, graphic formulae and spatial characteristics that are associated with ethnic cultures. Some of these characteristics are seen across the sample. For example, (i) the depiction of humped cows, the traditional kind of cattle, is universal [17]; (ii) the 'floating picture' (Fig. 14), an arrangement of figures that is located in the upper and centre part of the paper, is used by over seventy per cent of the children; and (iii) combinations of differing aspects for a single object or for several objects in one drawing – side, front, aerial, inside, outside, transparency and/or fold-over – were used in over eighty per cent of the drawings.

Mila drawings tend to have a similar 'look', linear, clear, flat, impersonal, neat lines construct generalised schemata which are arranged topologically on the surface plane. Often, the very flatness suggests an

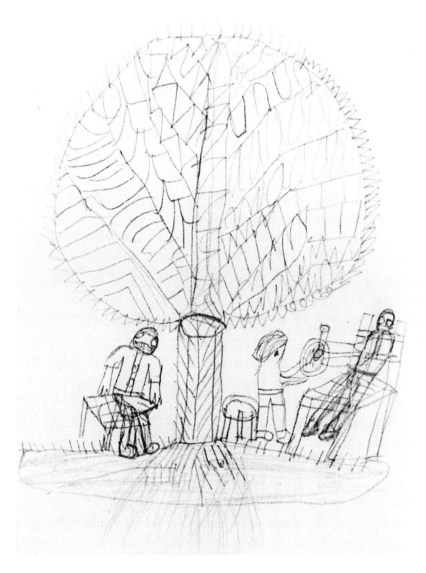

14 Spatial characteristics of the 'floating picture': drawing by KATHELE KITHUKU, Kamba (male, 12 years).

artisanal response to the material quality of the paper. Yet emerging ethnic styles can be discerned; these are artisanal, all-over decoration for the Kamba (Fig. 15), understatement with selective detail for the Luo and expressive, and highly visual rendering for the Samburu (Fig. 16). Some attributes were particular to a group. For example, Kamba children decorated their schemata with cross-hatching similar to the grid marks used in incising calabashes. Only Luo children drew fishing boats; these match the shape and decoration of their actual canoes. The majority of Samburu children drew their homesteads with a circular, aerial view enclosure; this matches its physical appearance and represents the circle which is central to their cosmology. Most frequently drawn by the Samburu, the depiction of ethnic artefacts offer the most literal rendering of traditional influences and were specific for each group, for example, Luo boats, Samburu ornaments.

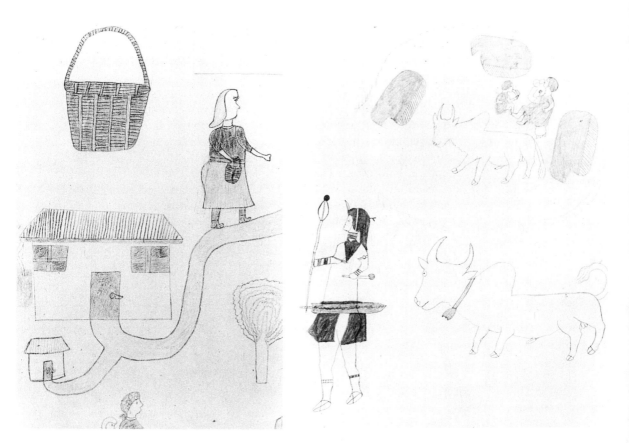

15 Kamba women's basket – important artefact and source of income for rural women: drawing by NDUUTU MUSYOKA, Kamba (female, 13 years)

16 Samburu homestead and warrior adornment: drawing by KOKOILA LENAINGISWA, Samburu (male, 14 years).

School experience

For the majority of rural children, formal education provides the only opportunity for drawing with paper and pencils. The quality of educational provision varies greatly from mere attendance to informed teaching, and must be considered in attempts to specify the relationship between school experience and drawing performance. While 'just going to school' has some effect on performance, mastery of the medium (defined as picture making and perspectival drawing in the 1985 Syllabus [18]) is clearly linked to tutoring and practice. Accordingly, the graphic influences which are associated with formal education vary.

Mere attendance means the children are exposed to the prevailing school art style. This comes close to a conflation of art with writing, in which drawing is like an extension of the alphabet. Children began their drawing of neat, small figures in the top portion of the paper and often stayed there (less than five per cent of Standard I children used the whole paper). Their drawings were arranged in a 'floating picture' or aligned, like the word-chart, without a baseline or ground. These figures are usually common school conventions, such as the house with the polygon roof (sixty-four per cent), the house with a path to the granary (twenty-four per cent), the 'inverted' perspective table (twenty-four per

cent) [19], embroidery-type flowers. In the three schools where there was no tuition in drawing, few changes were observed in children's performance between Standards I and V; they continued to draw with general schemata.

In the three other schools where art education was taught according to the syllabus, children learned the conventions for making 'pictures' and some developed considerable skill in descriptive drawing (Fig. 17). Many children attempted to depict volume for carpentered objects, with a particular fascination for tables; a very keen few tried to represent depth in landscapes. Progress in picture making was greatest amongst the Samburu boys, from two per cent in Standard I to eighty-five per cent in Standard V, while a personal, and often humorous, quality of expression distinguished the drawings of many older Kamba children. Generally speaking, those who had achieved some 'progress' were most eager to continue building their skills.

17 'Taught art': drawing of landscape with eland and civet cat, by RAIMONDE EKAL, Samburu (male, 13 years).

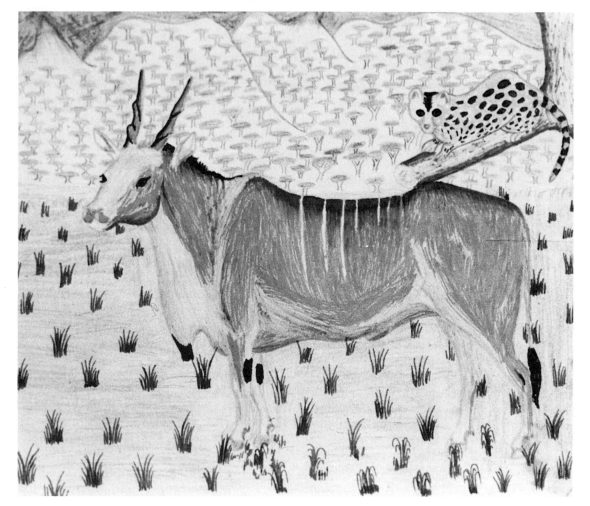

Maendeleo

The Swahili for progress, *maendeleo*, connotes a general idea of motion, and aptly characterises the kinds of drawings which are associated with changing values and modern interests. These emphasise 'action', doing something, going somewhere (fourty-five per cent drew vehicles for 'Free choice') and/or space, the illusion of volume for objects and figures (see below) and the depiction of depth in landscape, from two per cent for Standard I to thirty-six per cent for Standard V, with higher percentages for Kamba children (sixty per cent) and Samburu boys (eight-five per cent). Across the sample, however, less than ten per cent of children drew pictures, defined as a unified representation using the whole paper. To a large extent, the *maendeleo* drawings portray real or desired improvements in material conditions and suggest life beyond the village. The main subjects are individual portraits (twenty-four per cent, mostly Luos), Western dress, manufactured goods from watches to motor vehicles (Fig. 18), carpentered buildings and furniture. The largest percentage of *maendeleo* drawings were by Kamba children and Standard V boys from the other ethnic groups.

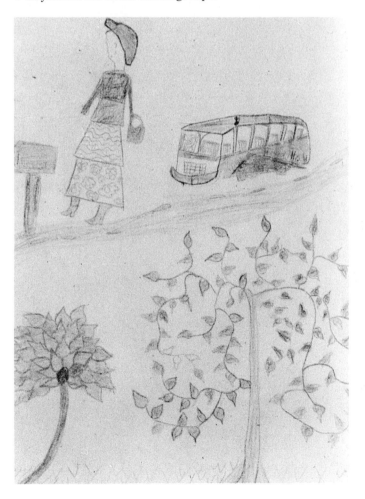

18 *Maendeleo* drawing including vehicle and Western dress, by KALUI NGEMU, Kamba (male, 12 years).

61

However, an indication that many children are aspiring 'moderns' is seen in the finding that nearly sixty per cent of them drew tables in their responses to the 'Myself eating' stimulus, although tables were not requested. The table is a modern artefact which is easily accessible in the rural areas. Its very presence represents an improved standard of living. In eighty-three per cent of the table drawings, there was some attempt to portray depth; most children drew two views, followed by inverted perspective and parallelograms, while less than three per cent drew tables with receding, converging lines. The common 'inverted' perspective formula provided them with a way to show their awareness of 'depth' (Figs. 19 and 20). Such attempts show an interest in modern technology.

Varying gender differences, reflective of socialisation practices, are apparent in some drawings. For example, Luo and Samburu children tended to draw male figures much larger than female figures, while most Kambas did not exaggerate gender size. A comparison of transport drawings shows different treatment for a similar subject – the boy

19 Inverted perspective table: drawing by YERPENE LEKERPEET, Samburu (female, 15 years).

concentrates on the means of transport (the vehicles) and the girl upon the effect (going somewhere). Nonetheless, apart from some differences in subject matter, gender did not significantly influence drawing performance in this study.

20 Inverted perspective tables: drawing by MILKA ADHIAMBO, Luo (female, 13 years).

Some theoretical implications of these findings

1 Drawings by the youngest children provide baseline evidence to ascertain how drawing performance is modified by the acquisition of traditional and school conventions as well as by personal growth, whether maturation or individuation. The results clearly show graphic expression is a 'natural' and 'aesthetic' activity. Most of the young children drew vigorously with concentration, often with organisation. This facility strongly suggests connections between psychological functions, while tendencies for certain kinds of mark-making within a group as well as a consistent ethnic 'look' or style are evidence of the very early influence of ethnic culture.

2 The findings about the influences of *mila* affirm the introductory quotation from Kenyatta. Drawing can facilitate the recording and transmitting of ethnic cultures, thus assisting in their maintenance. Influence and interaction occurs in a number of ways. The most obvious is content, but further insights into values and art are seen in the use of detail and from spatial conventions. A particular group style or quality was manifest for each ethnicity, reflective of their values.

For the most part, the effects of traditions are most apparent in the work of people who have had least opportunity to either make or look at pictures, whether they are young or untutored or both. In addition, attitudes toward art-making are conditioned by living in cultures where

63

the visual art forms are usually created by the repetition of common or shared symbols for social purposes in contrast to the more individualistic and innovative emphases characteristic of Western kinds of art.

3 The principle that drawing performance is closely related to the quality of *school experience* is strongly supported by the evidence. Indeed, because of the paucity of opportunity elsewhere, the significance of formal schooling cannot be overemphasised. The school is a key arena for cultural transition, between the traditional or local culture and the modern or national culture. Drawing performance is a significant indicator in this sphere, reflecting various syntheses from the classroom, locality and larger society. Sometimes, traditional and classroom influences reinforce each other, such as in the convention of arranging figures in rows or columns. Alignment reflects familiarity with the piece-meal arrangement of proverbs and seriate patterning as well as the ubiquitous classroom word-chart. At other times, school and modern influences work together as in the representation of tables in linear perspective and other more individuated kinds of expression.

4 As a medium, drawing readily reflects values and ideas. New kinds of content, new ways to represent space and more personalised imagery (beyond the standard conventions) show how drawing helps to express contemporary culture, or *maendeleo*. Drawing is also an instrumental means to becoming modern, with regard to its roles in modelling and styling for innovative design.

The consideration of drawing in its cultural context provides a comprehensive account of the complexity of the medium, both as a process of learning and as a product of a particular socio-cultural or historical situation. Qualitative 'thick description' of the ethnographic kind allows for a depth of understanding which would be unobtainable from a 'thinner' study. Multivariate statistical analyses indicate the importance of socio-cultural factors in defining the terms for individual and genetic influences. Rather than the dominance of a singular social or any other factor in the shaping of drawing performance, these findings show there is a dynamic or interactive relationship between the two key cultural influences: ethnicity and school experience. Thus far, the results add strong support to those theories of drawing development which are comprehensive with regard to the individual and his or her intentions, art and society [20].

This basic research with its queries about the complexity of drawing and culture should be viewed as the beginning or, at best, the foundation for further study. In this pursuit, these theoretical musings and preliminary results may lead to further appreciation of the scope of drawing in art and across the curriculum. On a larger scale, this greater awareness may encourage humane progress through the arts, which is nurtured by diverse traditions and by interactions between groups and guided by the inspiration of individuals.

Notes and References

1 The notion of an explicit link between heritage, formal education and the generation of contemporary culture has been advanced by leading Africans over the past fifty years. See KENYATTA, J. (1938 [61]), *Facing Mount Kenya* (London, Heinemann), pp. 127–28.

2 This paper began as a talk prepared for the openings of the exhibition *Drawing on Culture* and an art education seminar in Nairobi on 23 October 1989. The exhibition was on display during the conference *Drawing Art and Development*, and then travelled to four venues in Zimbabwe and Kenya, where it was presented to the Kenya Institute of Education. See COURT, E. (1989), 'Drawing on culture: the influence of culture on children's drawing performance in rural Kenya', *Journal of Art and Design Education* 8, 1, pp. 65–88. See also COURT, E. (1989), '*Drawing on Culture: a Catalogue for a Travelling Exhibition of Children's Drawings from Rural Kenya*, p. 2.

3 GULBENKIAN FOUNDATION (1982), *The Arts in Schools: Principles, Practice and Provision* (London), pp. 37, 39. See also WILLIAMS R. (1976), *Keywords: a vocabulary of culture and society* (London, Fontana), pp. 87–93.

4 See PHILLIPSON D. (1985), *African Archaeology* (Cambridge University Press), pp. 55–56. See also LEAKEY, L. S. B. and M. D. LEAKEY (1950), *Excavations at the Njoro River Cave: Stone Age Cremated Burials in Kenya Colony* (Oxford University Press).

5 MINISTRY OF EDUCATION (KENYA) (1986), *Primary Education Syllabuses, Drawing*, Vol I, pp. 5–12, and Vol II, pp. 39–58; MoE (1985), *Secondary Education: Art and Design Syllabus; Drawing for Forms 1–4*, pp. 1, 7, 14, 21. See also (1988), *Presidential working party on education and manpower training for the next decade and beyond* (Nairobi, Government Printer), especially Chapter 2 'The Cultural, Social, Economic and Political Context of Education in Kenya'.

6 KENYA INSTITUTE OF EDUCATION (1978 [87]), *Primary Art and Craft Teachers' Handbook for Standards One, Two and Three* (Nairobi, Jomo Kenyatta Foundation), p. 1.

7 BURT, C. (1921 [4th ed. 1962]), *Mental and scholastic tests* (London, Staples Press), pp. 417–429; READ H. (1943 [rev. 1961]), *Education through Art* (London, Faber), pp. 118–126; MACDONALD S. (1970), *The History and Philosophy of Art Education* (London University Press), pp. 327–28, 373. It is likely that Burt's model entered Kenyan art education through Read.

8 NEWICK J. (1973), 'Study of the context of participation in the arts', in FIELD D. and J. NEWICK (eds), *The Study of Art and Education* (London, Routledge), p. 99. See also BRUNER J. (1981) in LLOYD B. and J. GAY (eds) (1981), *Universals of Human Thought: Some Evidence from Africa* (Cambridge University Press), pp. 260–62. With reference to 'universals', Bruner states: 'For what is most striking is the manner in which universal competences are shaped to the uses of different cultures . . . You cannot talk about a mode of representation in drawing in isolation without taking into account the set of supporting cultural traits of which it is an expression'.

9 Anthropology: TORDAY E. and T. JOYCE (1910), *Les Bushongo* (Brussles, Annales du Musée du Congo); FORTES M. (1981), 'Tallensi Children's Drawings', in LLOYD and GAY (n.8).
 Psychology: SULLY J. (1895 [1919]), *Studies of childhood* (London, Longman), Chapter X; PAGET G. (1932), 'Some drawings of men and women made by children of certain non-European races', *Journal of the Royal Anthropological Institute*, 62; ANASTASI A. and J. FOLEY (1936), 'An Analysis of spontaneous drawings by children in different cultures', *Journal of Applied Psychology*, 20.
 Cross-cultural psychology: DENNIS W. (1966), 'Goodenough scores, art experience, and modernisation', *Journal of Social Psychology*, 68; DENNIS W.

(1966), *Group Values through Children's Drawings* (New York, John Wiley). Art history: GOMBRICH E. (5th ed. 1977), *Art and Illusion* (Oxford, Phaidon); GOMBRICH E. (1979), 'The Primitive and its value in art', *The Listener*, 15 Feb–8 Mar. Art education: TROWELL K. M. (1937), *African Arts and Crafts: their Development in the School* (London, Longman, Green and Co.); COURT E. (1985), 'Margaret Trowell and the development of art education in East Africa', *Art Education*, 38, 6.

10 COURT E. (1980), 'A study of developmental drawing characteristics of selected school-attending Kenyan children in Nairobi and Kiambu' (unpub. MA thesis Nairobi); COURT E. (1981), 'The Dual Vision: Factors affecting Kenyan children's drawing behaviour' (unpub. paper presented at the INSEA World Congress, Rotterdam, Aug 1981); COURT E. and D. PATEL (1982), *Report to teachers' colleges on the Art Education paper* (Nairobi, National Examinations Council).

11 For further discussion about socio-cultural mediation, see Introduction and Chapter 7: The location of cultural experience, in WINNICOTT D. (1971 [74]), *Playing and Reality* (Harmondsworth, Penguin). See also introduction and essays by BRUNER, SCRIBNER and COLE in WETSCH J. (ed) (1985), *Culture, Communication and Cognition: Vygotskian Perspectives* (Cambridge University Press); VYGOTSKY L. (1985), *Mind in Society: the Development of Higher Psychological Processes* (Harvard University Press). These scholars stress the relative importance of (i) interpersonal learning, and (ii) the relationships between functions, which means the dynamic interaction between psychological domains.

12 WILSON B. and M. WILSON (1987), 'Pictorial composition and narrative structure: Themes and the creation of meaning in the drawings of Egyptian and Japanese children', *Visual Arts Research*; WILSON B. (1988), 'The Artistic tower of Babel: Inextricable links between culture and graphic development', in HARDIMAN G. and T. ZERNIK (eds), *Discerning Art: Concepts and Issues* (Illinois, Stipes Publishing Co.).

13 In 1980 I compared the drawing performance of young rural and urban Kikuyu children from four schools in two communities. Assessment was carried out with Western criteria for human figure structure and spatial usage. These criteria did not work well with the data, in that, (i) there was little variation in performance on the human structure scale because the drawing characteristics across age were very similar; (ii) the spatial usage scale was not sensitive to the variation in drawing performance, so categories had to be added to record this evidence; and (iii) the sets of criteria did not tap what appeared to be an outstanding characteristic of the drawings: detail in decoration and texture.

14 The sample total was 898 children, including 88 from homesteads, 78 nursery school children and 732 primary school children. The total number of their drawings is 3260. Eighty-four primary school children (about ten per cent) participated in a series of individual tasks. The field work was carried out during 1984 and 1985. In 1989, following a conference which was in part for discussion of this study with Kenyan colleagues, visits were made to two of the communities. In sample schools, fifty-five per cent of the teachers were college trained, half of whom had some sort of art education. There was evidence of practical art/craft in 15 classrooms (out of 21), with one hundred per cent of the Kamba. An assessment using an index of variables for the art environment rates sixty-five per cent of the classrooms as supportive, with the Kamba teachers generally offering the most encouragement. By coincidence, for each ethnic group, one school had supportive environments for art while the other did not. There were large differences between the two schools on Rusinga Island and in Wamba district. This can partially be attributed to the school head, but is also the result of an outstanding teacher in art at each of the schools.

15 The Cow-Person-House stimulus was suggested by Dr Nancy Smith, during one of the pilot study trips to Rusinga Island in 1984. The stimulus 'Myself eating' was suggested in a letter from Professor L. Brittain (20.4.78). Changes in procedures were made following my first study (1980–81) and after the first phase of field work in this study (1984).

16 This section follows closely the pattern of presentation used in the exhibition *Drawing on culture*, offering a narrative description of key preliminary results based upon analyses up to July 1989. See the exhibition catalogue for over forty reproductions of the drawings.

17 The hump indicates a zebu, the indigenous cow. It is able to survive in arid conditions, thus enabling the continuance of pastoral life. The hump is considered to be the 'sweetest' meat. The structure of the cow changes with age and experience, offering a good unit for analysis.

18 *Ibid.* (n.4).

19 Inverted perspective is a way of portraying the illusion of space, particularly for carpentered objects, in which the diagonal lines come forward, converging in front of the picture plane, rather than converging back as in linear perspective. It is a major convention in two-dimensional representation throughout Eastern Africa, and has been in the pool of available imagery for a long time. In this study, it was widely used for the drawing of tables. OSBORNE H. (ed) (1970), *The Oxford Companion to Art* (Oxford University Press), pp. 846–48; PICKFORD R. (1972), *Psychology and Visual Aesthetics* (London, Hutchinson), pp. 35–45; DUBERY F. and J. WILLATS (1983), *Perspective and other Drawing Systems* (London, The Herbert Press).

20 The suggestion is that these Kenyan results add support to theories whose approaches are dynamic and comprehensive. See WILSON and WILSON (n.12); WOLF D. and M. PERRY (1988), 'From end-states to repertoires: Some new conclusions about drawing development', *Journal of Aesthetic Education 22*, 1 (repub. in PERKINS, D. and H. GARDNER (eds) (1989), *Art, Mind and Education: Research from Project Zero* (Urbana, Ill., Illinois University Press). These approaches are considered and extended from a British point of view by ATKINSON D. (1991), 'How children use drawing', *Journal of Art and Design Education*, 10, 1, pp. 57–72.

Acknowledgements

I wish to thank Mrs W. Muito, Dr K. King, Dr S. Malvern and Dr S. Paine for their helpful comments on earlier drafts of this paper, and to acknowledge the financial support of the Wenner-Gren Foundation; the Ford Foundation (Nairobi) and the Hilden Charitable Fund (UK).

Chapter Six

TAHA ELATTA Sudanese Graphic Imagery: a Survey for Art Education

Introduction

The Sudan acts as a bridge between Islamic and African cultures. These ancient cultures continue to effect contemporary Sudanese life significantly, but in differing ways. People in the northern regions of the Sudan are influenced by the way of life of neighbouring Arab countries, while those in the southern regions are influenced by neighbouring African countries. With regard to formal education, strong Islamic policy and practice are mediated by educational structures and teaching materials which are from the North and particularly from the United Kingdom through the colonial legacy. Accordingly, Sudanese art and design education curriculum models, techniques and resources are Western European.

In 1983, however, the Khartoum College of Art (the only tertiary level institution for art training) implemented a new curriculum policy and practices aimed at developing students' awareness of Sudanese artistic heritage and cultural diversity. One of the objectives states that students are to be trained in such a way that it deepens their cultural awareness of the range of Sudanese art forms. Although there are no visual resources available for teaching about indigenous art, this objective is being met through field visits by students to different regions of the country.

There are still very few studies concerned with the nation's material culture or authentic visual arts, and none focuses upon its traditional graphic imagery. This situation was the motivation for a research project which has resulted in the provision of basic information, reflective of the Sudan's indigenous cultural heritage, for curriculum planning and reform in art and design education. This chapter reports on a specific aspect of this work – a survey and analysis of linear surface designs on local artefacts [1].

Research design and implementation

This relatively small aspect of the research as a whole was organised as follows. First a literature review was undertaken to identify published work relating to material culture and surface designs. The second task was to identify, in consultation with a panel of Sudanese experts, specific cultural regions and samples of artefacts characteristic of each [2]. Then followed the documentation of surface designs from these selected artefacts, mostly containers and ornaments.

The fourth stage was to prepare and apply a classification system

according to the identified kinds of imagery, namely *representation* (figurative imagery, visual likenesses of humans, animals or plants); *motif* (the unit within a pattern); and *pattern* itself (the repetition of related motifs, and the arrangement of imagery on surfaces). The research then set out to analyse the geographic distribution of indigenous surface designs, to discover whether there are distinctive regional cultural styles that could be accommodated within a constructed taxonomy. And the final objective in this initial phase of the project was to analyse the findings and their implications for curriculum planning in art education, with particular reference to graphic design.

The literature

The review of previous research [3] identified studies of material culture in anthropology, some of which focused upon the surface design of artefacts. Several of these were concerned with the classification and interpretation of graphic imagery, for example, Glover's research into *Adinkira* (Ghana) textile patterns reports on motifs and their symbolism. In *African Design*, Trowell shows a range of surface designs – motifs, patterns and 'decorative' (as contrasted with 'photographic') representations. Vansina's *Art History in Africa*, includes a review of motifs found on sub-Saharan artefacts, which the author states are usually applied for decorative reasons and to provide a frame to enclose other imagery.

Hodder's title, *Symbols in Action*, refers to the key finding in his study of the distribution of indigenous decorations on clothing, ornaments and containers for a number of neighbouring tribes in Eastern Africa. He concludes that people actively keep clear distinctions in the expression of their material cultures in order to maintain the identity of their group. In another comparative study of cultures in the same region, John Mack offers an alternative view which suggests that there is much sharing between neighbouring groups. He advances the notion of regional clusters of culture rather than 'one tribe, one style'. The studies which were most useful to the research project were by Trowell, Donnan and Korn (although the latter two works are about visual systems of pre-industrial societies outside Africa.

Descriptive summary of the findings

Northern region
Although the majority of artefacts were ornaments, there were also a few containers. No representations of human figures were in evidence here; there was only one figurative image – a bird engraved on an ear ornament. The majority of motifs were floral and geometric. Pointed stars were seen on many ornaments, in various placements and sizes, including a flower-like motif in the form of a star (Fig. 21). All patterns were arranged symmetrically on the surfaces of the artefacts, and all were linear.

21 Northern Sudan: a flower-like motif in the form of a star.

Western region

Artefacts were ornaments (including charms), containers (gourds, trays) and weapons (for example, swords). There were no human representations, but there were many highly stylised animal and bird images on charms, created by Nigerian artisans who live in the region [4]. However, the majority of surface designs were not representational but geometric. While the few organic motifs were drawn in outline only, the others were infilled with various linear marks and/or small geometric motifs (Fig. 22). The majority of patterns were arranged symmetrically, their purpose decorative, with neither symbolic meanings nor visual referents.

22 Western Sudan: organic outlines with linear and geometric infilling.

70

Eastern region

A variety of artefacts were examined, including containers (trays, coffee and water jars), tools (combs, daggers, kohl applicators – women's traditional implements for applying eyeliner or kohl) and cloth (veils, mats). There were no images of humans or animals. All motifs were carefully drawn in outline, using repeated lines to provide some contrast (Fig. 23). There was widespread use of different geometric motifs in various combinations, and minimal use of floral motifs. All patterns were decorative in purpose and symmetrical in arrangement.

Central region

The artefacts were containers (coffee pots, trays), clothing (caps), charms and tools (kohl applicators). All of the motifs – geometric, floral and organic – were skilfully rendered. Some motifs were borrowed from the Northern, Eastern and Southern regions while others were of local origin; for example, flower-like patterns engraved on coffee trays (Fig. 24), derived from motifs on early Khartoum iron fences. There were different arrangements of motifs on head caps, for example, brick-like geometric motifs and other contrasting patterns of arrow motifs.

South-western region

The variety of artefacts included ornaments (for forehead and chest decoration), containers (gourds, bowls) and weapons (such as boomerangs). Generally, decorations were linear and rather crudely drawn, covering the entire surface. With regard to figurative imagery, there were no representations of people, but some animals and birds. An interesting example on a gourd container depicted four stages in the biological development of a frog (Fig. 25). Triangles and squares were seen on most of the artefacts, while there were very few circular, floral or organic motifs. The experts supplied visual referents, such as the sun, guns and frogs, for ten of these motifs. The majority of patterns were asymmetrical in arrangement and decorative in purpose.

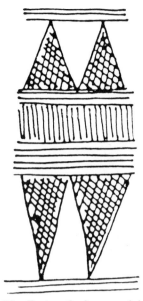

23 Eastern Sudan: careful outline drawing with repetitive liner contrast.

24 Central Sudan: flower-like motifs derived from early Khartoum iron fences.

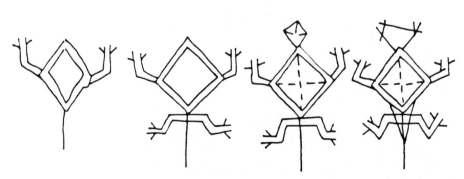

25 South-western Sudan: a gourd container depicting stages in the biological development of a frog.

Southern region

The artefacts were containers (pots), tools (pipes, fans) and ornaments (for chest decoration and masks). Although there was little evidence of

26 Southern Sudan: a full figure person infilled with geometric motifs.

figurative imagery, that which was in evidence was remarkable – for instance there were full figure images infilled with geometric motifs (Fig. 26). The majority of patterns were constructed from geometric motifs, such as diamonds and triangles; they sometimes formed abstract shapes and were arranged asymmetrically on the surface. There were very few floral motifs. The experts confirmed that the purpose for these motifs was decorative.

South-eastern region

Very few artefacts were available for study, but the few that there were had many surface decorations. These artefacts included three gourd containers, two boomerangs and two woollen ornaments. The imagery was linear; most was infilled or surrounded with dots or hatches (Fig. 27). There were many representations of humans and animals. Some gourd surfaces were totally covered with human figures engaged in a range of daily activities, including a portrayal of a sexual act. Geometric motifs were rare; in one case, repeated triangles represented mountains [5].

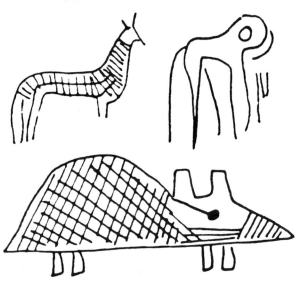

27 South-eastern Sudan: linear imagery infilled or surrounded with dots and hatches.

Summary and conclusions

Representations

No human or animal representations were observed on artefacts from the Northern, Western, Eastern or Central regions, while there were many differing kinds of animal representations from the three regions of the South. Those from the Southern region were skilfully drawn and highly stylised; those from the South-western region were constructed from geometric motifs; those from the South-east were crudely drawn with a series of single lines. This method also served for the human figure.

Motifs

Floral motifs were common in designs from the Northern and Central

regions, but rarely seen on artefacts from other regions. Geometric motifs were the predominant surface designs on artefacts from the Northern, Western, Central, Eastern and South-western regions, but very few were evident on those from South and South-east.

Patterns

For all regions except the South-east, geometric patterns were constructed out of one or two motifs. Artefacts from Southern and South-western regions nearly all had contrasting solid or filled-in patterns, which did not occur in the other regions.

Regional art styles

The characteristics of surface designs observed on artefacts from the seven geographical/cultural regions of the Sudan provided evidence to support classification into two main stylistic groupings, a Northern and a Southern.

The findings about the style of the Northern region were as follows. All surface designs were geometrical. There were no human or animal representations. Motifs and patterns were skilfully drawn in continuous outlines. Imagery was arranged symmetrically, partially covering the surface.

The findings about the style of the Southern region were as follows. Most surface designs were figurative, and the majority depicted humans and animals. Some designs from the South and South-west were geometric. For the most part, drawings were crudely executed in broken lines. Imagery was asymmetrically arranged, over most of the surface area.

Applications

This investigation led to the categorisation of indigenous Sudanese imagery on containers and ornaments into two major regional groups, with considerable differences in their graphic styles. The findings were analysed with regard to possible educational applications and outcomes. Two specific results were the establishment of a computer-based data bank of Sudanese imagery for the Khartoum College of Art, and the development of a revised programme of study for its Foundation and Graphic Design courses. Major recommendations for these courses were the inclusion of compulsory study of theoretical and practical components of material culture, and introduction of fieldwork-supported investigations into the cultural meanings of artefacts.

Certain broad learning outcomes were identified, namely that art and design students should be able, (i) to understand the meanings and utility of indigenous art forms and their relationship to contemporary Sudanese society and culture; (ii) to demonstrate that they have undertaken and are capable of research into indigenous cultural heritage, particularly with regard to comparisons between regional art forms in the Sudan and with those of other African cultures; and (iii) to promote the application of Sudanese art forms and aesthetic values in contemporary art and design.

Notes and References

1 ELATTA T. (1990), *An analysis of indigenous Sudanese graphic imagery and implications for curriculum development in art education* (Centre for Postgraduate Teacher Education, Leicester Polytechnic). Other sections of the work, not reported here, included testing the validity of the taxonomy by means of a survey of work produced by graphic design students at Khartoum College of Art between 1968 and 1988; and educational applications and outcomes. The survey showed that there were significant variations in the use of imagery along regional lines as well as an increase in the frequency of cross regional indigenous imagery in the work of students. Fieldwork in the Sudan was carried out during three months in 1988.

2 The initial selection of regions followed those used for government administration. The enquiry involved interviewing experts in the Sudan, including archaeologists, artists and collectors. Material sources in Khartoum were the College of Art, Ethnographic Museum, the Institute of Afro-Asian Studies, Sudan National Museum, Sudanese Folklore Centre, records of the Department of Archaeology and Antiquities and private collections.

3 DONNAN C. (1976), *Moche Art and Iconography* (Los Angeles, UCLA Latin American Studies Centre); GLOVER E. (1969), *Adinkra Symbolism* (Accra, Ghana, GLO Art Gallery); HODDER I. (1982), *Symbols in Action* (Cambridge University Press); KORN S. (1978), 'The formal analysis of visual systems as exemplified by a study of the Abelem (New Guinea)', in GREENHALGH M. and V. MEGAW (eds), *Art in Society: Studies in Style, Culture and Aesthetics* (London, Duckworth); MACK J. (1982), 'Material culture and ethnic identity', in ROBERTSHAW P. and J. MACK (eds), *Culture History in the Southern Sudan: Archaeology, Linguistics and Ethnohistory*, Memoir 8 (Nairobi, British Institute in Eastern Africa); TROWELL M. (1960), *African Design* (London, Faber); VANSINA J. (1984), *Art History in Africa* (London, Longman).

4 Sudanese experts El Tayib, a folklorist, (1987) and M. Hakim, an archaeologist, (1987) agreed that the 14 symbolic representations of animal and birds were produced by resident Nigerians for the purpose of magic. The images were positioned asymmetrically on the surface of charms, and frequently words or letters were incorporated into images rendered as a single unit.

5 There are two reasons why there are so few artefacts from the South-eastern region in collections: because they are made for tribal use and are not for sale to outsiders; and because of the protracted civil war in the region.

Chapter Seven

BRENT WILSON and JOHAN LIGTVOET
Across Time and Cultures: Stylistic Changes in the Drawings of Dutch Children

Jonathan Miller: Now you say in *Art and Illusion* that we can learn a lot about the use of schemata by looking at the way in which a child draws. This has changed very little in 500 years, even 2000 years, and I'm sure that pictures by Egyptian children were exactly the same [as today].
Ernst Gombrich: Yes I think that's roughly true. Though our children are also influenced nowadays by picture books they see or the shows they watch they are pretty much impermeable to these influences. [1]

It is most curious that Gombrich should have made such a response to Miller. Gombrich, perhaps more than any other person, has shown that it is not mere observation of the objects of their environment through which artists create the graphic schemata that represent their worlds. Rather, they borrow from culturally available schemata or patterns of graphic conventions which they correct or refine in order to depict the specifics of the objects they wish to represent. If adults deal with graphic tasks in this way, then is there reason to believe that children would do otherwise?

Art historians classify works of art according to style—according to graphic characteristics and compositions that distinguish the art of one group of artists working in a given time and place from the art of other times and places. Works of art produced in cultures that are close in time, geographic location, culture, and environment usually have greater stylistic similarity than works from cultures that are distant. Northern and Southern Renaissance paintings both reflect the artists' preoccupation with perspective, but for a time the Northern painters shaded into hard contours while the Southern painters experimented with *chiaroscuro*. By the early twentieth century the lightened palette and loose handling of paint associated with Impressionism exerted a powerful influence on painters in many countries. Nevertheless, the Impressionist-inspired paintings of Britain are different from those of the United States, Japan, or Italy. The world of art is infected by a variety of stylistic influences but those infusions are modified culturally into a variety of stylistically distinct strains.

Previous investigations have shown that, like adult art, children's drawings are not entirely immune to cultural influence. Features such as two-eyed profiles, bottle-bodies and moon-faces, stacked figures, occlu-

sion, and cropped objects are found among some groups of children yet are almost entirely absent from the drawings of other groups. The two-eyed profile, for example, was found in the late nineteenth and early twentieth-century drawings of children in Western Europe and North America. A rectangular torso with a fused neck is used by a high percentage of children throughout the Middle East, while profile heads in the shape of a quarter-moon are found primarily among Egyptian children [2]. Still, we have few insights into the manner in which children's drawings change across time and cultures. We have even fewer hypotheses regarding the factors that influence these changes. Although we have considerable knowledge regarding children's drawings from the perspective of psychology, we have little understanding of children's drawings from the historical, anthropological, sociological, or even educational perspectives.

The challenge of the 1937 H9 collection

At the Tilburg Academy of Art Education and other Dutch art academies there is a marvellous collection of children's drawings created in 1937 by the students of nine teachers from the Hague who encouraged creative expression and placed great emphasis upon fantasy and imagination [3]. The underlying theories of B. Merema, the group's leader, were grounded not only in child art and creative expression but also in a Jungian-based psychoanalytic explanation of the psyche [4]. Notes and lists of art educational periodicals that circulated within the group, found in the original folders in which the drawings are stored, indicate that the members of this association of dissident art teachers, calling themselves the H9 or Hague Nine, were well informed regarding current theories of child art and creative expression. It is important to note that some H9 members attended summer courses in Austria given by Richard Rothe, a former student and assistant of Franz Cizek.

Van Rheeden tells us that the establishment of the H9 marked an important point in a long but 'slumbering' conflict between the conservatives and progressives [5]. The underlying intensity of the ideological struggles to determine how children should be taught is illustrated in an assessment of the drawings by the students of the H9 teachers by Wierink, a board member of the conservative *Nederlandse Vereniging Voor Tekenonderijs* (NVTO) or Dutch Association for Teachers of Drawing and Painting. Wierink suggested that allowing children to draw freely was somehow associated with the sexually explicit drawings of Pompeii. He declared:

> Most of the free drawings are rather insignificant, of the copied
> kind. The figures of most of the kids correspond perfectly with
> those found on the walls of Pompeii [6].

In light of the innocence and charm of the drawings in the Tilburg Academy collection, the suggestion is rather surprising. The drawings which were done at three-week intervals by seven, eight, and nine year-old children, centre around a variety of assigned topics: two girls under an apple tree; a family at a table where a boy is tipping back in his chair;

a playground; a figure walking; *Cinderella*; a street scene; animals in a pasture; a beach scene; and *The Princess and the Pea*.

In collegial discussions, the H9 group members frequently analysed the children's art based on Jung's archetypal grid. Special attention was directed toward such things as contrasting pairs: upward-striving force versus downward-pulling energy, and the archetype mother versus the archetype father.

As we examined the drawings, however, it was not the ideology of creative expression reflected in the drawings so much as the schemata used by the children that commanded our attention. Their drawings appeared at first glance to be closer stylistically to European children's drawings at the turn of the century than to Dutch or American children's drawings of the 1980s. Was our assumption correct? We decided to undertake a cross-era and cross-cultural study of 'two figures under an apple tree', and as a result this chapter will report on our investigation of children's drawings of trees.

Issues and questions

The general purpose of this investigation was to consider some factors that affect children's graphic imagery by making a comparison of the Dutch 1937 drawings and drawings of Dutch children in 1986 as well as drawings from children in other countries. The specific questions towards which we directed our attention were:

1 Are the tree schemata found in Dutch children's drawings created in 1937 and 1986 essentially alike?
2 Do Dutch children's tree drawings created in 1986 have a greater affinity to drawings of American and Italian children than to the Dutch children's drawings of 1937?
3 What factors relating to changes in art educational practices, societal and cultural differences among the children, and almost half a century of societal and cultural changes within the Netherlands might account for the patterns of difference and similarity?

We knew that any study in which such questions were posited would be fraught with methodological and procedural difficulties. We could only speculate about the conditions that surrounded the creation of the original set of Dutch children's drawings. Any attempt to recreate those conditions would probably be wrong in ways that we could never know. We also knew that any hypotheses we might formulate regarding the reasons for differences and similarities in schemata and organisational patterns among the groups of drawings would have to be carefully evaluated in subsequent studies.

Samples and methods

Cross-cultural and cross-era groups

The girls and boys were between seven and nine years old [7]. The sample included (i) the original 1937group of Dutch children from one elementary school in the Hague; (ii) 1986 Dutch children from three

schools in and around Tilburg in the southern part of the Netherlands; (iii) 1986 American children from a public school in Centre County, Pennsylvania and an Orthodox Hebrew school in Pittsburgh; and (iv) 1986 Italian children from Bari, Foggia and Rome [8].

The drawing task

The precise instructions given to the children in 1937 are not known, so a set of instructions was reconstructed for the drawing of two girls under a tree. These took into account the 1937 collection and employed a 'motivation' such as we imagined a teacher influenced by Franz Cizek would use to introduce a lesson.

> I am going to describe a scene, and as I describe it, I want you to imagine in your mind's eye all the things that I tell you.
> It is a bright day in the fall of the year. Look at the trees. Some of the leaves are still bright green and some are beginning to turn brilliant orange, yellow, and red. Now look into a back garden behind a house. In the middle of the garden you see the most beautiful apple tree you have ever seen. The tree stands all by itself surrounded by green grass. Look at how large the tree is; and, oh, look at its branches: there are so many – almost too many to count. On each branch there are lots of leaves. Look again, among the leaves there are shiny red apples – hundreds and hundreds of big, round, juicy apples.
> Now look at who is coming into the garden. Two girls dressed in pretty dresses run to the apple tree. Now they are standing beneath the lower branches of the apple tree. They look up into the tree. Now they spy the apples. Can you see them now, up on their toes, stretching their arms to the lower branches of the tree, trying to pick the apples?
> In your mind picture the whole scene – the apple tree with all the branches, leaves, and apples. Look beneath the tree at the two girls trying to pick some of the apples. Draw what you have seen in your mind's eye.

Analysis of the tree drawings

Six general components of the tree were analysed: tree tops, tree trunks, tree roots, branches, leaves, and fruit. Within these categories, 22 classifications were derived from an analysis of the trees in the children's drawings (Fig. 28) [9]. The drawings were classified by an experienced research assistant and the results were checked by another. Neither of the assistants was aware of the questions being asked about the children's drawings. The few differences in the analyses were resolved through discussion.

Findings about the schemata of trees

Table 1 shows the percentages of children who depicted trees using the 22 different classifications. Through the use of a chi-square analysis, 16 significant differences in the use of schemata were found to exist among the four groups of children. When significant differences were not found

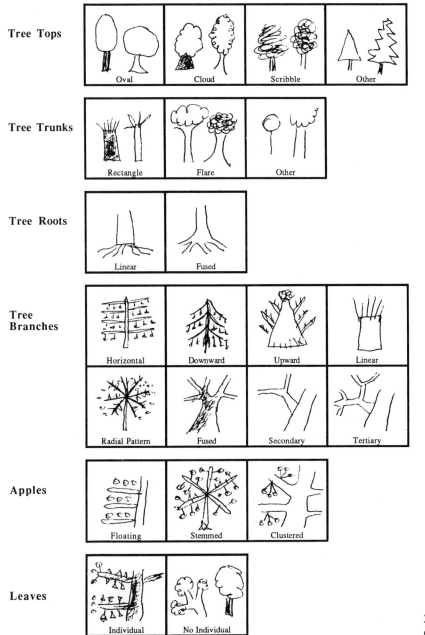

Tree Tops — Oval, Cloud, Scribble, Other

Tree Trunks — Rectangle, Flare, Other

Tree Roots — Linear, Fused

Tree Branches — Horizontal, Downward, Upward, Linear, Radial Pattern, Fused, Secondary, Tertiary

Apples — Floating, Stemmed, Clustered

Leaves — Individual, No Individual

28 Tree schemata classifications.

it was because the schemata for tree roots, clusters of apples, and miscellaneous tree trunk schemata were seldom employed by children in any of the groups.

The tops of the trees – the contour and the manner in which the branches are formed – provide the most varied and interesting employment of schemata. It should be noted that some children in each of the

Table 1

Group Differences in the Use of Schemata to Represent Trees

	Dutch '37 N= 32	Dutch '86 N= 93	US '86 N= 70	Italy '86 N= 236		
	%	%	%	%	Chi-Square (D.F.=3)	*p*
Tops						
Oval	3.0	20.4	14.5	17.8	5.8	>.05
Cloud	3.0	51.1	60.9	40.9	33.3	<.001
Scribble	0.0	1.1	11.6	2.1	18.7	<.001
Other	93.8	28.3	11.6	35.2	69.3	<.001
Trunks						
Rectangle	54.5	56.5	29.0	36.4	17.8	<.001
Flare	42.4	41.9	68.6	63.1	18.9	<.001
Other	6.1	2.2	2.9	0.8	4.9	>.05
Roots						
Linear	6.1	3.3	2.9	3.8	0.7	>.05
Fused	3.0	3.3	2.9	2.1	0.4	>.05
Branches						
Horizontal	39.4	8.6	15.9	10.2	24.0	<.001
Downward	9.1	11.8	5.8	4.2	6.8	>.05
Upward	66.7	15.2	18.8	54.2	65.3	<.001
Linear	51.5	4.3	30.4	72.9	136.7	<.001
Radial	51.5	3.3	14.5	29.8	43.9	<.001
Fused	3.0	8.7	13.0	28.0	25.1	<.001
Secondary	45.5	6.5	30.4	51.5	59.3	<.001
Tertiary	21.2	12.0	11.6	33.9	25.4	<.001
Apples						
Floating	30.3	41.9	60.9	42.0	10.7	<.01
Stemmed	72.7	62.0	44.3	62.7	10.3	<.01
Clusters	6.1	1.1	2.9	1.7	3.4	>.05
Leaves						
Individual	87.9	2.2	33.3	64.8	131.1	<.001
Absent	12.2	97.8	67.1	33.6	137.4	<.001

groups and many of the children in the Dutch 1937 and the Italian 1986 groups combined a number of these schematic possibilities to form their trees. It was as if they had learned schemata for representing the tops and branches of trees from several different structural systems and had inventively combined schemata from various systems with little regard for their lack of correspondence to the structure of trees in the natural world. Some of the differences among the groups were as follows.

Group profiles: Dutch 1937
This group of children used the greatest number and the greatest variety of schemata to represent the branches and the contours of the tops of trees. Their use of three schemata – horizontal branches mounted perpendicularly to the trunks of trees, branches in radial patterns emerging from an axis near the tops of tree trunks, and the delineation of

individual leaves – distinguished their trees from those of the other groups (Figs. 29 and 30). Trees drawn in this manner, besides trees with radial patterns, can be seen in the plates in Kerschensteiner's book published in 1905 [10]. It is the use of these two schemata for trees that give their drawings the appearance of a style that is closer in some ways to turn of the century drawings than to the children's drawings of the 1980s.

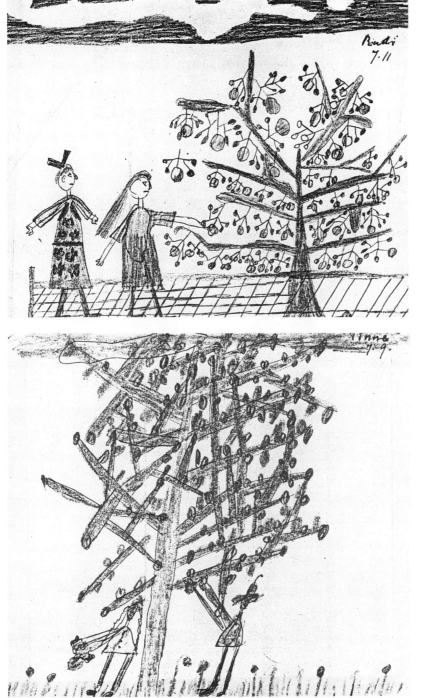

29, 30 Dutch children's drawings, 1937.

Dutch 1986

Nearly all of the Dutch children in 1986 drew the tops of their trees by making little cloud-like clusters of undifferentiated leaves (Figs. 31 and 32). Many also combined these clusters with a generalised cloud-like form to represent the entire top of a tree. It is notable that very few of the Dutch children's drawings from 1937 have these features.

31, 32 Dutch children's drawings, 1986.

Italian 1986

When we considered the tree in its entirety it was the Italian children who made the most consistent use of all of the schemata in our classification system. They made the tops of their trees with oval and cloud contours with a frequency similar to the 1986 Dutch and the American children. Their use of secondary branches and branches mounted on the baseline formed by the top of the tree trunk was similar to the Dutch drawings of 1937. They drew even more tertiary branches than the Dutch children of 1937. Their drawings contain more radial patterns, and many more individual leaves than either the 1986 Dutch or the American Drawings. Their more frequent use of 'V' and 'U' shaped branches fused to the trunks of trees is indicative of a higher degree of visual realism than is found in the drawings of any of the other groups.

American 1986

In their use of tree schemata the American children were generally closer to the Dutch 1986 group than to either the Italian group or the Dutch 1937 group. Only one feature, the tree top formed with a scribble, sets these children apart from the other groups of children.

Patterns of difference

The patterns of difference found among the few groups were especially interesting. Some of the schemata for depicting trees used with regularity in one of the groups was virtually absent from the tree drawings in other groups. Moreover, the ratio of tree schemata differed greatly among the groups. When the outliers were analysed (the group or groups that made the greatest or least use of a schema or sub-schema) the 1937 Dutch children's drawings were found to be the least like the drawings of the other three groups [11]. In four other instances the 1937 Dutch drawings and the Italian drawings were the outliers (always with the highest scores). Thus for 12 of the 16 instances in which significant differences were found, the 1937 Dutch children contributed most to those differences.

Perhaps the most surprising finding of our study was the dissimilarity between the Dutch children's drawings of 1937 and 1986. In only two instances were the Dutch 1937 and the Dutch 1986 drawings found to share essentially similar patterns of configuration usage – both in the depiction of trunks of trees. Even the 1986 Italian children and the 1937 Dutch children employed similar schemata more frequently than the two groups of Dutch children. Children from the United States were found in the outlier position only once – for their scribbled tree tops.

Discussion

What is it about this factor of time that might account for the differences in the children's drawings? How might the 1986 differences among the children in the three countries be explained? At the outset we posed questions relating to whether the schemata found in Dutch children's drawings created in 1937 and 1986 were essentially alike and whether

Dutch children's drawings created in 1986 have a greater affinity to drawings of American and Italian children than to the Dutch children's drawings of 1937. Our assumptions were that if there were regular patterns of difference in the schemata employed by the four groups, then those differences should be attributed to factors relating to the two different time periods and to the different cultures in which the children created their drawings.

In other words, we assumed that the schemata used to draw trees were not created by these particular children, but that they were merely adopted and modified by them. We found that despite the cultural differences between the Dutch, Italian, and American children, their 1986 drawings have a greater similarity to one another than to the Dutch children's 1937 drawings. How might we explain our findings? What changes in art educational practices, societal and cultural differences among the children, and a half century of societal and cultural changes within the Netherlands, might account for the patterns of difference and similarity?

There are at least four possible explanations for the differences in schemata, (i) *task administration* – differences in the manner in which the drawing task was presented to the four different groups of children accounted for the differences in their drawings, (ii) *art education* – the school-based art instructional programmes and practices of the different countries and differences in art instruction in the Netherlands in 1937 and 1986 accounted for the differences in the drawings; (iii) *available schemata* – in the Netherlands in 1937, and in Italy, America, and the Netherlands in 1986 there were differences in the graphic configurations or schemata available from which drawings of trees might be composed; and (iv) *implicit reinforcement* – although essentially the same graphic schemata that might be used for drawing trees were available in the three countries during the two time periods, the use of some tree schemata were systematically, albeit implicitly, reinforced while others were not.

Task administration

We must assume that there were differences in the way the task was administered. The primary difference would probably have been between the 1937 and the 1986 administrations, since in 1986 all the administrators followed the same script, albeit in different languages. We do not know what script was followed in 1937. We think, however, that the Dutch teachers who were adherents of Cizek's philosophy of creative expression would not have asked their children to draw trees of a particular shape; to make branches in a radial pattern, or to draw limbs perpendicular to a central trunk. In short, we think that few of the differences in the tree schemata can be attributed to the differences in administration.

Art education

The 1937 Dutch children's drawings appear to be much more highly detailed than the drawings of the other three groups. This is particularly the case when we examine such things as the delineation of individual leaves. The amount of detail and the amount of care taken by children in

84

producing drawings is affected by patterns of expectation established by their art teachers. Art teachers, in turn, generally respond to sets of social and educational expectations regarding how art ought to be taught [12]. If teachers expect children to draw carefully and show lots of detail, and if sufficient time is permitted for such activities, it will be reflected in the drawings.

We think that the Dutch children's drawings of 1937 reflect a more systematic approach to the teaching of art than is found in the Netherlands and the United States today. Certainly it is the case that the Dutch teachers in 1937 who were associated with H9 had a professional education in art and art education, they were deeply interested in art instruction, and they met frequently to talk about child art and ways to improve their teaching of art. The 1986 Dutch children's drawings were collected in classrooms where the teachers were generalists who had not received a professional education in art. Moreover, the 1937 assignment given to the children was a part of a carefully structured art programme; the task presented to the American, Italian, and Dutch children was an assignment isolated from the art programmes of the schools.

Of course we can only speculate about the effects of particular approaches to art instruction. There is virtually no research that reports the long-term effect on children's drawings resulting from different systematically applied approaches to art teaching. There are studies waiting to be undertaken, but for now we cannot discount the possibility that the Dutch art instructional practices of 1937, which appear to be more systematic than those practised today, affected the manner in which children employed schemata in their drawings.

Available schemata
Did some groups of children possess schemata for trees that others did not? The 1937 Dutch children did not form tree tops with scribbles. This is the only instance, however, in which a particular graphic configuration was not employed by at least a few children in each of the groups. We can be quite certain, however, that the scribble was present in the Netherlands in 1937 since the scribble appears to be a universal configuration. So why did the 1937 Dutch children not use the configuration? It is possible to speculate that the highly detailed angular and linear trees drawn by the Dutch children in 1937 would make the casual and ambiguous scribble seem highly inappropriate as a way to draw tree tops.

There are other factors relating to available schemata that might explain the difference in tree drawing among the different groups of children. Children's graphic schemata may be influenced by the illustrations in children's books and by television. Illustrators and animators sometimes derive their schemata from the drawings of children. Consequently, in illustrated books and cartoons it is possible to see lollipop trees – sometimes represented in a more regular and more highly schematised fashion than children themselves would produce. It is ironic that these schematically simple images that were originally derived from children may return to children as second-hand models

that push today's children's tree drawings towards increasingly higher degrees of simplicity and regularity.

The Italian children's tree drawings exhibited the greatest variety of schemata. Our data do not tell us why this is so, but an inspection of the Italian children's drawings reveals that in a single tree a child might draw a tree top with an oval or cloud form, inside that form draw the highly structured branches similar to those found in the drawings of the 1937 Dutch children, and then attach more branches to the tree trunk below the oval or cloud form. It was as if the Italian children lived in graphic worlds similar to both the Dutch children of 1937 and 1986 and that they combined in a freewheeling manner the generous supply of tree configurations from both of those worlds. Their mongrel trees sometimes had very little relationship to the trees of the natural world, but drawings of trees come from drawings of trees not from 'natural' trees.

Implicit reinforcement

Despite the fact that many of the same sub-schemata and ways of ordering them into tree schemata appeared in each of the samples, our data still appear to reinforce the notion that child art is socially constructed. Differing ratios of sub-configurations were used and they were related to one another differently. Furthermore the trees appeared to be stylistically dissimilar, especially those done in 1937 and 1986.

We think that the children drew trees of a particular style primarily because they observed other children drawing trees in a similar manner – they learned to depict trees in the style employed by their peers. In other investigations it has been shown that schemata such as round or rectangular torsos and ways of attaching necks and limbs to bodies show definite cultural patterns [13].

As we have already noted, the way in which the Dutch children of 1937 drew tree branches in radial patterns and mounted limbs that were perpendicular to the trunks of trees is closely related to features found in European children's drawings at the turn of the century – especially those presented by Kerschensteiner in 1905. It appears that there were fewer intervening graphic factors in Europe between 1905 and 1937 than there were between 1937 and 1986.

Conclusion

Is there any significance to our findings? Obviously there are many satisfying ways that trees might be drawn. A realistically drawn tree may be aesthetically much less satisfying than a tree composed entirely of shapes ordered at right angles – one that fulfils a child's intuitive sense of order. There may be nothing implicitly more valuable about a tree with scores of overlapping branches and hundreds of apples that may have taken an hour or more to draw, than another tree with a top that a child has scribbled in a few seconds. But the exquisite lacy quality of the 1937 Dutch children's trees makes us wonder if something might be missing from art education today that may have been present in the art instruction of 1937.

It is doubtful that the Dutch teachers of 1937 imposed a particular set of tree configurations on their children any more than the 1980s Dutch, American, and Italian teachers did. The particular configurations in the 1937 Dutch children's trees seem to be the products of a style prevalent among European children at the time. But it also seems apparent that the Dutch teachers of 1937 were able to instil a sense of discipline and of craftsmanship in drawing that is generally absent in the drawings of the other groups of children in our sample. The drawings of the 1937 Dutch children seem to reveal that their teachers combined a love of children's graphic imagery with a sense of pride in the creation of drawings that are rich in detail and complexity. The 1937 Dutch teachers may have taken delight in the images that they assumed to be the products of the natural flowering of children's creative capacities, but they also had high expectations for their students.

The H9 teachers probably encouraged children to create elaborate drawings (although it is doubtful that they would have recognised that the schemata their students used were derived from those of other children). Today's teachers seem to have taken the *laissez-faire* approach to art instruction to such an extreme that it may actually handicap students. When virtually every 1937 Dutch child's tree is filled with leaves and virtually every 1986 Dutch tree is without leaves, it may be possible to conclude that the earlier Dutch children not only depicted more, they may also have learned more through the act of drawing than their counterparts learn today.

We have pointed to some of the differences in children's tree drawings that seem to have been affected by the passage of time and differences in culture and educational practice. We have speculated about some of the reasons for the differences found among the four groups of drawings. Our study, however, may do little more than point to the enormous task involved in unravelling the full range of conditions that affect the depiction of even a single object in the drawing of a child.

Notes and References

1 This dialogue may be found in MILLER J. (1983), 'Psychological aspects of the visual arts: dialogue with Ernst Gombrich', in MILLER J. (1983), *States of Mind* (New York, Pantheon Books), pp. 219–20. See also GOMBRICH E. H. (1965), *Art and Illusion* (New York, Bollingen Foundation).

2 WILSON B. and M. WILSON (1981), 'The case of the disappearing two-eyed profile; or how little children influence the drawings of little children', *Review of Research in Visual Arts Education*, 15, pp. 1–18; WILSON B. and M. WILSON (1984), 'Children's drawings in Egypt: cultural style acquisition as graphic development', *Visual Arts Research*, 10, 1, pp. 13–2; WILSON B. and M. WILSON (1987), 'Pictorial composition and narrative structure: themes and the creation of meaning in the drawings of Egyptian and Japanese children', *Visual Arts Research*, X, 1, pp. 10–21.

3 The sets of tiny drawings are on permanent loan to the Tilburg Academy for Art Education and to other Dutch art academies from the widow of H9 member van Koppenhagen. For further information see VAN RHEEDEN (1980) (n.5 below).

4 MEREMA B. (1939), *Levensontplooiing in vorm en kleur: 9 tot en met 13* (S-Gravenhage, Joh D Scherft).

5 VAN RHEEDEN H. (1980) 'Van nabootsing tot uitdrukking', in KOEVOETS B. and H. VAN RHEEDEN (eds), *Geen dag zonder lijn* (Haarlem, Fibula-Van Dishoek).

6 *Ibid.*, pp. 49–52.

7 The 1937 group were from Hyacintweg B Elementary School in the Hague. The Dutch 1986 group consisted of 17 children from Deken van Hout Elementary School in Asten; 24 children from Lambertus Elementary School in Breda; 27 children from Centrum Elementary School in Tilburg, and 25 children from De Willibrordus in Deurne; the American group consisted of 49 children from Fairmount Elementary School in the town of State College, Pennsylvania, and 21 from Yeshiva, an Orthodox Hebrew school in Pittsburgh, Pennsylvania; in the Italian group 93 of the children came from Foggia, 60 from Bari, and 84 from Rome.

8 We wish especially to thank Pia M. Salvatori who collected the drawings from the American children and arranged for the collection of the Italian children's drawings. Some of the data presented in this paper were also included in Ms Salvatori's honours thesis: Style in the Tree Drawings of American, Dutch and Italian Children, Pennsylvania State University, 1986.

9 We used four classifications to characterise the contour of the upper part of the tree, (i) a 'lollipop-like' circle or oval; (ii) an implicit circle or oval shape formed with arcs to produce a cloud-like tree top; (iii) a tree top formed by scribbled lines; and (iv) other shapes or trees whose tops were not formed by a generalised shape to indicate the contour. There were three classifications for tree trunks, (i) a rectangular shape with no flaring at either the top or bottom; (ii) two essentially parallel lines with an outward flare at either the top or the bottom; and (iii) other tree trunks such as those formed by a single line or two parallel lines that are not closed at either the top or the bottom. We looked at two systems the children used to draw roots, (i) a series of lines added to the flat bottom of a trunk; and (ii) roots that appear to be fused to the bottom of the trunk. We used the greatest number of classifications for branches, (i) horizontal branches – those that are perpendicular to the trunk; (ii) branches that slope downward from a trunk; (iii) branches that slope upward from a trunk; (iv) branches that form a radial pattern with the centre of the radial beginning at the top of the trunk; (v) branches, usually single lines, that emerge from a baseline formed by the top of the trunk; (vi) somewhat organically-appearing 'Y' and 'V' shaped branch configurations that emerge from the trunk; (vii) secondary branches that are attached to primary branches; and (viii) tertiary branches that are attached to secondary branches. There were three classifications for the manner in which children depicted apples, (i) apples that appear to be floating or with no stem attached; (ii) apples with a single stem; and (iii) apples clustered in groups of three or more with stems joined at a common axis. Finally, there were two classifications for leaves, (i) leaves drawn individually; and (ii) the presence of leaves indicated by the depiction of little clumps or cloud-like forms that appear to represent clusters of leaves, or trees with oval, cloud, or scribble tops with no individual leaves depicted.

10 KERSCHENSTEINER G. (1905), *Die Entwickelung der Zeichnerischen Begabung* (Munich, Druck und Verlag von Carl Gerber), pp. 196–205.

11 In five instances the 1937 Dutch children used one of the specific schemata more frequently than children in the other groups and in three instances they used schemata least frequently.

12 For example, in Japan children frequently work at their paintings for four and sometimes eight class periods, whereas children in the United States might take only one class period to complete a painting. The result is that Japanese children's school art is generally much more highly detailed, more carefully produced, more technically advanced, and more carefully observed.

13 WILSON and WILSON (1984) (n.2).

Chapter Eight

LESLIE PERRY Towards a Definition of Drawing

Drawing is taken to be an activity which is completed when its product is complete. This product is also known by the same word, 'drawing'. The observations made here come accordingly from a scrutiny of the product and also observation of the persons (including the writer) engaged in the activity of drawing. No drawing should ever be regarded as fully judged unless both the drawing as outcome and the preceding activity have been appraised, whenever the teaching and learning of drawing is involved.

Two varieties of drawing can be detected at the outset. One is drawing instrumental to preplanned aims, whilst the other – usually called free, creative, creative play, and the like – does not start from prior aims to be attained, but builds them up in the course of and along with carrying out the activity. So in the case of creative drawing, the aims are only discerned at the end of the activity. Thus whereas the first-mentioned kind of drawing deals extensively with cognitive thinking-out as something both preceding and concomitant with the activity, the second dispenses with an *a priori* cognitive approach but uses cognitive states of mind at will, building them in as necessary whilst the activity goes on, or even using them on occasion in an extremely peripheral way.

Pauses occur in the course of both kinds of drawing activity, but the first kind, which is here called 'representational', uses those pauses for cognitively guided assessment, whilst the second kind of drawing, here called 'creative', contemplates the current drawing activity during a pause, in terms of the feeling states and attitudes that the drawing is at that point capable of arousing in the mind, and then taking guidance from what has been felt. In creative drawing, it is a mistake to think of cognition as entirely absent, though it may be very passive. Likewise in representational drawing it is a comparable mistake to think of feeling-states as entirely absent, though they too may be passive. In no case (contrary to what has been urged by some writers) should emotions be thought to obstruct the activity, though their role may bring it to a stop, as may also apply to the role of cognition [1].

Pauses are an essential part of the drawing activity, indeed, of all activity. They are constantly needed for the continued activity in both varieties of drawing. They arise from a decision either to finish altogether (which ushers in the final product) or to finish for the time being (in which case a product is available but not submitted for spectator judgment, appraisal or assessment). So far as teaching and learning of drawing is concerned, no final judgment for interim products should ever be confused with that for the final product, because it will damage the progress of the learner and misinterpret his or her position.

Representational drawing utilises all perceptual conventions of a visual kind, including standard signs and symbols as used in any culture. These have to be regularly and systematically learnt. This side of drawing activity is concerned with a well-known and well-understood traditional activity, with systematically applied rules for its outcome.

However, the creative type of drawing, which does not issue in a routine manner from high cognitive mental loading and prior experience saturation, has other consequences than those mentioned. It is marked by a mental condition in which feeling states and attitudes are deliberately freed from cognitive guidance and instead are allowed free movement, a decisively different state of mind. Why this should be so is commented on later.

Drawing is an activity which produces a great variety of outcomes. It is making marks on a surface, with or without line, with or without colour, with or without black and white, with tools and selected surfaces or dispensing with them, with or without prior aim and purpose. It shades off, with no clear distinction, into painting, low-relief carving, etching, computer graphics, and many other activities in science and engineering. It is not, as has been urged, a more intellectual activity than, say painting: such a view arises from the fallacy that greater economy of expression will necessarily result in a more abstract product. It is not, in its creative mode, a preparation for something else, though it may subsequently be so used, as is often the case with representational drawing. The pleasure of doing things really well, even of attracting an aesthetic response, is not absent from representational drawing. But when we speak of plans, diagrams, preliminary sketches, written language (a highly conventionalised form of drawing) then representational drawing is clearly being used instrumentally.

Drawings as instrumental preparatory products should not be judged according to general drawing criteria. Each variety of drawing will bring with it the necessity to find different or sometimes additional criteria for judgment.

Representational drawing undoubtedly continues to feature strongly in the curricula of schools, though the so-called 'creative subjects' provide considerable opportunities for creative drawing. In art the latter is often treated as the principal form of drawing, with representational drawing as a mere prelude to it. This latter view is unsound: the two modes of drawing, as will be later discussed, are reciprocally essential.

Provisions for training in drawing may be described as slight. Most curriculum subjects dealing in representational drawing accept no responsibility whatever for training in it. The crucial importance of good drawing for many subjects and the total neglect of its training, results in technical courses in engineering and architectural drawing, for instance, having to be provided in post-school education, when the foundation has to be laid. The resulting loss of time for design and technology may well hold back the development of those areas in schools. It is a situation analogous to assuming that we should 'pick up' reading and writing whilst studying other things, and therefore training can be dispensed with. Drawing probably is not used instrumentally as much as it might

be in many educational areas because of this lack of training provision. The one subject with this concern is art, which has a kind of informal aegis for training. But here many teachers all too frequently concentrate upon creative training and neglect the representational underpinning. Training of both kinds ought to proceed together step by step with a full observation of their interaction.

The choosing of an object or objects to draw makes of them a Subject to draw. This sets up a situation for drawing in terms of standard perception of recognisable and known objects. By this is meant that they have already been categorised by the conceptual-perceptual activity of the mind. So the student is – when a Subject is given or set up – working in terms of standard known material, already learnt in perception. The result of this procedure is to produce intense observation and highly focused attention on the Subject group of objects. This is often called (erroneously in my view) training of perception, but is more suitably seen as a time for concentrated observation and attention such as occurs in all subject matter when very intense mental focusing is apposite. It is neither necessary nor desirable to memorise the subject of a drawing: there is no evidence that this will improve it. What this procedure does do however, is to augment the ability to draw things as they are in standard perception, by learning the observations and the concomitant physical movements of the hand that accompany the work.

But creative drawing does not stand in the same relationship to the Subject-Object process. For here the Subject-Object is whatever attracts the attention of the person drawing. It 'chooses itself' by which is meant that the suspension of normal cognitively loaded choosing leaves the attention free for the guidance of feeling-states. Creative drawing may then cognitively reinforce a choice or reject it, or cognitive activity may even be left aside completely. Creative drawing is concerned with exploring what drawing will do and what it will suggest to both percep- tion and cognition. Such uncommitted states of mind occur very widely outside drawing concerns, and are in no way unusual. They provide the opportunity for creative decision.

The intent of the individual drawing creatively is to explore imagery turning up on the working surface, and to play with the various ways in which it might be developed. Some of the richest things in adult life happen in the course of play, and this is one. But adults, curiously enough, seem to think that it is all right only for children, and belongs to the childish things which St Paul wants us to put away. Nothing is less true for creative living. There is a whole conventionalised world on which to work – written language, gestures, public post-verbal signs of all kinds and, in building, the modified ruins of past intentions, and the like. Creative drawing is involved with the question: What happens if you partially or wholly break the standard perceptual conventions and assigned meanings? Then you move into a private world built by the draughtsman or woman and intelligible to the spectator only to the extent that the draughtsman or woman supplies clues. And he or she often does, either by starting from partial acceptance of conventional- ised meanings for what he or she perceives, which act as a bridge for the

labouring mind trying to understand the drawing, or by resort to language (as discussed below). But the draughtsman or woman may refuse all cues or bridges and leave the spectator to struggle with the meaning of the drawing, because he or she wants the spectator, saturated with conventional meaning, to do some new perceptual work. Creative work thus supplements conception and perception. But to break into a conventionalised area like conventional drawing, it has to be tough and oblige the spectator to work. This often results in a very lukewarm welcome from the layman or woman for creative drawing.

Drawing can provide a complete alternative to the use of language (a relatively unexplored research area) or it may supplement or support language when language is acting (as it usually does) as the principal means of communication. Language in this role is usually supported by other means to achieve full communication. Images, observation of gestures, accompanying sounds, are all built into the total offering available for communication. Drawing often has a powerful role here, not, as is often thought, as a supplementary activity, but as a necessary condition for achieving full communication. This is particularly true of representational drawing, hence my insistence upon thorough training in how to draw. The case for that can indeed be made without recourse to art and creative drawing.

In both representational and most particularly creative drawing, the intention of the draughtsman or woman can sometimes be made more explicit by the use of language to guide the spectator. Hence titles. Spectators are very dependent upon supportive language. Some titles 'repeat' the drawing, others are allusive or judgmental. But in creative work the situation is more complicated. There, the title can guide the spectator, but at the price of cognitive leads in thought, because language is saturated with prior cognitive experience (and one of the main struggles of the poet is to shed a great deal of this in the course of writing). Now, creative draughtsmen or women quite often do not wish to give cognitive help, and so they will lead the spectator up the wrong path (as in Dada) or give perversely tantalising titles (Klee) or bawl slogans to enthuse the spectator (Futurism) or positively bulge with significant concealed meaning (Pollock). They are not entirely perverse in this: creative drawing must avoid unwanted cognition of a conventional kind.

In teaching, titles should not be neglected (children are often very intent upon them) but should be discussed. All of this is no way impugns the right of the spectator to ignore the draughtsman or woman completely, including his or her title, and to develop a spectator reaction based on neither knowing nor caring what the draughtsman or woman wanted, except as an additional point of interest. But large numbers of spectators do wish to have what support language can give. If the draughtsman or woman thinks and creates in terms of prior titles (not at all unknown) he or she should carefully examine what the resort to language is doing to the understanding of the drawing.

Much representational drawing for pupils and students has no aesthetic intention. Even in art work, it can be absent, and replaced by

craft standards, the desire for extreme accuracy, the joy of dominating the surface, or interest in 'telling' the spectator all about the subject chosen (very frequent in schools). But what is more surprising is that creative drawing also has no necessary connection with aesthetic intention or the attempt to attract aesthetic judgment. That is, to be creative does not as a necessary condition carry any aesthetic ambitions on the part of the draughtsman or woman. This arises because creative activity is in no way tied to aesthetics, though aesthetic and many other intentions are compatible with creative work. It follows (a very important point) that a drawing should not be regarded as a failure because it does not elicit an aesthetic judgment from the spectator or assessor. The assessor is only a special kind of spectator who should examine exactly what kind of drawing is presented, but must pay careful attention to the aim and attitude of the draughtsman or woman, judging as one criterion whether that aim was realised. Drawing is much more than the exclusive purview of aesthetic judgments, though for many the drawings we love most may lie in that area. In these, the act of drawing, the suggestibility of the surface, the drawing implement, one's own fingers (as is said of Titian) a whole personal history of perceived imagery, may warm 'the feeling states' into action.

Imagination is part of a terminology for describing the kind of mind that we have: the total list (or rather lists) includes cognition, motivation, intention, feelings, attitudes, emotions, drives, and many more, and a whole group of aims, purposes, objectives, goals, and the rest. The role usually assigned to the imagination in all this is to explore possible alternatives to the world as we find it, ranging from the modification of routine conventional detail – such as 'imagine a car hitting this wall at 30 m.p.h.', or 'let X equal a number greater than the square of 27' – to the creation, as Elliott has said [2], of a new world in contrast to the one we have (a notion underlying many accounts of Utopias). Piaget [3] saw it as a means of conceiving the future (an ultimately evolutionary line of explanation) as if our only preoccupation were shrewd and deft planning. This gives rise to a 'luxury' use of the imagination as fantasy, daydreaming, watching TV thrillers. But imagination has a job of a specific kind to do in fantasy and daydreaming (as Freud has made clear [4]).

Representational drawing is a long training in the standard perceptual-conceptual nexus, in terms of which we handle the physical world and the social construct that each culture interlaces with its physical environment. The distinction between fantasy and reality is unceasingly worked at by the imagination, and constantly modified by it, made sharper and more precise. Not only is it busy in representational drawing, but it partakes heavily in guiding creative drawing, where it does not float whither it listeth, like dandelion seeds, but is much more specific and 'navigatory'. The eliciting and training of imagination is a valuable part of the training given to us by drawing.

The remarks on imagination do not include 'imaging', a word used in the National Curriculum report on Design and Technology. The use of this word, in engineering and management, fails to face the unresolved

theoretical position which its use covers. Imaging used in connection with drawing must deal in a special type of thinking or other mental activity. It appears here that normal cognitive thinking, with its logical and verbal underpinning, is being supplemented by some special use of an image. The nearest to this is the image-based type of thinking which precedes, in the theory of Piaget, the development of the hypothetico-deductive type of thinking. However, in art and design, it is clear that mental images play a vigorous and constant role, and certainly the mental activity going on is not solely hypothetico-deductive in character. And if not, image-based thinking is a state of mind co-existent permanently with hypothetico-deductive thinking, and it should be trained, like cognitive mental processes, alongside the more cognitive type. I do not believe that this image-based thinking is superseded by hypothetico-deductive thinking nor incorporated into it. This opinion has the implication that the more abstract logical type of thinking has to be supplemented by image-based thinking in certain pursuits such as drawing, and that such abstract thought has a less wide purview than has formerly been assumed. I am not of course trying to maintain that abstract and logical thinking is absent from all drawing, indeed I have accepted the contrary. But it cannot totally account for the practice, training and problems of drawing, unless the very prominent role of imagery in such work gives a clear theoretical backing to 'imaging'.

The relationship between drawing and design is such that design is an aspect of any drawing, irrespective of whether the draughtsman or woman intended it or not. In this sense it is a judgment, comparable to aesthetic judgment and often included in an aesthetic judgment, but not always. That is to say, not all design involves (perforce) aesthetic judgment, though it can be made into a judgment of function and structure. Aesthetic judgments can always arise here or anywhere else where they were neither invited nor desired! But in the sense of designing, the draughtsman or woman is motivated to stress the design aspect of the drawing and hopes to attract a favourable judgment and often an aesthetic one. (Design also occurs in the natural scene or 'artificial' social environment, where no deliberate attention has been paid to it.)

Where design is not to be seen (in some inner part of an engineering structure, say) purely practical considerations may dominate, and this will appear in the representational drawing, if any, made prior to the structure, and often used then for greater clarification of the problems involved. The present pressure for training and education in design relates to a particular situation, where it is argued that in order to sell a product you must produce an attractive design. Nothing at that time is said about the preceding activity. All we are concerned with is the look of the final product. Many think this is where training in design drawing should concentrate. However, the matter is not quite so simple. The disquiet about the state of design in drawing and making has not adequately analysed the sources of such disquiet. These arise from an over-concentration upon purely structural considerations governed by the materials used and their properties. This leads to an effort to apply 'good' design to a structural situation already set up and complete.

Good design starts, on the contrary, at the beginning of practical activity, and cannot be rammed on to the set up situation at the end, as many industries have learned to their cost. An awareness of design, and a cultivated sensitive judgment of it by constant observation of the progress of the whole work, are started at the beginning, which is the level of preparatory drawing, and continued throughout. The way to train pupils in the art of supportive drawing is to ensure that a drawing is not to be laid aside unmodified after the preliminary stages, but amended step by step during the work.

The judgment of such drawings is complex. Criteria for judgment ought to include the functional efficiency of what is offered, as well as appearance. The attractive is not, however, always and automatically the aesthetic. There are fashions of judgment which may dominate the aesthetic area, though those fashions often arise for social reasons that can be very distant from aesthetic emphasis. Certainly, training in the cultivation of an alert and sensitive aesthetic judgment of the product in the making is a great help. But it does not go all the way as an explanation of what will sell. The aesthetic has to be reconciled to the prevailing and fashionable social climate and, whilst education in design is very worthy, customers will not be induced to buy aesthetic things in place of what they like. Education in design, when it applies to the general public, has to be a slow, subtle and indirect affair. And this is an area worthy of specially oriented teaching.

The exact place in which design emerges will be in the pauses occurring in the continuing activity for which the drawings prepare and thereafter accompany. For it is a judgment of the whole and the relating together of its parts. An aesthetic judgment *en route* will exert a steady pressure upon the product and contribute to the moulding of its future shape and structure, and the supportive drawing should be modified step by step to record that progress. Clearly this is a good case of drawing in an ancillary role. But since it is design that we are hunting for it is the overall relationship that we watch whilst keeping in mind the practical pressures. The contribution from art teaching and training on this side is sustained attention to the aesthetic aspect of design. And it trains pupils by taking this out of the industrial context of application, and sets design in a free creative context, for which no practical context or use is proposed. This enables the student to have a full experience of using aesthetic feeling-states to guide the judgment. But art teaching would profit by much more intensive training of the student in design judgment, and by discussion of what happens to a free creative design judgment when it is placed in an instrumental and practical setting, with the accompanying problems. This type of 'applied' and not 'pure' design teaching ought to be very specific.

I should like to comment further upon my main distinction – that between representational and creative activity in drawing. This distinction of course affects the whole curriculum. The educational undertaking tries to do two things here in the Western, and many other, cultures. Between these two there is a tension which comes out typically in drawing and the problems of art and design. Our concern is to initiate

students into a cultural tradition, with all its ways and usages and its cognitive and conceptual procedures. And this is as complete in matters of art and design and drawing as it is everywhere else. As Oakeshott has pointed out [5], we mature and understand things in the presence of a strong continuous tradition. Initiation into the varieties of human activity and the resulting accumulation of knowledge and experience, requires of the teacher a thorough grounding of the rising generation, whether in school or out of it. But cultural ways and traditions undergo constant change, and that change must be prepared for and faced by newcomers into the tradition. Such change can happen quite rapidly as well as more gradually. Tradition always struggles to include change by modification, but regularly also entirely refuses to do so. Drawing is not free from this: anyone studying the history of drawing assessment from the days of the Ministry of Education's drawing examination will soon notice the tell-tale fashions of assessment.

My suggestion is that two kinds of drawing are found; the one, which is the representational, carries the responsibility of initiating the tradition, whilst the other, the creative, caters for modification and repudiation of tradition, both minor and major. It is built into the educational system and rightly so: creative work is not some luxury provided as a bonus for the delectation of students, but an essential and regular part of the procedure for tackling change. Creativity is the standard habit breaker, a point well grasped by Dewey [6].

Creative work engenders a type of drawing which must respond to different criteria, because those criteria are in the course of being set up during the work, and cannot be left out of any conscientious assessment. Once established and accepted, or partly so, these creative changes form part of the growth of a tradition of drawing, and in due course come up for change themselves. The creative introduces and fights for change; the routine and representative consolidates and explores the accepted change.

Creativity and its products are here treated as a universal aspect of the mind, not as a rare visit from the stars. People differ in the degree to which they use creative and routine states of mind: routine and cognitive activity is a great refuge from change for all sorts of children and adults too. Progressive education, by overrating creative work, brought about the formless sprawl which can happen if routine work is underestimated. Formal instruction, posing as a complete education, brings about the barren routine framework which denies that any change can be suitably accepted from the results of creative work. So the heart of the matter is this: out of the tension between creative and representational drawing comes fertile change. And a similar comment applies all over the curriculum and the learning process.

I have ranged widely over the concept of drawing and have no compact definition to offer. It is no easier to define drawing than to define written and spoken language. Both modes of human activity carry an enormous responsibility for transmitting cultural tradition; a closer investigation of their intrinsic and their joint communicative power would be well worthwhile in research. But definition, which is a tool on

the way to enquiry, is not available in any comprehensive way, and, as Sir Karl Popper [7] once remarked to me, in such a case it is wiser to halt at description, and not impose on the investigation an exactitude which it is not in a condition to bear. But the creative use of these communicative and expressive media always results in further proof of their enormous fertility and resource, and makes a case in learning for the fundamental and basic role of drawing, both for itself and alongside language.

Notes and References

1 For a discussion of the emotions see PETERS R. S. (1974), *Psychology and Ethical Development* (London); DUNLOP F. (1984), *The Education of Feeling and Emotion* (London, Allen & Unwin); BEST D. (1985), *Feeling and Reason in the Arts* (London, Allen & Unwin).
2 See ELLIOTT R. K. (1974), 'Love of one's subject, and the love of truth', *Proceedings of the Philosophy of Education Society*, 8, January, pp. 135–53.
3 PIAGET J. (1973), *Structuralism* (London, Routledge & Kegan Paul), Chapter IV.
4 FREUD S. (1976), *Introductory and New Introductory Lectures on Psychoanalysis* (Harmondsworth, Penguin).
5 OAKESHOTT M. J. (1933 [66]), *Experience and its Modes* (Cambridge University Press); OAKESHOTT M. J. (1962), *Rationalism in Politics and Other Essays* (London, Methuen).
6 DEWEY J. (1961), *Democracy and Education* (London, Macmillan); DEWEY J. (1975), *Interest and Effort in Education* (South Illinois University Press).
7 See POPPER K. R. (1976), *Unended Quest* (Glasgow, Fontana).

Bibliography

COLLINGWOOD R. G. (1974), *Principles of Art* (Oxford University Press).
GHISELIN B. (ed) (1952), *The Creative Process* (Cal., Mentor Books).
HESPERS J. (1969), *Introductory Readings in Aesthetics* (NY, Macmillan).
OSBORNE H. (1972), *Aesthetics* (Oxford University Press).

Chapter Nine

STEVEN GARNER The Undervalued Role of Drawing in Design

In recent years the spectrum of activities that comprise 'designing' have come under the scrutiny of educationalists. However the relationship between drawing and designing has been sadly neglected. This chapter highlights the functions of drawing for a wide range of people engaged in design activities. It focuses on the undervalued potential of drawing within exploratory and manipulative aspects of designing, and highlights a number of drawing strategies within the design process.

The demands for clarification and development of the role of drawing within design have long been voiced but very rarely met. In *Design Magazine* in 1979 Phil Gray, then design group manager of Loughborough Consultants noted:

> the skill of drawing is so low on the list of priorities in design
> education that people now have to be reminded that drawing is,
> after all, a fundamental element in the design activity [1].

Colin Tipping echoed this view, stating that a fluent sketching ability is:

> the single most important factor in developing any general
> design ability [2].

Evidence of research or analysis into the importance of this activity is, however, thin on the ground. It was as long ago as 1976 that Bruce Archer proposed his three language model of education in which drawing was identified as a fundamental component of the wider language of 'modelling' [3]. The relationship of drawing to the modelling of ideas has received little subsequent attention from designers or design educators. Perhaps it is the immense scope of drawing that stifles a clear articulation of its function. Not only can it be employed to communicate precise intentions, as in a technically drawn orthographic projection, but it can encompass mood or feeling. It may be exploited at the very earliest conceptual stages, and as a final act in the design process. Between these extremes drawing can provide a profound and diverse resource. The scope of the activity of drawing, in addition to the range of products that constitute drawings themselves, results in a variety of definitions for the term. The *Collins English Dictionary* provides clarification on forty-one uses of the verb 'to draw'. While this includes 'to depict or sketch as with a pencil or pen', it also interestingly refers to 'choosing at random, shaping, and attracting'.

The research on which this chapter is based derives from case studies of professionals active in design. Case study analysis is an entirely appropriate method for certain types of research. Authors such as Parlett and Hamilton [4] and Kidder [5] have demonstrated the benefits of case study methods for research in the social sciences. The basis of their argument is that where research is not of the classical kind – that is, not

logically supporting or disproving testable hypotheses – then the research strategy ought to be different. They propose that the 'richness' of any individual case study is likely to reveal greater 'truths' about chosen issues than any classical hypothetico-deductive strategy. It is an important feature of case study analysis that primary material is made available for later researchers to analyse and propose alternative interpretations [6].

My interviewees were chosen to reflect as wide a range as possible of professional design activities, and this results in varying opinions concerning benefits of graphic strategies within designing. The designers' range of activities encompassed industrial product development (Roy Axe, Director of Concept Engineering at Austin Rover) and sculpture (Clifford Bowen who leads that department at Glasgow School of Art). Between these is a rich and varied collection of people including ceramicists, architects, fine artists, engineers, silversmiths and graphic artists – many of whom are also design educationalists.

In spite of the breadth of the case studies there appears to be unanimous support for the importance of drawing. Not only is it seen as an appropriate means of defining solutions or products, but it is considered as profoundly affecting the process. For a spectrum of designers drawing is a tool and many believe that it is vital to the organisation of thought. John Aston, Head of Graphic Design at the BBC, states that he would not appoint anyone without strong drawing skills. Peter Ashen (who at the time of this research was Head of Furniture Design at Birmingham Polytechnic) is not alone in believing that his early years spent learning drawing were 'perhaps the most valuable years of the whole of [his] education'.

All of those I interviewed had to wrestle with language in order to articulate this value. There exists a great deal of literature on how and why information needs to be communicated. Many interviewees were able to dissect the phenomenon of communication and discuss its importance for them. However, communication is only one of the purposes of drawing within design activity.

Design necessitates creativity, often a private activity. Those interviewed displayed a prodigious drawing output, much of which would never be seen by others. Communication may not be the primary objective for such graphic activity, but it may have something to do with the personal construction of an appropriate response to a given area of enquiry. It is this area that requires analysis and articulation and which therefore formed the focus of the questioning during interviews. Drawing for communication appears to be well defined and understood. However, the role of drawing in the creation and development of ideas is less familiar, and therefore my research has concentrated on the concept of drawing as design exploration and manipulation.

Drawing as exploration and manipulation

It is quite clear that designing and creativity exhibit a very close relationship. What has not been made so explicit is the relationship of drawing

to creativity within the sphere of designing. It receives support from sculptors, product designers and graphic artists, all highlighting the developmental role of drawing for an individual's creativity. The product designer Dick Powell believes you are:

> a more creative person if you can draw . . . because you can
> have this conversation with yourself, you can express your ideas
> to others and you can organise your thoughts better.

The complexity of 'conversing with yourself' is compounded by the variety of activities in designing which may include answering problems, constructing the right structures and asking the right questions. Perhaps Clifford Bowen's reference to his use of drawing as a means of 'assimilating information' provides a link. He presents drawing as a means of turning over fresh information, a way of trying things out and a way of consolidating a theme or thought. Bowen uses the term 'homing-in' which extends the role of drawing from a 'problem-solving' device into a 'problem-finding' one.

My research found considerable support for the concept of drawing within the creative act of problem-finding. Architect Ian Ballentine categorically stated that the whole process of drawing is to do with identifying very clearly what the problem actually is. He went on to stress, as Einstein did, that the solutions to problems are much less important than definitions. Similarly Alan Williams, a director of David Carter Associates, who uses drawing to assist the definition of problems, said:

> If I go and see people and talk about potential problems, I
> always end up with a pencil in my hand, drawing the problem.

It appears that those involved in design education are particularly concerned with this relationship. Of those interviewees who hold positions in higher education, a great many stated that they examine prospective students' drawings, not to assess their finished products but for an indication of their approaches to problems with no immediate solutions.

Exploratory drawing receives support for more than just its role in the definition of problems. Ashen views drawing as a valuable means of gaining visual literacy. He promotes the activity of observational drawing as a means of exploring, understanding, remembering and (particularly) critically judging. Raising awareness towards quality, detailing and proportion are presented as vital to the development of visual literacy and Ashen believes that drawing is the appropriate means of doing so. This is strongly supported by Mike Fuller. As an architect he believes that when you draw you:

> look at things more thoroughly, in a much more concentrated
> way than if you don't draw.

It is interesting to note here the consensus between designers and artists. Claire Webber, a painter, points to drawing as an aid to understanding. Speaking of observational drawing she refers to 'tracing' the object in order to understand it better, and says:

> I draw to help me understand. It's rarely used to express myself.
> It's learning about what you are looking at and being surprised!

100

Such analytical or exploratory drawing appears to increase the potential of discovering or 'seeing' new information (Figs. 33 and 34). The case studies reveal widespread, deliberate and planned graphic personal development. Articulation is difficult; people loosely referred to 'feeling' or 'expression' in drawing, even when engaged in what seemed to be controlled and systematic design processes.

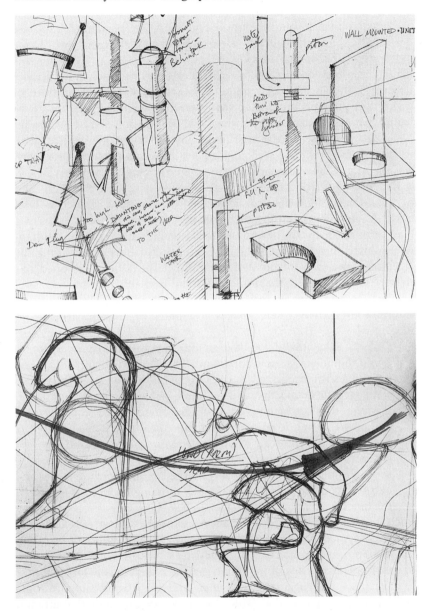

33, 34 Analytical or exploratory drawing, whether conceptual or observed, increases the designer's potential for discovering or 'seeing' new information.

Pamela Howard, Head of Theatre Design at the Central School of Art and Design, views drawing as an external expression of an internal response. This belief in drawing as 'making a response' forms a very important component in her work with theatre designers. She comments:

> We encourage people not to try and think out the solutions before they draw it but to start with a blank piece of paper, start making lines, putting colour on a piece of paper, making marks . . . and through that discovering something about the feedback process of drawing.

Clearly this may not provide a useful strategy for all designing activity but the intuitive approach does receive support from a number of quarters. It may be anticipated that a sculptor such as Sally Matthews would define her successful drawings as those which 'seem to catch what you want' because of the traditional interpretation of creative work within the fine arts. However, such a deliberate and structured approach was mentioned by others involved in applied or commercial activities.

Ballentine referred to the importance of free discourse in the creation of architectural concepts and highlighted the thumbnail sketch as both evidence of, and catalyst for, such cognitive activity. Similarly Axe saw a long-term future for the notorious marker pen renderings of the automotive industry simply because there is no other means of capturing the essential 'caricature' of the designer's intention. Ashen developed this theme, and indicated the profound links between, (i) drawing as a personal, exploratory or inspirational activity and (ii) drawing as an externalising activity where images communicate conceptual development.

> One has to say that if you have an idea in your mind, it is very rare if that idea is seen in the round. The idea may revolve around a structural idea – an idea of the use of materials, even some stylistic details that you are interested in, but I always maintain that it is incomplete until I have set it down on paper and have drawn it from different points of view. As soon as you start drawing it you realise how inadequate your mental image is. You think you have got it contained in your mind but as soon as you put it down on paper you recognise there are facets of it that you can't really grasp just by thinking about it. So it is the first externalisation of an idea to test it.

Such graphic discourse, while seen as important, is not easy to teach. Richard Seymour works in partnership with Dick Powell and identifies the randomness of much sketching activity which he refers to as a 'flow of consciousness'. Lack of inhibition may be a prerequisite for such flow to take place, as suggested by Fuller, and this would support some important developmental activities within design education that attempt to reduce inhibition.

Somewhere between the analysis of the problem and the conscious exploration of proto-solutions lies a cloudy perceptual domain within which designers refer to sources of motivation or inspiration that result from quick sketches they have made. These are ambiguous, offering no

102

logical way forward, yet sufficiently clear to the designer's intuition to suggest potential development. Thus a creative analysis is begun that appears to display some congruity with Michael Tovey's dual processing model of activity within the mind [7]. There is support for the importance of ambiguity. Bowen, for example, refers to his reliance upon drawings with flexibility, 'drawings which can be interpreted in a number of ways'. Central to this is the deliberate reduction of preconceived 'meaning' without the sacrifice of 'feeling'.

Imogen Margrie illustrates this point when she discusses the nature of her drawings made at London Zoo in preparation for ceramic sculpture:

> I like the movements of the birds but it is very difficult to draw
> them. I make just a quick squiggle . . . sometimes it is a feeling
> from the birds, perhaps it is aggressive or cheeky – there isn't
> anything definite, it's just a feeling I want to get over.

Matthews's search for feeling within drawing has already been mentioned but perhaps it is better represented as a process of enquiry regarding the 'spirit' of appropriate solutions. Such a spirit is difficult to visualise at any time but perhaps drawing is one of the more appropriate tools for attempting it. As Seymour said:

> the wonderful thing about drawing . . . is that you generate a
> spiritual conception of what you are doing, you can erect the
> spirit of something in a sketch!

Ballentine offers support for this viewpoint with reference to one of the great designers of the twentieth century.

> Alvar Aalto did very, very sketchy, embryonic, schematic
> drawings which were purposely ethereal because he was trying
> to catch what you could only call the spirit or the essence of the
> job. He did not wish to compromise solutions by seizing on
> form too quickly.

Underlying this exploitation of drawing as an exploratory tool is a considerably more basic foundation. This is the sheer enjoyment in the activity. It appears that the interviewees would draw during design activity whether it presented an advantage or not. It is difficult to isolate the functional requirement to draw from an inner motivation, but a great many designers appear to be unable to stop themselves from drawing as they talk, listen or create. Seymour referred to drawing as an 'immensely gratifying' activity, and this seems to be the result of capturing something that eludes words. Whether the ability promotes the practice or vice versa is unclear, but the majority of those interviewed regularly made time to maintain their graphic abilities through recreational sketching or painting.

A cross-section of designers referred to the frequency with which they drew. The practice may be formalised, such as life drawing classes, or informal as discussed by Williams. He keeps a sketch pad in the car and expressed enjoyment in drawing birds and stones. It was this latter interview that perhaps most successfully explored the relationship between recreational sketching and the exploitation of drawing within the pressurised, commercial world of design. In this Williams referred to the very great importance of 'inquisitiveness' to a designer. 'If you lose

interest, you might as well pack it all in!' What is important here is the relationship Williams presents between inquisitive sketching and design activity:

> I think your level of inquisitiveness drops off if you are not constantly looking and thinking and sketching about a notion or thought.

Ashen also presents an interesting analysis of the desire to draw:

> When I went into the army I continued drawing. I've got sketchbooks full of drawings, simply because it was a means of coming to terms with the world around me; new landscapes, new situations, new people. It seemed to me a way of making contact in a very real way.

This relationship between drawing and designing was further articulated by the product designer and lecturer Norman McNally:

> If you can't report on what exists, that is, you don't have an investigative vision of the world around you, then you can hardly be expected to report on what doesn't exist – things that you are pulling out of your head. Objective drawing constantly informs conceptual drawing.

This represents one of the clearest statements in the research to establish a relationship between graphic ability and cognitive development.

The traditional subject for drawing studies, the human model, received some support as an appropriate focus but this was by no means unanimous. Whilst Powell suggested that designers may improve particular capabilities by sharpening their powers of observation and recording through life drawing, McNally was more cautious about its contribution. His belief that life drawing provokes certain ways of drawing 'in the way that marker pens do' should be considered carefully alongside the traditional easy acceptance of such activity.

The role of drawing within an exploratory strategy is clearly then not limited to small areas of application. It lies at the very heart of the search for understanding. Exploration has been presented as a conglomeration of interrelated activities, some revolving around problem analysis and inquisitiveness, others around creativity or discovery, and still others concerned with making visible the products of such exploration. The role of sketching as a vehicle for free discourse provides a good example of the third of these activities. A number of the interviewees illuminated this activity but preferred to use the term 'expression'. Howard even used this term as part of her definition of drawing as an 'external expression of an internal response'.

Mention has already been made of the deliberate exploitation of ambiguity – the production of sketch drawings whose flexibility deliberately provokes a variety of interpretations by both the viewer and, more importantly, the drawer. Closely involved with this is the occurrence of serendipity or happy chance. This is so commonly mentioned by those who exploit drawing that one may be persuaded to believe that 'happy chance' can be conjured up or provoked at will. Perhaps the immediacy of drawing assists this process. As Matthews said:

> I think the nice thing about drawing is the spontaneity of it.

STEVEN GARNER *The Undervalued Role of Drawing in Design*

> You may have not even intended to do a drawing – you were
> just feeling around.

Paul O'Leary, a product designer, spoke of 'fleeting moments' during designing, and presented evidence for considering humour as an important catalyst in this process of spontaneity and serendipity. Webber and Ballentine independently referred to drawing as a 'trigger' mechanism and perhaps the same illogicality that makes us laugh provides the trigger for the creative reinterpretation necessary in designing activity.

Such analysis is made difficult by the conflicting or opposing terms used by the interviewees. Whilst the consensus revealed drawing as a pleasurable activity it appears that success is only achievable after great anxiety or mental strain. Betty Edwards's analysis of creative activity has highlighted a similar condition [8].

Another anomaly is the desire to produce fast, transitory sketches as a means of developing an idea. Although they are intended to possess no more than fleeting value, such drawings often have characteristics that make them very precious to the drawer. A blend of serendipity, skill, speed, economy, pleasure, pain, anger and humour can often produce a sketch of more interest to people than the finished artefact – whether a building, domestic product (Figs. 35 and 36), sculpture or painting.

In fact the 'roughness' of a sketch would appear to be an important characteristic of some types of design drawing. A very detailed conceptual sketch may stifle ambiguity and might tend to fix early thoughts that could be improved upon. Williams described a certain type of drawing he does as 'appalling', but only if it were evaluated as a communicative device. This is supported by Margrie and Webber who exploit their drawing talents in the production of different types of images, some of which are deliberately unpolished. 'Sometimes the best drawings for me are the rough sketches', says Webber.

The area between exploration and idea development is a very grey one in the design process. Rarely does one get the opportunity thoroughly to complete research activity before manipulating such information in a response to various problem areas. In fact a case could be made for the importance of creatively examining the breadth of the problem, and possible responses to it before a systematic research process is completed. Thus drawing strategies that aim to explore problems, manipulate information, and visualise responses, have no clear divisions between them.

Designing is not a linear process. Its iterative nature is well accepted and this results in different requirements for drawing at any one stage of the process. To compound this issue skilled practitioners, as presented in the case studies, were able to produce drawings that provide more than one function. That is, while a designer may be exploiting drawing to explore an area creatively and personally, these same drawings may communicate form, detail, scale, or other information quite readily. Similarly much sketching activity is used simultaneously to clarify conceptual development, facilitate evaluation, and provoke the further generation of ideas. In reality, drawing styles and purposes merge gradually into one another and reflect the personal preferences of the artists,

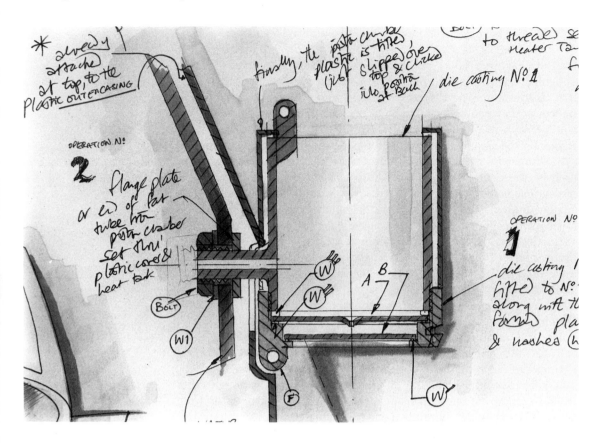

The following handwritten annotations appear on the drawing:

* already attached at top, to the plastic OUTER CASING

finally, the pasta chamber plastic is fitted (just slipped over top & clicks into position at back) / die casting N? 1

to thread se Heater Ta

OPERATION N?
2
flange plate or end of fat tube into pasta chamber
set thru' plastic cover & heat tank

BOLT

W1

OPERATION N?
1
die casting fitted to N? along with the formed pla & washes (h

W W W1 A B F W

35, 36 A blend of serendipity, skill, speed and economy cultivates creative ambiguity and discourages the early fixing of preconceived ideas.

engineers, sculptors, designers or craftspeople themselves. Williams provided a suitable statement that illuminates this interrelationship between exploration and manipulation:

> Perhaps in certain circumstances a quantity of sketching or scrawling is an indication of a poor or illogical process of thinking, but it can reveal a way of using a pencil as a tool to uncover ideas. Few people can actually sit down and draw something that they have imagined. It is a natural way of developing ideas. One can usually identify by looking at somebody's scrawlings how hard it is for them to get any ideas. If there is a flow of ideas the sketches, the drawings seem to indicate the lucidity of thinking.

This link between the two domains was referred to by Margrie as 'formulating' ideas but perhaps McNally provided the most appropriate articulation, which owes something to Archer:

> Drawing is a very economical way of modelling, it is the fastest and best way of having a quick idea – a visualisation – of what is in your head and thus leads naturally into solid modelling.

The use of the word 'play' occurred frequently (and a little apologetically) in conversations, as if there should be no requirement for such apparently unfocused activity. On the contrary, play can be quite a focused activity and there are times when such a capability is extremely

useful within the design process. Drawing and playing appear to possess a particularly close relationship which may reveal itself in both a formal and an informal sense.

Drawing has been promoted as an essential component of designerly thought. However, the research indicates that it has implications beyond the relatively narrow sphere of the design professions. Support for graphic skills of all types has been documented and analysed and researchers have already proposed links with short-term and long-term memory. The value of drawing cannot be overstated and its develop-

ment is viewed as a prerequisite for all students, not only those specialising in design. Drawing appears to facilitate creativity in the most fundamental sense, with many of the case studies illuminating the relationship between the two. In addition to qualitative advantages there was much evidence that highlighted quantitative benefits of drawing for design thinking. Edward Hill is one of many authors who have promoted drawing for its major contribution to perceptual development. He notes:

> Drawing can and does heighten visual sensitivity. It prods the
> draughtsman to sharpen his observation beyond the ordinary
> level [9].

Many of the case studies revealed strategies of graphically turning around and recoding information in a similar manner to Bruner's identification of the capability of natural language. They presented strong evidence for viewing drawing as a major means of supporting manipulative thought, particularly in design activity. Perhaps drawing may rightly be considered a language. The facility afforded by drawing for exploration also has a number of parallels with published studies of language. Douglas Barnes identifies a type of talk which he terms 'exploratory' and which is presented as a means of groping towards a meaning. The similarity between this activity and the graphic version used by designers is striking:

> It is usually marked by frequent hesitations, rephrasing, false
> starts and changes in direction [10].

This discussion highlights the vital role that drawing plays in exploring ideas and manipulating information, and suggests that the nature of drawing may differ widely depending on its purpose (Figs. 37 and 38). It also illuminates the valuable service afforded by drawing for the analysis and understanding of ill-defined problems. Educationalists of all disciplines – but particularly design – need to be motivated to examine the role of graphic strategies within the learning process. They require more

37, 38 Drawing plays a vital role in exploring ideas and manipulating information, as a means the analysis and understanding of ill-defined problems.

than the 'hows' of drawing; they also need the 'whys' in order to under-
take their own curriculum development. Drawing for design awakens
latent creative talent in many – the opportunity to do so must be made
available to all.

Notes and References

1 GRAY P. (1979), 'Why drawing is a fundamental design skill', *Design
 Magazine*, 363, p. 76.
2 TIPPING C. (1985), 'Acquiring design skills for teaching', *Studies in Design
 Education, Craft and Technology*, 16, 1, p. 45.
3 ARCHER L. B. (1976), *The Three Rs*, lecture, Manchester Regional Centre
 for Science and Technology, 7 May.
4 PARLETT M. and D. HAMILTON (1977), 'Evaluation as illumination: a new
 approach to the study of innovatory programmes', in HAMILTON D. (ed)
 (1977), *Beyond the Numbers Game* (London, Macmillan).
5 KIDDER L. (1981), *Research Methods in the Social Sciences* (London, Holt-
 Saunders).
6 For this reason the full version of this research includes transcripts of all
 interviews, and may be consulted on application to the NSEAD, Corsham
 Court, Corsham, Wiltshire,
7 TOVEY M. (1986), 'Thinking styles and modelling systems', *Design Studies*,
 7, 1.
8 EDWARDS B. (1979 [81]), *Drawing on the Right Side of the Brain* (Los
 Angeles, Tarcher [1981 Souvenir Press]).
9 HILL E. (1966), *The Language of Drawing* (Engelwood Cliffs NJ, Prentice-
 Hall).
10 BARNES D. (1976), *From Communication to Curriculum* (Harmondsworth,
 Penguin).

Chapter Ten

SEYMOUR SIMMONS Philosophical Dimensions of Drawing Instruction

Creative processes in the arts have long been differentiated from those employed in other spheres. Art is held to rely on inspiration rather than logical thought, intuition rather than information, spontaneous reaction rather than method [1]. These apparent dichotomies have led to the isolation of artists from other members of society and the segregation of art studies from other aspects of the curriculum. They also make it difficult to explain how art can be taught and learned. At least some of these problems may be dispelled by an open-minded examination of various methods of drawing instruction and a search for the principles which unite them with practices in other disciplines. This chapter will trace four teaching methods, linking each to a specific philosophical system and to associated fields of knowledge. Each approach will also be briefly critiqued to highlight strengths and limitations.

To begin, analytic approaches to drawing will be considered in the light of rationalist philosophy and thereby associated with the study of mathematics. This system will then be compared to a direct observational approach which can be associated with philosophical empiricism and, by this means, linked to the study of natural sciences. Third, an experimental approach to drawing will be tied to the pragmatic school of philosophy and thus to experimental science. Finally, a graphic approach, associated with semiotics, will help link drawing ends and means to language and logic.

As I will argue, recognition of philosophical continuities may provide a more objective picture of the diverse thinking processes applied in art, thereby enabling students to connect art study to other educational experiences. It may further encourage cross-disciplinary dialogues, allowing the wider public to understand and come to participate in the arts. Finally, it may stimulate the development of comprehensive drawing courses for general university education and facilitate the restoration of similar courses of study for professional training in art and design. In reference to this final point, I will conclude by suggesting components of a comprehensive course and consider its contribution to tertiary education.

Analytic drawing

The analytic approach to drawing instruction stands in strict opposition to popular attitudes about spontaneity in art. It begins with the assumption that all objects, whether natural or made, can be perceived and understood in terms of simple geometric shapes – either two-dimensional forms as in the late mediaeval illustrations of Villard

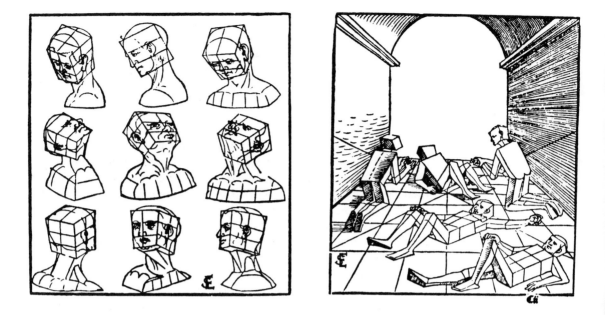

de Honnecourt, of three-dimensional forms as in the post-Renaissance studies of Albrecht Dürer or Erhard Schön (Fig. 39) [2]. Whether in simplistic *How to Draw* books or in the more sophisticated approaches considered below, the pedagogy associated with analytic drawing follows a common pattern. Students begin by mastering a set of predetermined geometric forms and schemata which are then combined or developed into forms of ever-increasing detail and refinement.

A contemporary example of the analytic approach is employed in the foundation programme at the School of Design in Basel, Switzerland [3]. Here students begin by mastering the representation of simple geometric solids – cubes, cylinders, spheres, and so on – as seen from various angles. These are then combined and subdivided to represent more complex objects. Though taken from observation, the drawings are intended as 'abstractions' rather than 'photographic copies'. They are, therefore, done in line rather than tone with both seen and unseen facets depicted. In the beginning, at least, 'spontaneity of pictorial expression is subordinated to logical representation of the object', this apparently providing a solid foundation upon which a more personal style may eventually be built. But even when controls are loosened, as in more advanced studies from sculpture and still life, procedural rigour is maintained and individuality is constrained according to the needs of analysis.

Similar criticisms have, of course been lodged against the most influential analytic approach, the notorious 'academic method' [4]. Students in the academies of art, which spread throughout Europe and America from the mid-sixteenth to the mid-twentieth century, began by mastering the representation of generic features – eyes, noses, mouths, and so on – which were themselves reduced to simple geometric forms. These features were then combined in linear studies of faces and figures

39 Schematic heads and bodies. ERHARD SCHÖN (1538), *Underweisung der Proporzion und Stellung der Possen* (Nuremberg), from E.H.GOMBRICH (1960) *Art and Illusion* (Princeton UP).

which, in turn, were intended as preparation for tonal drawing from casts, all this being considered the necessary foundation for drawing from life. Each step was designed to help the eye seek out general structure when looking at particular individuals, while at the same time also helping the mind find ideal proportions when looking at the imperfect individuals found in the natural world.

Academic theorists frankly derived their educational agenda from neo-Platonic and Cartesian rationalism, thus linking art with mathematics, science, and philosophy. First, they applied rationalist aesthetics and epistemology to the study of art, citing the neo-Platonic theory that all objects derived their structure and beauty from partaking in fundamental geometric forms which were the essential elements of the universe [5]. These forms, according to the theory, could be known directly to the reflective intellect, such knowledge being then applicable to both making and judging works of art. Of course, the theorists recognised that the 'reflective intellect' needed preparation to perceive these forms. This included studying mathematics itself along with mathematically determined principles of composition and proportion, and also by analysing and copying works of art which exemplified the mathematical ideal.

Second, the academic theorists determined the order and arrangement of this material based on the 'method' of a contemporary rationalist, René Descartes [6]. Descartes's method promised that all problems could be resolved by reducing them to a number of constituent elements, setting these in due order from simple to complex, and checking each step to be sure nothing was left out [7]. Adhering to these principles, both modern and traditional analytic teaching methods follow a step-by-step curriculum, beginning with simple problems and moving to those of increasing complexity. Success, at least in regard to initial problems, is typically determined by adherence to rules, and similarity to exemplary models rather than by inventiveness. As such, learning within these systems may require more perseverance than talent.

Analytic drawing instruction, like all teaching methods, has its strengths and weaknesses. Dealt with comprehensively, it can provide skills which apply to both observational and conceptual drawing, thus being useful in design, architecture, engineering, and fine arts. It is, perhaps, weakest in this latter category since, according to many critics, it tends to repress individuality of perception, feeling, and style by addressing nature only through the intermediary of preordained schemata.

Observation drawing

The second method to be considered, the observational approach, directly addresses this last complaint by suppressing analysis and requiring students to reproduce exactly what their eye beholds. This approach has a history almost as long and impressive as the analytic method [8]. Its goal – fidelity of the image to the direct visual

experience – is exemplified in the early Renaissance naturalism of Pisanello and the late Impressionist tonal drawings of Seurat.

A popular, if controversial, version of this observational approach is presented in a book entitled *Drawing on the Right Side of the Brain*, by Betty Edwards [9]. As suggested by the title, the author associates her approach to drawing with functions apparently housed in the right cerebral hemisphere. Among these functions are listed: visual-spatial perception, kinesthetic sensibility, synthetic processing, intuition, and emotion. In short, those operations typically associated with creativity in the arts. These are contrasted to left-brained functions such as logical, linear, and analytic processing, convergent thinking, and the tendency to use symbols to stand for concrete experience – in short, all those processes typically associated with traditional academic disciplines as well as with analytic approaches to art.

In fact, it is the tendency to substitute left-brain schemata for right-brain observation which, the author claims, accounts for the problems people have in drawing what they see – a point she illustrates by showing portraits done before and after her course. With the problem of schema-tisation in mind, the course begins with exercises designed to confound left-brained functions while 'drawing on' those of the right. Among these exercises, a contour drawing done without looking at the paper requires careful observation of line and shape (a right-brain function) while nullifying the tendency to make value judgments of the result (a left-brain function). Further exercises employ contour drawing and the observation of negative spaces towards the representation of such complex subjects as chairs, portraits, and, eventually, interiors. This last task is accomplished without reference to the laws of perspective which are considered 'too left-brained'.

Like the previous approach, the present method has its strengths and limitations. Among the strengths, it offers a clear and well-ordered presentation of basic representational techniques. Among the limita-tions: by focusing on the pure visual experience it fails to accommodate the needs of conceptual and imaginative drawing. Moreover, it perhaps overemphasises the role of careful rendering skills while neglecting freer sketching techniques which are typically deemed necessary for compli-cated subjects like the human figure or landscape.

These last limitations are taken into account by an unacknowledged precursor of Edwards in the field of observational drawing, John Ruskin. Though best known as an art critic, Ruskin was himself a capable draughtsman. He also taught drawing courses at the Working Men's College in London and later at Oxford. Ruskin's initial course of study and philosophy of drawing instruction are presented in a book, first published in 1857, entitled *The Elements of Drawing* [10].

Like Edwards, Ruskin used drawing as a means to train visual percep-tion freed from the intermediary schema. This he called 'seeing with an innocent eye'. Moreover, he viewed such perception as a fundamental but neglected complement to traditional education, and argued for it as a means to lead students to an appreciation of the beauty of nature [11]. With this in mind, Ruskin's first exercises were intended to train

students to attend closely to natural formations: the interstices between branches of a tree or the tonal gradations on the rounded surface of a stone. From such basic studies, he then went on to teach a wide range of rendering techniques as well as those sketching procedures required to represent subject matter too complex or fleeting to allow for detailed depiction: grassy banks, flowing streams, swiftly moving clouds.

Ruskin departs still further from rendering skills when devoting a lengthy discussion to principles of composition. Unlike the seemingly arbitrary mathematical rules of academic composition, Ruskin claimed that his principles derive from natural laws and could therefore be observed *in* the object of perception rather than imposed upon it. For example, the 'law of radiation' in which 'several lines spring from or close towards a single point', gives organisation to the potential randomness of tree branches; awareness of this law enables an artist to find a similar order in broad landscapes and apply it to his or her art.

The fact that Ruskin's compositional theory, like his earlier approach to nature drawing, relies on observation rather than invention betrays the influence of empiricism, a philosophy Ruskin studied in his youth. Beginning with John Locke [12], empiricists opposed the rationalist belief that ideas existed *a priori*, and could therefore be directly apprehended by reflection. They argued, instead, that the mind began as a 'blank slate', receptive to the imprint of sensory experience which in turn formed the basis of all knowledge. The theory was well suited to the romantic appreciation of nature and the development of natural sciences, both of which directly influenced Ruskin's life and thought. Moreover, the approach to drawing which Ruskin taught is particularly applicable to the study of the natural sciences and still contributes to the growth of knowledge in these fields.

Experimental drawing

Though perhaps more tolerant of individual differences than the analytic method, the observational approach to drawing takes relatively little account of the range of subjective responses – sensations, feelings, and imaginative thoughts. These, of course, have been much a part of art since earliest times and are particularly important today. Such responses are more fully accommodated by a third approach which I have called the experimental method. Here, cautious drawing is eschewed as the artist responds spontaneously to an exploratory urge. The result: a searching sketch which tries to discover unique qualities of a particular experience or, alternatively, an abstracted image resulting from an interest in the expressive possibilities of medium and form. Examples of the former include the compositional studies of Michelangelo; examples of the latter include the preparatory drawings done for Picasso's *Guernica*.

A compelling exposition of the experimental approach is contained in a book entitled *The Natural Way to Draw* by Kimon Nicolaides [13]. Where previous approaches claim to prepare students for more subjective involvement, Nicolaides begins with this and uses subjective

40 Gesture drawing. From KIMON NICOLAIDES (1941), *The Natural Way to Draw* (Boston, Houghton Mifflin Co.). By permission of Houghton Mifflin Co.

responses as the foundation for both highly developed representational drawing and more abstract and expressive imagery. These seemingly disparate styles are tied together, according to the author, in so far as both should derive from personal experience. For one thing, experience in Nicolaides's terms involves the integration of all the senses (not simply sight) and combines these with feeling, imagination, and intellect. For another, experience requires an experimental attitude – learning through trial and error.

The first exercise, a blind contour drawing, gives students a taste of the multi-dimensional nature of experience. The task differs significantly from the purely visual exercise proposed by Edwards in that, here, Nicolaides's aim is to tie vision to tactile sensation. Students are to draw while imagining that their pencil is actually touching the edge of the model, thereby feeling the form as a solid object – soft or firm, textured or smooth. The second exercise, gesture drawing, brings out the process of trial and error. Here is the embodiment of the experimental approach as drawing begins with a rapid, flowing, scribbled attempt to capture a sense of the whole figure in the first five seconds (Fig. 40). This initial

'hypothesis' typically serves as a basis for correction and elaboration as students continually check and redraw.

In keeping with the holistic nature of experience, Nicolaides's curriculum differs from those previously considered. These tended to focus on one approach to drawing which developed linearly, whereas his text teaches a variety of strategies, developing them almost simultaneously, then uniting them in diverse ways. Gesture and outline exercises, for example, are initially complemented by, and eventually combined with, structural studies; observational exercises are expanded into activities calling for memory and imagination. All, however, are ultimately united by the common reference to experience and experiment.

Though in many ways more comprehensive than methods previously considered, Nicolaides's curriculum also has its limitations. For example, it concentrates primarily on life drawing, and in so doing fails to provide for conceptual object drawing, landscape studies, and even portraiture. But there is at least one text that seeks to accommodate these concerns and more, while maintaining the attitude of experimentation exemplified by Nicolaides. Unfortunately, however, the text was so ambitious as to never reach completion. This was the *Treatise on Painting* by Leonardo da Vinci [14].

Leonardo was of course among the first to use the free-flowing gestural style for drawing from observation as well as for the development of composition and he refers to both uses in his text. But, like Nicolaides, he also combines the experimental approach with both analytical and perceptual studies, all of which are complemented by lengthy and well-illustrated theoretical discussions. In the realm of analysis, Leonardo devotes an entire chapter to principles of light and shadow. Observational skills are addressed by, among other things, detailed examination of atmospheric perspective. And experimentation is encouraged as students are invited to use drawing's magic to depict 'monstrous things, such as devils and similar creations'.

The experimental approach to learning has been fundamental to human creativity since the beginning of civilisation, often manifesting itself in rapidly scribbled sketches which are later translated into more refined works of art as well as other products of human invention and design. Yet despite this long and well documented history, the philosophical formulation of this approach as a search for knowledge is of remarkably recent origins, emerging only in the late nineteenth and early twentieth centuries in the writings of pragmatist philosophers such as C. S. Peirce, William James, and John Dewey [15].

Where previous philosophers saw the search for knowledge as a relatively passive affair involving either reflection on innate ideas (as in rationalism) or the accumulation and comparison of sensory perceptions (as in empiricism), pragmatists viewed it as a matter of active experiment, involving trying something and undergoing the consequences, making necessary adjustments and trying again. These adjustments, it should be noted, affect both Subject and Object in relationship to one another. In science, adjustment occurs as the experimenter changes his or her initial hypothesis based on the results of operations performed on

the object of experimentation, even as the object is itself changed by the operations performed upon it. In art, the artist's feelings are changed or clarified as he or she tries out different expressive effects.

The graphic approach

Among Leonardo's major limitations is, understandably, a failure to accommodate the needs of non-representational art. Perhaps less understandable is a failure directly to attend to the abstract elements which have formed the basic language of drawing since the beginning of art itself.

Whether in fine, commercial, or decorative arts, the graphic dimension not only provides the means of imaging, but serves as the ultimate source of an image's meaning [16]. For this reason, twentieth-century artists have paid particular attention to mastering and expanding their graphic vocabularies. Among the results are early Abstraction, Cubism, Surrealism, Abstract Expressionism, Minimalism, Bauhaus Design, and so on. But, despite this history, the graphic dimension and non-representational imagery are given only brief notice by Nicolaides and Ruskin and are completely neglected in the other courses here considered.

They are, however, directly addressed by a fourth teaching method which I have called 'the graphic approach'. Here, the lines, marks, shapes and patterns become the starting point of study and sustain their importance throughout the course. For example, Josef Albers in his basic drawing course at Yale emphasised the symbolic dimension of drawing by entitling his teaching approach *Drawing as a Graphic Idiom* [17]. He drove home the relationship between art and language from the first exercise – which used the student's own signature as a design motif (Fig. 41) – to one of the last, which employed abstract marks to create the visual impression of a page of type. Albers accompanied such activities with others aimed at helping students develop and apply their graphic vocabulary to both abstract design and representational imagery.

Like the other teaching methods considered here, Albers's approach has its strengths and weaknesses. Among the former it provides a highly intellectual approach to drawing, one which thoroughly links theory to practice and unites art studies to a range of other disciplines. Among the latter: it tends to overemphasise control, potentially blocking the expressive freedom which many feel is borne of spontaneity.

The method also has its historical precedents. Students of traditional Chinese brush painting began by mastering a vast array of brush strokes quite similar to those employed in calligraphy [18]. These were then combined in accordance with highly specified rules to depict rocks, plants, people, and so on – the basic 'vocabulary' of landscape. (We might also note the continuity between language and art revealed in the calligraphic commentary written by poets and patrons directly onto many paintings.)

Both examples of graphic approaches considered here provide students with a rich vocabulary of forms and marks potentially leading to

41 Reversed signatures.
From JOSEF ALBERS (1969),
Search Versus Re-Search
(Hartford, Trinity College
Press). By permission of
The Josef Albers
Foundation, Orange, CT,
USA.

an infinity of variations. Still, the stress in such systems on mastery and control could potentially discourage wide-ranging experimentation and spontaneous self-expression. This was specifically cultivated in the experimental approaches previously considered.

As mentioned earlier, the branch of philosophy linking graphic and language arts is the theory of signs (sometimes referred to as semiotics) whose concern is the nature and variety of meaning. The obvious cross-disciplinary reference is to language, and in fact contemporary semiotics has largely concerned itself with language-derived symbol systems. Yet Peirce, the father of semiotics, saw the theory of signs as being equally necessary to science, mathematics and logic [19] and a few philosophers, like Nelson Goodman, have expanded Peirce's original broad vision to include the many forms of art. Goodman has further pointed out continuities between artistic and other symbol systems in that all may serve the aim of cognition. Goodman notes that:

> The use of symbols beyond immediate need is for the sake of
> understanding . . . what compels is the urge to know, what
> delights is discovery . . . [20].

As stated at the outset, the search for philosophical principles linking art and academic studies is intended to advance the educational experience of art students and non-art students alike. For those unfamiliar

118

with art, recognition of common principles may lead to a better under-standing of what artists do and convince students of the value of art to education and culture in general. By the same token, such recognition may encourage art students to step outside their chosen discipline and seek knowledge in fields like mathematics, science, and philosophy – areas which have been important sources of inspiration for artists in the past. Finally, knowledge and acknowledgement of underlying principles may help teachers communicate essential concepts to students from diverse backgrounds, while helping students themselves connect their experiences in art with those taken from other areas of life and learning.

I would also hope that the search for underlying principles will lead to the establishment of more comprehensive drawing courses in university education and encourage the restoration of similar courses in schools of art and design. These courses, as I have suggested, should integrate theory with practice. They should further incorporate analytic, observa-tional, experimental, and graphic approaches in order to meet the widest range of student needs. Thus established, these courses would expose students to continuities between contemporary and traditional art as well as similarities between art and other disciplines. I have cited examples which may serve as models: Leonardo's proposed curriculum (a prototype for early academic programmes), Ruskin's theories outlined in *The Elements of Drawing*, Nicolaides' course, and Josef Albers' drawing class at Yale.

Such comprehensive programmes of study are admittedly rare even under the best of circumstances since they depend for their development on teachers of vision – those who can see beyond disciplinary boundaries and at the same time understand the special contribution art can make to education. If, as I suspect, these courses have become increasingly rare in the past few decades, it may reflect a certain narrowness in our educational systems, this in turn being a reflection of the tendency towards specialisation in society as a whole.

Drawing, in the past, has served to unite diverse disciplines providing practical and conceptual tools applicable to the arts as well as the sciences. It is further linked, on a level of principle, to such diverse subjects as mathematics and philosophy, as I have suggested. For these reasons, I believe that the institution of comprehensive drawing courses – based on the acknowledgement of continuities – can work to oppose the trend towards narrowness, bridging disciplines and uniting artists with other professional and academic populations in a common search for knowledge.

Notes and References

1 See BEST D. (1985), *Feeling and Reason in the Arts* (London, Allen & Unwin).
2 See GOMBRICH E. H. (1960), *Art and Illusion* (Princeton University Press).
3 See MEIER M. (1977), *The Basic Principles of Design* (New York, Van Nostrand Reinhold).
4 PEVSNER N. (1973), *Academies of Art, Past and Present* (New York, De Capo Press).
5 See GOMBRICH (n.2).
6 See PEVSNER (n.3). See also LEE R. W. (1967), *Ut Pictura Poesis: the Humanistic Theory of Painting* (New York, Norton).
7 DESCARTES R. (1637), *Discourse on the Method of Rightly Conducting Reason and Seeing Truth in Science.*
8 See GOMBRICH (n.2). See also KRIS E. and O. KURZ (1979), *Legend, Myth and Magic in the Image of the Artist* (New Haven, Yale University Press).
9 EDWARDS B. (1979 [81]), *Drawing on the Right Side of the Brain* (Los Angeles, Tarcher [1981 Souvenir Press]).
10 RUSKIN J. (1857 [1971]), *The Elements of Drawing* (New York, Dover).
11 See HEWISON R. (1976), *John Ruskin: the Argument of the Eye* (Princeton University Press).
12 LOCKE J. (1693 [1964]), *An Essay concerning Human Understanding* (New York, Meridian).
13 NICOLAIDES K. (1941), *The Natural Way to Draw* (Boston, Houghton-Mifflin).
14 MACMAHON A. P. (trans.) (1956), *Leonardo's Treatise on Painting* (Princeton University Press).
15 See DEWEY J. (1929), *The Quest for Certainty* (New York, Putnam).
16 See RAWSON P. (1969 [87]), *Drawing* (Philadelphia, University of Pennsylvania Press).
17 ALBERS J. (1969), *Search versus Research* (Hartford, Trinity College Press).
18 SZE M. (1956), *The Tao of Painting* (Princeton University Press); see also SZE M. (1956), *The Way of Chinese Painting* (New York, Random House).
19 PEIRCE C. S. (1958), *Selected Writings* (New York, Dover).
20 GOODMAN N. (1976), *Languages of Art* (Indianapolis, Hackett), p. 258.

Chapter Eleven

ROBERT CLEMENT The Classroom Reality of Drawing

The purpose of this chapter is to reaffirm the importance of the teaching of observational drawing to children in our Primary Schools. This kind of drawing has much greater value than those exercises for training the hand and eye which led to its introduction into the curriculum over a hundred years ago. Drawing remains the essential, core activity in art and design education, without which it is impossible to achieve meaningful work of quality. Nowadays, the value of drawing as a cross-curricular activity is widely recognised; it supports and extends children's learning in other subjects. Indeed, the process of learning in observational drawing gives children 'another way of knowing the world', that is visual and holistic and, at best, engages all of the senses.

Introduction

Drawing has a special purpose for very young children. It enables them to create and control symbols. This provides them with a form of communication that is more flexible and more specific than spoken and written language. Creating their own images supports children in their thinking; it helps them to name and describe their world as well as to respond to and enjoy its complexities. How children make drawings in response to differing experiences is determined both by the nature of each experience and by the way that it is placed into context for them by a teacher.

> Like all forms of human expression, art [the making of images]
> is evidence of response to different kinds of experience [1].

The majority of primary school teachers have had little or no aesthetic education. Very few have drawn since they left school, and some readily admit that they never teach drawing because they cannot themselves draw. In these circumstances, it is best to focus on strategies which can increase the confidence of teachers, so that they can enable their students to draw. Here, there is a parallel between 'teaching and the use of drawing' and 'teaching and the use of language'. In teaching language, good teachers introduce different kinds or methods of writing and their appropriate usage according to need and occasion, for example 'descriptive' (as in recording) and 'expressive' (as in imaginative) writing.

Teachers also match writing tasks to the perceptions and skills of their pupils. If children are to be taught to draw effectively, within the reality of the average classroom (probably one teacher and thirty children in an area of five hundred square feet), then the task of teaching drawing has to be undertaken as seriously as, and perhaps similarly to, that of

teaching language. My purpose here is to help teachers to understand how they can use drawing *most* effectively in their classrooms.

How children's drawing changes

Young children come to terms with the world by 'naming' it graphically. Their drawings stand for or 'symbolise' their views of the world. Sometimes, an image and its meaning can change several times during the process of production. Very young children are not fully able to analyse their responses to their environment. They tend to select an aspect of a thing or person which signifies it best, like the domination of large heads in their drawings of people. These drawings have little reference to formal, adult forms of visual expression. Yet children are not confused by the differences between the images they draw and the appearance of the real world. They easily kaleidoscope time, space and scale within one drawing. This very quality gives their work spontaneity of expression. Young children rarely say 'I can't draw' or 'I don't want to draw'.

Children gradually develop the ability to see and respond to the world independently of their feelings. With this increasing objectivity, they become conscious of existing visual media and imagery, and of their apparent authority. Similarly, they recognise that their own drawing has public consequences. Thus children come to know the complexity of the visual environment as well as the problem of interpreting the actual 'real' world. Their awareness of the differences between the images which they make and those which surround them is probably the most critical point in the development of skill in observational drawing. This is a time of transition when the teacher's supportive role is crucial. But in their art education (or lack thereof), children are frequently denied access to the means for progress in visual representation.

Many children are frustrated because they cannot make the images they want, and some take refuge in stereotypes or copying. These are usually acceptable approaches for their peers and, indeed, for some teachers. All this corresponds with an increasing emphasis in their general education upon the rationalisation of the world as objects. Often, a split develops between the real world of learning and the make-believe world of Art. In such situations, instead of being a natural vehicle for communication, drawing becomes a special kind of activity, requiring particular skills and ways of seeing. This results in kinds of imagery which need to be regarded separately as things in their own right, and which have little relationship to the world 'out there'.

The teacher's role

In mid-primary school, with children in years three and four, the teacher's role is to support visual enquiry across the curriculum. This involves helping children to appreciate and to interpret the complexity of their environment graphically. It requires that teachers have the knowledge and ability to use a variety of methods for drawing, which were less

critical in the earlier years of schooling.

The first step toward helping children make the transition from 'symbolic' to 'descriptive' drawing is a recognition that this transition takes place! The second is to provide opportunities for the continuing use of both systems in drawing lessons. Thus drawing serves as a means for personal and imaginative response as well as for investigation and communication. Once children know that general shapes can be used in various combinations to express and to record, they are comfortably bilingual in their drawing. By the age of five children are capable of using their vocabulary of shapes to make both 'careful looking' (Fig. 42) and 'story telling' drawings. For example, in response to a discussion about the appearance of teddy bears, children can make basic descriptive drawings. How much they describe is dependent upon how well the questioning focuses their attention. They can also find pleasure in depicting teddy bears when the task is based upon a familiar story like 'The Teddy Bears' Picnic'.

42 Reception pupils (5 years) making their first 'careful looking' drawings from a shell.

The teaching of drawing

Drawing is graphic evidence of a response to a particular experience. A response relates to a child's personal reaction as well as to how the teacher helps him or her to make sense of a given experience. What kind of drawing a child makes is influenced by (i) how the task is framed and presented, that is, the intentions of the lesson; (ii) what questions are asked, for example, how visual attention is directed and moved toward a graphic response; and (iii) what pool of imagery is available, that is, accessible graphic sources.

For example, consider the following strategies for the topic 'house'. This is a universally favourite subject for children, and offers a range of 'problems' and some anticipated responses in terms of kinds of imagery. If asked to draw a house – any house – with neither supporting discussion nor observation, children usually produce variations on a standard stereotype. This is constructed of a triangle roof and a rectangle frame, and has a central door with windows to each side. Children with more confidence and perhaps more competence usually apply more detail to the basic formula.

However, if asked to draw the house *they live in*, following a discussion based upon their memory of their house and an exploration of visual differences between it and others, children draw houses with more purpose and greater specificity [2].

If the same children are then taken on a field trip to a nearby group of houses to make a visual investigation – including sketching, taking notes, making diagrams and follow-up discussion – both their on-site and subsequent images will have more visual accuracy and authenticity.

They may then grasp basic conventional drawing systems. For example the teacher may guide a discussion of a doll's house with the front removed, talking about different kinds of drawing and gradually guiding them towards an appreciation of how to make a sectional view. After this preparation children may apply their observations to the making of diagrams, that is, sectional drawings, of their own houses.

If children are now asked to design houses to shelter mythical or other unusual creatures, their drawings take on another kind of purpose and quality, with imagery that is both diagrammatic and expressive (Fig. 43).

All these ways of understanding houses have valuable functions. They involve children in recording, analysing, conjecturing, imagining and communicating ideas and information. It is essential for teachers to use these strategies if drawing is to become a useful educational tool for all children. Yet, too often, in primary schools the aim of drawing is 'to make a drawing' rather than to use it as a means for communication and thinking or for the expression of ideas and feelings (Fig. 44).

The most objective function of drawing is to describe or record the appearance and quality of things in the environment, whether for the pleasure of rendering or for gathering basic information. The 'simple' act of looking, very closely and carefully, at figures and objects does in itself provide a strong stimulus for children. It is a better use of time than any amount of copying from pictures or photographs.

This is what the castle of camelot might of looked like.

43 Transactional drawing (6 years) of a mediaeval castle in association with a fiction-based project 'Dragon Days'.

Drawing is a very important way of looking, whereby the individual can relate to the particular qualities, relationships and feelings of the thing observed. Through the response and handling of the chosen medium, confidence to interpret rather than to copy will be achieved [3].

This kind of drawing begins with the desire to record appearances, but, in practice, it is both descriptive and expressive. The physical experience of engaging with a real object has a dynamic effect, by evoking previous associations and by provoking new ideas. Consider how some children portrayed their teacher's teddy bear, her favourite toy. The drawings show how they were engrossed with the rounded

44 Observational drawing (10 years) in the North Devon landscape.

shapes of the bear's body and limbs and furry texture, as well as with the expression of its emotional importance to their teacher (and, most likely, to themselves through associations with their own teddy bears). Such emotional engagement or value extends drawing beyond the act of description.

There are two essential ways in which the teacher can assist children to make observational drawings – through supportive talk and with appropriate materials. The key element is to harness the talk to the use of materials. The importance of talk: describing, questioning, analysing, cannot be overemphasised. It is through talking, as much as through looking, that children develop clarity and sensitivity. For example, a careful sequence of questions can help them to select what is of importance. The making of comparisons is a direct way to foster visual skills. With careful observation children see subtleties of form, colour and texture.

One way to do this is by pointing out the differences between two similar things. These can be simple objects, such as leaves, or more complex ones like houses. There are also classroom 'games' – for instance, 'the finger request' in which children are asked to draw one of their fingers so precisely that its model can be identified straight away! Similarly, each individual within a group of children sitting round a table may be asked to draw a facial feature of another child, such as an eyebrow or nose, so distinctively that it can be matched with its owner.

Just as talk assists children to sort out what they are drawing, so do various kinds of focusing devices. The basic one is the viewfinder, which

isolates a selected object or part of a scene from its background. It is easy to make, by tearing a small hole in a paper or by cutting a rectangle in card (Fig. 45). Another kind of focusing device is a magnifying glass or lens. Along with its accepted function of enlargement (important!: to see details more clearly), it offers an imaginative bonus by presenting familiar things in new contexts.

45 Selecting and focusing (10 years): using a viewfinder to make 'snapshot' drawings from the environment.

'Metamorphosis' through dramatic change of scale is an important method for visual stimulation. For instance, viewed through a magnifying glass, wood lice become lumbering monsters, a cluster of television valves become space city. Scale can also be changed by placing things upon an overhead projector; see them fill the whole wall. After these experiences, the teacher will be more readily able to use discussion to bring about an imaginative focus.

To shift 'looking' into another context merely ask children to 'see' or imagine something in a different scale or from a different point of view – for example, the garden seen from the characteristic viewpoints of birds.

Observation can also be heightened through the sense of touch. Sensitive feeling (accompanied by discussion) helps to increase our understanding of the surfaces of objects and figures. For instance, in preparation for drawing self-portraits, ask children to explore the contours of their faces very gently with their fingers. Another approach is 'blind' drawing, which is made entirely through the sense of touch, by concealing an object in a bag or box and/or by keeping eyes shut.

Modifications such as these help to transform the routine processes of observation and recording, and thus place them firmly within an imaginative context. The child who carefully renders an old boot is engaged in one kind of drawing. The child who explores the surface of the old boot through a tiny viewfinder, like a space traveller hovering over a strange planet, will respond in a different way, with imagery that corresponds to his or her perception. Together they may be seen as an expression of the truism that children's responses through drawing are best based upon 'real experience'.

Drawing across the curriculum

Drawing has always had an important part to play in many aspects of the primary school curriculum. The increasing emphasis upon the grounding of learning in real experiences strongly affirms this, and means that drawing, in its many forms, is more critical for the acquisition of knowledge in the humanities as well as in the sciences. These forms range from a pictorial map to a serial story, and include modes of representation from literal and objective images to symbols, diagrams and abstractions. The common denominator is communication.

Particularly good use of drawing may be made in the teaching of environmental studies. One of most popular tasks is the serial story, a sequence of events or stages – for instance, the transition from spawn to a tadpole to a frog. What is surprising (given the significance of the comic strip) is that relatively little use is made of children's familiarity with this convention. It would be practical to capitalise on this interest by involving children in problems that use techniques of graphic design, rather than leaving them to copy the comic strip characters.

In addition, children are familiar with a whole host of other forms for visual communication and these, too, might serve as 'triggers' to stimulate activities. Road signs, badges, games, playing cards, picture puzzles are genuine challenges for the involvement of children in the awareness and creation of their own visual culture. It is essential that the making of images (including symbols and diagrams) shall be an integral part of communicating ideas and information, and not simply their decoration.

In the early years of schooling most children use drawing in association with other subjects such as language, to convey information as well as to express feelings and ideas. For them, the interaction between imagery and language is both natural and dynamic. With schooling, they learn to discriminate between verbal and visual language, recognising the distinct functions of both.

This split can lead to an impoverished use of drawing, bolstering the assumption that it is an inferior form (rather than *another* form) of communication in comparison to language. This certainly happens in those schools where drawing is a secondary activity, used like a visual aid to illustrate what has already been observed in words or numbers. Yet, much of the good work in science and technology demonstrates how children are using different kinds of drawing in instrumental ways to facilitate their investigations.

Conclusion

The use of drawing, as a discrete activity, is well established in many primary schools. The vast majority of teachers encourage children to draw as a form of story telling. In recent years, there has been a marked increase in the teaching of observational drawing, which is being taught and used well.

Drawing becomes a significant agent for learning in those schools where it is normal to use a wide range of methodologies (or strategies). Where children are encouraged to observe, to invent, to investigate and to analyse the appearance of the real world through drawing, they are better able to communicate ideas and information. The reality of drawing for children should be its central role in their education. When drawing is used in splendid isolation or simply to decorate work, it will move inevitably to the periphery of their learning.

Notes and References

1 CLEMENT R. (1986), *The Art Teachers' Handbook* (London, Hutchinson), p. 12. For further background discussion about drawing in the classroom, see Chapters One and Two.
2 The task relating to memory of 'own' house could be extended to the association between 'my house' and 'my home', for instance, by contrasting the visual memory of 'my house' with other kinds of memories related to 'my home', for example, smells, sounds, even family relations. Discussion about 'home' will stimulate more expressive rendering of 'house' imagery.
3 GENTLE K. (1978), *Learning through Drawing* (Bradford, Art Galleries and Museums for the North Eastern Region of the Association of Advisers in Art and Design).

Bibliography

BARRETT M. (1989) *Around my house: An enquiry into the development of children's drawings of the environment* (unpub. MS).
DE BONO E. (1971), *The Dog Exercising Machine* (Harmondsworth, Penguin).
CLEMENT R. (ed) (1978), *Art 7–11* (London, Schools Council).
CLEMENT R. (1979), 'Children's use of drawing', *Athene*, 68.
DUBERY F. and J. WILLATS (1972), *Perspective and other drawing systems* (London, Studio Vista).
KELLOGG R. (1970), *Analysing Children's Art* (Palo Alto, Cal., Mayfield).
VERNON M. (1962 [71]), *The Psychology of Perception* (Harmondsworth, Penguin).
WILLATS J. (1977), 'How children learn to draw realistic pictures', *Quarterly Journal of Experimental Psychology*.

Acknowledgements

The drawings in this chapter are by children from Thornbury Primary School, Plymouth, Devon, where the head teacher is Liz Tarr and the curriculum leader for Art and Design is Annette Mason. The photography is by John Mason. I would like to thank them.

Chapter Twelve

NANCY R SMITH Development of the Aesthetic in Children's Drawings

In England drawing from observation is a staple of the curriculum; but in the USA it is rarely taught to children of five to eleven years. In fact for the last fifty years or so in the United States art teachers have been taught that younger children are unable to draw from nature and that such drawing is detrimental to their natural ability and creativity. However, it is evident from research [1], as well as British and European practice, that children do draw from observation, but that they use systems of representation consistent with their age. Observation drawing, it would seem, is a possible component of education if children's own systems of representation are respected.

Why might it be beneficial? It makes use of a number of human abilities; first and most obvious are visual analysis and inquiry. In addition and more important are aesthetic analysis and response. In a book on drawing, the artist Nathan Goldstein labels drawings that are motivated by the wish to inquire and experience as responsive.

> Here responsive refers to our perceptual, aesthetic, and empathetic interpretations of a subject's properties that hold potential for creative drawing. In responsive drawing, comprehending a subject's actualities precedes and affects the quality of our responses. Such drawings do more than recall what our outer or inner world looks like. They tell us what our intuitive knowledge informs us it is [2].

The process of creating a responsive drawing causes the maker to become aware of elusive qualities of subjects as well as the obvious. It offers children one of the few occasions in school in which they may create forms using aesthetic, intuitive, and objective responses at one and the same time. The shaping of such images must help, in the words of Dewey [3], to 'concentrate' and 'enlarge' experience. It seems destined to assist children in building a more holistic construction of reality.

Observation drawing can be beneficial. In fact, understood as *responsive* drawing it has comprehensive and fundamental goals – goals well beyond the technical such as learning perspective and illusionistic rendering. It assists children to develop greater awareness and comprehension of the world around them using objective, intuitive and aesthetic modes.

The nature of the aesthetic

It is a fundamental assumption of this paper that a phenomenon called *physiognomic perception* is natural in human beings and that it is a basic

foundation of the aesthetic in the work of children [4]. We are familiar with it in study of the elements of design (line, shape, texture, colour). These are understood in contemporary artistic theory and practice to be dynamic in nature. Many texts on art as well as most design courses refer to this aspect of them. For example, Arnheim explains why artists consider movement so fundamental:

> If 'movement' is absent, the work is dead; none of the other
> virtues it may possess will make it speak to the beholder. The
> dynamics of shape presupposes that the artist conceives of
> every object or part of an object as a happening rather than a
> static bit of matter, and that he thinks of the relations between
> objects not as geometric configurations but as mutual
> interaction [5].

In art it is commonplace to think of graphic elements such as lines or shapes as moving, fluid, excited or in interaction with each other, even though in reality they lie immobile on paper. This kind of understanding was called physiognomic perception by the great developmental psychologist Heinz Werner [6]. In *physiognomic perception* both subject matter and design elements may be perceived in a 'dynamic vectorial, global-holistic, affective' mode because they are predominantly understood through the motoric and affective attitude of the percipient. Werner demonstrated that the physiognomic is a primary mode of perception for young children, and noted that:

> Though physiognomic experience is a primordial manner of
> perceiving, it grows, in certain individuals such as artists, to a
> level not below but on a par with that of geometric – technical
> perception and logical discourse [7].

All humans have a potential for it, but some (for example, artists) are more aware and skilled in using it than others. It is a mode of thought that can function either unconsciously or in awareness. We use it intentionally or it may be evoked by objects or events. It is used for two functions in adult observation drawing. Typically, the artist directs aesthetic consciousness towards an object, searching for characteristics such as the movement of its lines and shapes. Then the artist focuses on graphic features of the drawing, seeking to establish similar or responsive aesthetics in them; thereafter he or she returns to the object, and so on, back and forth. In this back and forth process the artist comes to see and to formulate aesthetic nuances in the object and in the graphic elements.

As we have noted, aesthetic observation drawing of this sort is accessible to children through physiognomic perception and contributes to a more complete formulation of experience for them. Observation drawing can be a beneficial component of art curricula if the aesthetic receives sufficient emphasis to counteract our misunderstanding that observation drawing is simply correct replication of an optic array.

Observational drawing and perception

The aesthetic has been much ignored in studies of observation drawing. One reason probably is that we have a misconception about representa-

tion. We tend to think that 'correct' observation drawing is simply a faithful record of perception. This conception ignores the complexity of perception as well as artists' practice of using different systems of representation depending on their intention and culture [8]. Relying on this erroneous conception, researchers typically have either (i) ignored the possibility that drawing systems constitute an intervening variable between subject and drawing or (ii) have designed studies as if only one fixed and unitary system prevailed.

A number of studies have involved children in drawing from observation. Some of these used observation drawing to study children's cognition [9]. Others have tracked development in drawing [10]. Still others have used it to examine children's drawing processes [11]. In these different instances, no matter what question is under study, an underlying assumption of most has been that the purpose of observation drawing is to make an objective record of a stimulus.

But children's drawing processes depend on their development (including experience) and on their intention. Children make different types of images depending on their understanding of the task [12], and follow different systems than those of adults [13]. The process of making a drawing includes selecting appropriate systems for the particular task at hand from a larger repertoire – a repertoire developed over time.

Development redefined

The conceptualisation of development consonant with this view of drawing is different from Piaget's model of mutually exclusive cognitive stages that replace one another, or Lowenfeld's age-linked image descriptions. It proposes that with age children acquire an increasing number of graphic languages from which they may choose. Wolf and Perry, who are the authors of this formulation, conceive of development in drawing as yielding a *repertoire* of visual languages.

One of the subsets within the concept *repertoire* is drawing systems. They define a drawing system as:

1 rules specifying the kind of information it is crucial to
represent (for example, characteristic motions, position, size,
and so on); and
2 rules regarding which aspects of the individual drafter's
behavior (for example, his motions, speech, marks, and so on)
are entitled to carry meaning [14].

Recognisable systems are used by children as young as twelve to fifteen months and increase in number from that time on. No one drawing system is considered the fixed end state of development; instead there is a group of drawing systems which children come to know along with an understanding of the obligations and powers of each. Later languages do not supplant or replace earlier ones, but are added to the *repertoire* while the earlier become more focused and articulate.

Development of the aesthetic

To teach the aesthetic appropriately, teachers need to have a sense of its development. With that need in mind, I carried out an informal study using 200 observation drawings made by boys and girls, in low, middle, and high income private and public schools [15]. Most were made in art classes in public schools as a regular part of the curriculum. The drawings were sorted into age levels. The youngest group included ages five and six; the older, ages seven and eight; and the oldest, ages nine, ten and eleven. Each age grouping was then examined for aesthetic, more specifically physiognomic, use of line, shape and texture. The several trends that emerged are described below, beginning with those in use of line.

Aesthetic use of line

Energetic movement, revealing its origin in gesture was a primary characteristic of line for children of five and six years. For example, Sean F., age five, drew the school yard hill, with tree, climbing apparatus and a slide embedded in the side of the hill (Fig. 46).

46 SEAN F. (5 years): drawing of school yard, hill, tree, climbing apparatus and slide.

133

The long continuous line representing the silhouetted contour of the
hill and tree, is active and moving. It is segmented, combining five
different types of movement. The line (i) starts at the left rising and
falling in relatively even undulations of moderate tempo, (ii) turns 90
degrees and travels quickly upward in a straight line, (iii) inscribes
almost a full circle of great energy and irregular rhythms in a rapid series
of uneven short arcs, (iv) descends quickly, (v) turns another 90 degrees,
and then (vi) inscribes a slow, even curve that descends with a long
smooth slope on the right. Each segment of the line is active in and of

47 JON (7 years): drawing
of a figure wearing
crumpled jacket.

itself, but, joined as they are, the contrast between one segment and the next heightens the impression of movement. The motoric emphasis of Sean's drawing is particularly evident in his energetic rendering of the top of the tree, in which the shapes and sizes of the arcs derive very much from body movement.

The older (seven and eight years) children's work displayed more variations in line movement and direction, as well as variation in weight and darkness. They used a greater variety of characteristics including stolidity, nervousness, and awkwardness. Jon, age seven, created awkward energy by drawing irregular rhythms for the curves and angles in the folds of the jacket (Fig. 47). His use of line movement is more articulate than Sean F.'s, making possible this awkward irregular movement.

The oldest (nine, ten, and eleven) children exhibited more consistency and control together with more variety. Greater control enabled them to add focus and more complex characteristics as is evident in ten-year-old Sean H.'s still life (Fig. 48). The many smooth contours are

indicated by a line with minor irregular oscillations and changing weight. The changing weight and irregularity convey movement. The irregularity of line also interacts with the different playful textures created for the woven hat on the right, for the hat and veil in the upper centre, and for the broken hat in the lower left. The lopsided cylinders of the tin can, cup and hat add an eccentric air to the drawing. Each of these characteristics – irregularity of line, playful textures and eccentric cylinders – helps to create a somewhat whimsical and puckish quality giving unity to the drawing as a whole.

48 SEAN H. (10 years): drawing of still life with hats.

Aesthetic use of shape

An analogous pattern of development was found in shape. The youngest children again used movement but also weight (physiognomic perception of the heaviness-lightness of a shape). Movement and weight are combined, for example, in the drawing of cactus plants by Siobhan, aged six (Fig. 49). Weight is conveyed by the simple, squat pot fronts and oblate cactus leaves; nevertheless, because of the vertical axes of these shapes, they thrust upward, seeming almost to pull their bulk up off the bottom of the paper.

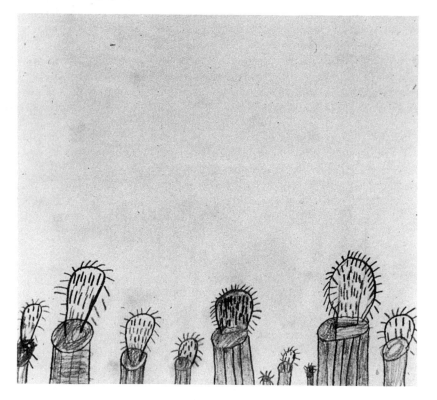

49 SIOBHAN (6 years): drawing of cactus plants.

Older children exhibited a greater variety of aesthetic characteristics in shape, among them stability and rhythm, while the oldest children demonstrated repetition and variation of location, size, proportion, and texture of shape, thus creating patterns. They made tension in shapes by contrasting smooth curves and awkward angles. They were able to control movement along a contour and coordinate it with defining a shape and to inscribe more articulated proportions. For example, Ben, aged nine, in drawing a live rabbit (Fig. 50), made slight modulations in the sweeping arc of the contour. The large proportion of the body shape contrasted by smaller details such as ears, nose and feet helps to indicate the weight and mass of the rabbit. The contrast between Siobhan's drawing of cacti and this drawing offers a good illustration of how articulation of weight develops. These trends in the expanding use of shape were similar to those of line.

136

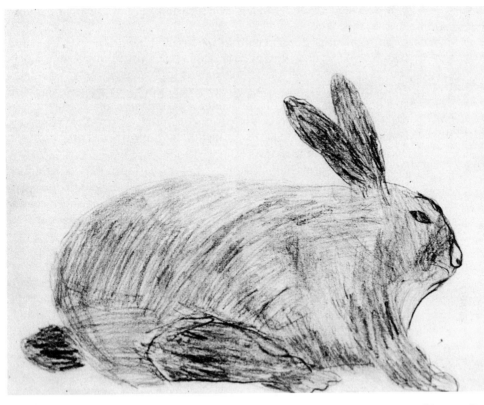

50 BEN (9 years): drawing of a live rabbit.

Aesthetic use of texture

Unlike line and shape, texture was absent from the drawings of younger children except when evoked by conspicuous texture in a subject. It may be that since texture is a less salient identifying property than shape it is less likely to be employed by younger children unless strongly evoked.

When prompted, the younger children displayed several methods of rendering texture. Some used repetition of a basic line or shape, for example rendering dragon scales by many separate rectangles or the bristling thorns of cactus plants by rows of straight lines. These repetitions tended to convey a feeling of obsessive numerosity. Other children chose to convey the tactile kinesthetic quality of textures, for example, rendering dragon scales by many parallel wavy lines, conveying nervous movement. Other children drew simply a generalised indication, as for example, the filling-in scribbly lines of Sean F.'s hill, conveying an overall irregularity.

Older children were less motoric and more specific. They could contrast different textures such as the wispy softness of hair against the crisp ridges of jacket cuff. They began to imply surface with texture and used filling-in to suggest mass and local colour.

The oldest children began to render different textures all within an expressive style, as for example in Sean H.'s whimsical drawing of hats. They indicated surfaces *per se*, often simply using a filling-in technique

137

and occasionally rendering light on a surface. Some conveyed qualities such as the hardness of metal or the fragility of a shell.

To summarise development in the aesthetic use of line , shape, and texture: due to their special awareness of action and movement and to the concreteness of their understanding, younger children display aesthetic features conveying movement in lines and shapes, weight in shapes, and the numerosity of elements in or tactility of a texture. Older children add more differentiated qualities such as stolidity, hesitancy, awkwardness, tension and continuity. In addition, they contrast specific textures. Finally, the oldest children demonstrate more focus and more articulation, displaying aesthetic properties such as playfulness, rhythmic unity, the interplay of textures within a style, and the presence of surface. Their drawings offer both more variation and more consistency in line, shape, and texture. In general, there is an ever-expanding repertoire of aesthetic characteristics from which children choose.

Conclusion

In this survey of observation drawings children readily included the aesthetic in their drawings. It was indeed remarkable how well physiognomic joined with objective characteristics in these drawings. It may be that the early union of aesthetic and objective is a developmental phenomenon; the two may be relatively undifferentiated to begin with and gradually become demarcated over time. Thus, children's effort may not be to integrate but rather to differentiate the two. Certainly expansion of the repertoire of physiognomic characteristics during the middle years and the increased focus and coordination of characteristics during later years tend to support this conjecture.

Evidence of the presence and natural development of the aesthetic in observation drawing is of primary importance educationally since it demonstrates that it is possible for children to concentrate and enlarge experience through drawing.

Teaching implications

Children draw from observation naturally but they often need help in understanding that the task in art is responsive drawing. In teaching them how to look when drawing, it is important to help them attend to aesthetic characteristics of objects as well as more objective features. Similarly, it is important to respond to aesthetic characteristics in children's drawings, pointing them out and helping children to become more aware of the presence and power of this aspect of drawing. Finally since there is change with age in their use of the aesthetic, lessons and responses should be developmentally attuned to the child. This chapter has offered a preliminary sketch of their growing repertoire that teachers will want to flesh out as they teach children to draw responsively.

Notes and References

1 LEWIS H. P. (1985), 'Children's drawings of cubes with iterative and non-iterative sides', *Studies in Art Education*, 26, 3, pp. 141–46; SMITH N. R. (1983), 'Drawing conclusions: do children draw what they see?', *Art Education*, 36, 5, pp. 22–25; SMITH N. R. (1985), 'Observation drawing: changes in children's intention and translation methods, Grades K-6', in KOROSCIK J. and T. BARRETT (eds), *Proceedings of the American Educational Research Assoc. 1985 Annual Meeting: Arts and Learning SIG*, 3, pp. 47–62; WILLATS J. (1981), 'What do the marks in the picture stand for? The child's acquisition of systems of transformation and denotation', *Review of Research in Visual Arts Education*, 13, pp. 18–33.

2 GOLDSTEIN N. (1977), *The Art of Responsive Drawing* (Englewood Cliffs, NJ, Prentice-Hall), p. xi.

3 DEWEY J. (1934 [58]), *Art as Experience* (New York, Putnam).

4 SMITH N. R. (1979), 'Developmental origins of structural variation in symbol form', in SMITH N. R. and M. B. FRANKLIN (eds), *Symbolic Functioning in Childhood* (Hillsdale, NJ, Lawrence Erlbaum Assoc.), pp. 11–26.

5 ARNHEIM R. (1954 [74]), *Art and Visual Perception* (Berkeley, California University Press), p. 434.

6 WERNER H. (1940), *Comparative Psychology of Mental Development* (New York, Harper).

7 WERNER H. (1957 [78]), 'The concept of development from comparative and organismic point of view', reprinted in BARTEN S. S. and M. B. FRANKLIN (eds) *Developmental Processes: Selected Writings of Heinz Werner, vol. 1*, (New York, International Universities Press), (1978) p. 123. See also SMITH (1979) (n.4).

8 DUBERY F. and J. WILLATS (1972), *Drawing Systems* (New York, Putnam); HAGEN M. (1986), *Varieties of Realism* (New York, Cambridge University Press).

9 PIAGET J. and B. INHELDER (1948 [56]), *The Child's Conception of Space* (London, Routledge).

10 CHEN M. J. (1985), 'Young children's representation of solid objects: a comparison of drawing and copying', in FREEMAN N. H. and M. V. COX (eds) (1985), *Visual Order* (New York, Cambridge University Press), pp. 157–75; CLARK A. B. (1902), 'The child's attitudes toward perspective problems', *University of California Studies in Education*, 1, pp. 283–94; COX M. V. (1985), 'One object behind another; young children's use of array-specific or view-specific representations', in FREEMAN and COX (op. cit.); LEWIS (n.1).

11 COLBERT C. and M. TAUNTON (1988), 'Problems of representation; preschool and 3rd grade children's observational drawings of a three dimensional model', *Studies in Art Education*, 29, 2, pp. 103–14; FREEMAN N. H. (1980), *Strategies of Representation in Young Children* (New York, Academic Press); PHILLPS W. A., S. B. HOBBS and F. R. PRATT (1978), 'Intellectual realism in children's drawings of cubes', *Cognition*, 6, 15, pp. 15–33; WILLATS (n.1); WILLATS J. (1985), 'Drawing systems revisited: the role of denotation systems in children's drawings', in FREEMAN and COX (n.10), pp. 78–100; WILLATS J. (1987), 'Marr and pictures: an information processing account of children's drawings', *Archives de Psychologie*, 55, pp. 105–25.

12 WOLF D. and M. D. PERRY (1988), 'From points to repertoires: some new conclusions about drawing development', *Journal of Aesthetic Education*, 22, 1, pp. 17–34.

13 SMITH N. R. (1979), 'How a picture means', *New Directions for Child Development*, 3, pp. 59–72; SMITH (1983, 1985) (n.1); SMITH N. R. and C. FUCIGNA (1988), 'Drawing systems in children's pictures: contour and form', *Visual Arts Research*, 14, 1, pp. 66–76; WILLATS (1981) (n.1).

14 *Ibid.*, (n.12) pp. 19–20.
15 I would like to thank Carolee Fucigna, Margaret Kennedy, and Dennie Wolf for their thoughtful comments on an earlier draft of this paper. In addition, I would like to acknowledge the many contributions of The Drawing Study Group. This group of eight teachers has met regularly since 1983 to carry out research and curriculum development in observation drawing. Discussions in the group have helped to shape my ideas and the drawings used in this study were from classes taught by group members. The members of The Drawing Study Group are Laraine Cicchetti, the Neighborhood Art Center, Boston, Massachusetts and Beverly Public Schools, Beverly, Massachusetts; Peggy Clark, Medford Public Schools, Medford, Massachusetts; Carolee Fucigna and Margaret Kennedy, Eliot Pearson School, Tufts University and The Center for Children, Waltham, Massachusetts; Barbara Gordon and Barbara Halley, Brookline Public Schools, Brookline, Massachusetts; Helen Werner London, The Neighborhood Art Center, Boston, Massachusetts; and myself, Nancy R. Smith, Boston University and The Center for Children, Waltham Massachusetts. The Neighborhood Art Center, no longer in existence, ran programmes for inner-city children. The Center for Children is a nursery school.

Chapter Thirteen

JOHN WILLATS What *is* the Matter with Mary Jane's Drawing?

What is the matter with Mary Jane?
She's perfectly well and she hasn't a pain,
And it's lovely rice pudding for dinner again!
What *is* the matter with Mary Jane?

<div align="right">A. A. Milne [1]</div>

Introduction

According to Piaget in *The Child's Conception of Space*:
> [The young child] appears to be rooted to his own viewpoint in
> the narrowest and most restricted fashion so that he cannot
> imagine any perspective but his own [2].

For Piaget, the development from childhood to maturity depends on the progressive abandonment of one's own limited, egocentric point of view; but as A. A. Milne's poem suggests even adults can find it difficult to understand someone else's point of view when it comes to disliking rice pudding.

The Child's Conception of Space was Piaget's major work on spatial representation in the child. In it he claimed that the young child's conception of space, and his or her early drawings, are based on topological rather than projective geometry. Older children, Piaget thought, based their drawings first on Euclidian geometry and then, finally, on projective geometry. Drawings based on projective geometry represent objects from a particular point of view; while drawings based on topological geometry represent spatial relationships like 'touching' and 'inclusion' which are intrinsic to the scene, and independent of any particular point of view. According to Luquet's theory of intellectual and visual realism, on which Piaget's account of drawing was based, it is only older children who draw views of objects from single, coherent viewpoints [3].

The snag is that Piaget's account of the development of spatial representation seems to be completely at variance with his theory of egocentrism. On the one hand the young child is supposed to be 'rooted in his own viewpoint'; and on the other hand his drawings are supposed to represent only those spatial relationships which exist independently of any particular point of view. How did this contradiction come about?

Morss has recently pointed out that Piaget's theory of egocentrism seems to consist of two different strands: 'social egocentrism' and 'spatial egocentrism'; and it is this second strand of spatial egocentrism which is in conflict with Piaget's theory of spatial development – what Morss calls Piaget's 'alternative' theory [4].

Social egocentrism is egocentrism in an interpersonal sense: the child's supposed inability to understand how someone else might actually enjoy rice pudding, for example. This is the sense in which Piaget originally used the term 'egocentrism'; and at that time he explicitly rejected a literal, spatial interpretation [5].

Spatial egocentrism appeared in Piaget's work as a result of the findings of Edith Meyer, who carried out the original 'three mountains' study. In the first experiment the child was asked to place a doll in a model landscape in a position from which the doll could take a 'photograph' similar to a picture shown to the child. In the second experiment the child was asked to select a picture corresponding to a picture taken by the doll, placed in position by the experimenter. In the third and final experiment the child was asked to construct a representation of the doll's view.

The results of the first two experiments suggested that young children had no understanding of individual viewpoints or different perspectives. However, the results of the third experiment led Meyer to claim something different: that the children chose not just any, arbitrary perspective as the doll's view, but *their own perspective*. It was this interpretation of the results that Piaget adopted in support of his theory of spatial egocentrism.

Unfortunately, this theory conflicts with the alternative account of spatial development which occupies most of *The Child's Conception of Space*. One chapter presents the case for spatial egocentrism, based on Piaget's interpretation of the results of the 'three mountains' study. The rest of the book develops Piaget's *alternative* theory that the child's understanding and ability to represent spatial relationships begins with topological geometry. Piaget cites Luquet's work on children's drawings in support of this theory, as well as introducing empirical evidence to show that it is only older children who can represent the shapes of objects as they are seen from a particular direction of view. Young children will, for example, use a line to stand for a pencil even when it is pointing directly towards them.

Piaget treats the theory of spatial egocentrism as if it were compatible with this alternative theory, whereas in fact the two theories seem to be in conflict. Which of them is correct? Morss argues that Piaget's interpretation of the results of the 'three mountains' experiment, on which the theory of spatial egocentrism rests, was not justified, and that the theory had not fared well in the light of recent theoretical developments [6]. On the other hand:

> The alternative theory...derives more directly from empirical foundations, including studies on children's drawings and on spatial representation. It presents important consistencies and convergences with recent non-Piagetian work, and should play a part in contemporary discussion [7].

I have drawn attention to this rather complicated issue because it is Piaget's claim that the young child's drawings are based on topological rather than projective geometry which provides the most radical alternative to Margaret Hagen's recent suggestion that all 'successful' pictures

142

are based on *projective* geometry. In Hagen's opinion all successful pictures are derived from the geometry of the optic array, and therefore show possible *views*. She writes:

> ... all successful representational pictures make available to the beholder the same kind of visual information as does the ordinary environment. ...
>
> My position is that representational pictures, all representational pictures from any culture or period in history, exploit the fact of natural perspective, the geometry of the light that strikes the eye. They succeed as representations because they provide structured visual information equivalent to that provided by the visual scene represented [8].

Dubery and Willats showed how a categorisation system based on projective geometry (the 'drawing systems') could be used to describe pictures by adult artists taken from a wide variety of periods and cultures [9], and I have argued that the same scheme could be used to analyse pictures by children aged five to seventeen years [10]. Hagen used substantially the same scheme to describe pictures by adult artists, again from a variety of cultures, and pictures by untrained adults and children aged six to ten [11]. She identifies the first of her categories, 'metric geometry', with Euclidian geometry; and her last category, 'projective projection', appears to be the same as Piaget's 'projective geometry' – that is, both appear to be equivalent with what is usually called 'linear perspective'. In all these descriptions of pictures by adults and older children there is much common ground.

Fundamental differences arise, however, in formal descriptions of pictures by younger children, and in accounts of the processes underlying picture production and the nature of drawing development. I am concerned here with the first of these questions: the question of whether drawings by young children can best be described in terms of projective geometry, or whether, as Piaget suggested, some other kind of geometry must be used. In order to understand the positions taken by the various protagonists, however, it is necessary to glance at the psychological issues involved.

Hagen specifically excludes from her analysis all 'unsuccessful' pictures. Unsuccessful pictures include pictures in divergent perspective, which Hagen does not regard as a coherent or characteristic style, and 'the unskilled drawings of children' [12]. I am not quite clear how wide this last category is intended to be, and it is introduced in order to exclude children's drawings as art, rather than as representations. Presumably, however, it includes children's drawings in 'divergent perspective', 'fold-out' drawings, and drawings by very young children – drawings in fact which cannot be described in terms of views: 'Indeed', she says:

> I have defined 'representational picture' to mean one that looks like the world, even to the relatively naïve [13].

The question of what constitutes a 'good' or 'successful' representation is a much debated one; but I think Hagen is correct in saying that pictures only 'look right' if their geometry corresponds, more or less, to

the geometry provided by a cross section of the optic array from a real scene. Again, so much is common ground [14]. However, this leaves unexplained the question of how to describe pictures, particularly children's drawings, which do not fit this formula – drawings which might well, in some quarters, provoke the question in my title: 'what *is* the matter with Mary Jane's drawing ?'.

Hagen's answer is a lofty disregard:

> In my opinion, the only stage of real interest for the
> development of picture-making skills *per se* is the last one, what
> Lark-Horovitz *et al* call the True-to-appearance stage [15].

Drawings which do not conform to one or other of the canons of projective geometry are simply the result of lack of skill:

> By drawing skills I mean something other than simple motor
> control; I mean cultural canons. Children's fine motor
> development improves with practice, just as does that of the
> adult learning a new skill like knitting or drawing. So one could
> plot the development of motor control in the creation of
> drawings if one wished. But neither the mastery of specifically
> taught canons nor the acquisition of motor skills is reason for
> the excitement generated by those who espouse the theory that
> drawing undergoes a developmental progression with ordered
> stages that differ qualitatively from each other. The assumption
> that drawing exhibits a truly developmental character implies
> significant age-related changes in the perceptual and cognitive
> components that underlie the understanding as well as the
> generation of representation. There may be such changes that
> occur in infancy, but the data do not provide evidence of their
> existence in childhood or later life [16].

Thus there is general agreement that most (although in my opinion by no means all) adult pictures can be described in terms of projective geometry. The difficulty is how to describe drawings by younger children. Hagen's answer seems to be either that they too are based on projective geometry, but look wrong because they are badly drawn; or that they are simply not worth considering. Piaget's answer is that they look different because they are based on topological rather than projective geometry. The following section describes some recent experimental evidence which suggests that Piaget's answer is correct, so far as it goes. However, the term 'topological' only refers to the way spatial relationships are represented in pictures: that is, the way the marks in the picture go. To give a full account of children's drawings we also need to consider what the marks stand for.

Experimental evidence

Pictures may be derived from objects or scenes using two sets of rules: the drawing rules, like the rules of perspective, which say where the marks in the picture *go*; and the denotation rules, like the rules which govern line drawings, which say what the marks in the picture *stand for* [17]. In the case of pictures based on topological rather than projective

144

geometry the drawing rules preserve spatial relationships like 'touching' or 'enclosure'. The first experiment to be described – by Light and MacIntosh – investigated the nature of the drawing systems used by children when drawing objects set behind, or within, other objects [18]; the second – by Moore – investigated the denotation systems which children used in drawing a cube [19].

Light and MacIntosh asked six and seven year-old children to draw two plastic funnels, placed one behind the other with respect to the child's viewpoint. As they expected, some of the children (about one third of them, in fact) drew the further funnel partially occluded, and the rest of them drew the two funnels separately, either side by side or one above the other. Light and MacIntosh then asked the children to draw another two scenes in order to test whether the children who avoided using partial occlusion did so because of production difficulties (lack of 'skill'). The first of these scenes consisted of a model house placed behind a glass beaker, and the second consisted of a model house placed *inside* the beaker. The view the children had in each case was virtually identical, so Hagen's theory would predict that the children should produce similar drawings in each case. Alternatively, we would expect that children who were basing their drawings on topological geometry would produce different drawings, because the topological relationship between the house and the glass was different from one scene to another.

Apart from one child who refused to draw either arrangement, all the children produced what Light and MacIntosh called 'unified' drawings for the 'inside glass' arrangement, whereas almost half produced 'separate' drawings for the 'behind glass' arrangement (Fig. 51). These results suggest that many of the children distinguished between the topological relationships of 'enclosure' and 'exclusion', even though the projective view they had of the arrangement was the same in each case. Thus for the 'inside glass' arrangement many of the children drew the house literally within the confines of the depicted glass on the picture surface, whereas they drew it outside the glass (either above or to one side) for the 'behind glass' arrangement. In this experiment, then, many of the six and seven year-olds used topological rather than projective geometry as a way of representing spatial relationships.

51 A typical pair of drawings obtained when the (left) 'inside glass' and (right) 'behind glass' arrangements were presented simultaneously to 6 and 7 year-olds. From P. LIGHT and E. MACINTOSH (1980), 'Depth relationships in young children's drawings', *Journal of Experimental Child Psychology*, 30, pp. 79–87.

52 Typical drawings
obtained when (left) 7
year-old and (right) 9 year-
old children were asked to
colour in their drawings of
a cube. From V. MOORE
(1986), 'The use
of a colouring task to
elucidate children's
drawings of a solid cube',
*British Journal of
Developmental Psychology*,
4, pp. 335–40.

The use of a denotation system different from that used by adults is illustrated in drawings obtained by Moore from seven and nine year-olds. Each child was shown a cube with a different colour on each face, and asked to draw the cube in pencil. When the drawing was finished the child was offered a selection of coloured felt-tipped pens, and asked to colour in the drawing. Many of the children produced an initial drawing which consisted of a single square. As Mitchelmore [20] has pointed out, such drawings may either represent one face of the object viewed front-on, or an outline of the object as a whole. This distinction was made clear when the children were asked to colour in the drawing. The two nine year-olds used just one colour, showing that their drawing represented a view of the cube. All the seven year-olds, in contrast, filled in the outline with six colours in horizontal or vertical stripes (Fig. 52).

52 Typical drawings obtained when (left) 7 year-old and (right) 9 year-old children were asked to colour in their drawings of a cube.

I myself obtained somewhat similar results when I asked children of various ages to draw a die presented to them in a face-on view [21]. The older children drew a square with just three dots in it, corresponding to the view they had of the front face; but some of the younger children drew squares containing a large number of dots, and one child drew a square containing all the dots on all the faces of the die in sequence (Fig. 53).

53 Drawing obtained when children were asked to draw a large die presented face-on: (left and centre) 6 year olds, and (right) 8 year-olds.

Again, these results show that children of different ages use different drawing rules. Drawings of a cube, or a die, by older children, can be described in terms of projective geometry: their drawings represent a legitimate view (that is, they are 'successful', to use Hagen's term), and

they employ a denotation system in which the lines stand for edges. In contrast, the drawings of the die by the younger children do not provide a possible view: in Hagen's terms they are 'unsuccessful'. However, this lack of success does not seem to be the result of lack of skill. Instead, the drawings by the younger children seem to be based on a different set of rules. In terms of spatial relationships, the boundary of the square representing the die separates the body of the die from the space surrounding it: a concept based on topological rather than projective geometry. Thus the square stands not for a view of one face, but for the volume of the die as a whole.

Children's figure drawings

Consider a page of drawings by Joanne, a partially sighted twelve year-old (Fig. 54). Just by looking at these drawings we can be quite sure that they depict views, because all these drawings contain instances of so-called 'T junctions', where one contour passes behind another [22].

54 Drawings by JOANNE, 9 years, a legally blind child suffering from tunnel vision.

147

Such junctions are only meaningful in relation to the idea of a point or direction of view. Drawings of this kind can thus be described in terms of projective geometry, and are based on a denotation system in which the lines stand for contours and the T junctions stand for points of occlusion.

Drawings by younger children, however, are not so easy to analyse. A drawing by Daniel, a five year-old (Fig. 55), can be interpreted in two quite different ways; however, because it was not done under experimental conditions it is not possible to be sure which interpretation is correct. One interpretation – Hagen's – would be that this is a badly drawn or 'unsuccessful' view. It is not nearly so detailed as the drawings of figures by Joanne, but the intention behind it is essentially the same, so that the line surrounding the head, or head-body, is intended, like the lines in Joanne's drawing, to stand for a contour. Similarly, in this interpretation, each of the lines below the head-body would have to stand for one of the contours of a leg, the contour on the other side of each leg being missing.

55 Drawing of a man by
DANIEL, 5 years.

The other possible interpretation is that this drawing is based on a different set of rules to those used by adults or older children. So far as the drawing system is concerned, this is based on topological rather than projective geometry: the ears and legs are thought of as 'attached' to the head-body, and the eyes, nose and mouth are thought of as 'enclosed' by the line representing the head or head-body. So far as the denotation system is concerned, I have suggested elsewhere [23] that in drawings of this kind the most fundamental shape property represented is 'extendedness': long regions or lines, like those used to represent the legs, are used to stand for volumes which are saliently extended in one dimension; and round regions, like the one used here to stand for the head or head-body, are used to stand for volumes which are saliently extended in all three dimensions. Although I have used a rather more up-to-date terminology, this idea is by no means new:

> We call these symbols 'natural' because their meaning does not
> first require to be learnt (as in the case of letters or
> mathematical signs), but directly occur to the child, and are
> used by him as a matter of course. Thus a long stroke is a
> natural symbol for an arm or a leg, a small circle for an eye or
> head [24].

One difficulty with an analysis of this kind is that it introduces an unfamiliar terminology: it is not always easy to remember the precise difference between a drawing system and a denotation system, or what 'extendedness' is, or the distinction between topological and projective geometry.

But perhaps an even greater difficulty is our own, adult, egocentric unwillingness to believe that children are doing something different from adults. It is so much easier to assume that children are doing what we are doing, but doing it badly. The same kind of easy assumption hampered early studies of children's speech, and has in fact only recently been overcome. For previous writers, 'imperfections' in children's speech, like the ungrammatical form of 'to bring' in the phrase 'Daddy bringed it' are simply mistakes, due to 'distracting stimuli' or to a 'tantrum which disorders [the child's] recent impressions' [25]. For more recent writers, however, such 'errors' are a normal, and indeed essential, part of the acquisition process.

> It is important to understand that when children make such
> errors, they are not producing flawed or incomplete replicas of
> adult sentences; they are producing sentences that are correct
> and grammatical with respect to their own current internalised
> grammar [26].

Thus when children use words like 'bringed' and 'goed' and 'wented', they are not simply mishearing or mispronouncing adult speech, but using language rules which are different from those used by adults. Far from being too uninteresting to be worth analysing:

> children's errors are essential data for students of child
> language because it is the consistent departures from the adult
> model that indicate the nature of a child's current hypotheses
> about the grammar of language [27].

Similarly, the results of the experiments described above suggest that children's drawings are not simply unsuccessful versions of adult drawing, as Hagen maintains, but are based on systems of depiction which are different in fundamental ways from those used by most adult artists. And Hagen seems to be equally wrong in supposing that the 'True-to-appearance stage' is 'the only stage of real interest for the development of picture-making'. As with speech, the 'errors' which children make in their drawings are 'essential data' for understanding the rules of depiction they use.

Conclusions

Margaret Hagen has claimed that all 'successful' pictures represent views. It is, however, difficult to tell whether she means that *all* pictures, including drawings by young children, represent views (as her claim that there is 'no development in art' suggests), or that 'unsuccessful' pictures are simply not worth studying. The alternative is that children's early drawings, like children's early speech, are based on rules which are different in fundamental ways from those used by adults. Piaget's suggestion that drawings by young children are based on topological rather than projective geometry is one example of a possible basis for an alternative drawing system.

The results of Light and MacIntosh and Moore suggest that it is this second alternative which is correct. When children were asked to draw views of a model house placed inside and behind a glass, the older children based their drawings on projective geometry, but the younger children based their drawings on topological geometry. Similarly, when asked to draw a cube, or a die, older children responded by drawing a view, but younger children drew the shape of the object as a whole.

Children's figure drawings can also be interpreted in two ways. Unless the drawing is done under experimental conditions, it can be difficult to decide which interpretation is correct; but the balance of probability suggests that these more complex drawings are also based on drawing and denotation systems which are different from those used by adults.

Interpreting drawings of this kind demands the use of a difficult and unfamiliar terminology. But the greatest difficulty is the psychological one of accepting the idea that children's drawings are anything but poor versions of adult drawings. If we are to help children with their drawings, however, we must understand them on their own terms, not ours. It is all too easy to attribute our own views to Mary Jane, in a literal as well as a metaphorical sense.

Notes and References

1 MILNE A. A. (1924), 'Rice Pudding', in: MILNE A. A. (1924 [65]) *When We Were Very Young* (London, Methuen). I am grateful to the publisher for permission to reproduce part of this poem.

2 PIAGET J. and B. INHELDER (1948 [56]), *The Child's Conception of Space* (London, Routledge and Kegan Paul), p. 242.

3 LUQUET G. (1913), *Les Dessins d'un Enfant* (Paris, Alcan); LUQUET G. (1927), *Le Dessin Enfantin* (Paris, Alcan).

4 MORSS J. (1987), 'The construction of perspectives: Piaget's alternative to spatial egocentrism', *International Journal of Behavioural Development*, 10, 3, pp. 263–79.

5 *Ibid.*, p. 266.

6 Notably the work of Cox. See COX M. V. (1985), 'One object behind another; young children's use of array-specific or view-specific representations', in FREEMAN N. H. and M. V. COX (eds) (1985), *Visual Order* (New York, Cambridge University Press), pp. 188–201.

7 MORSS (n.4) p. 264.

8 HAGEN M. (1986), *Varieties of Realism: Geometries of Representational Art* (Cambridge University Press), pp. xi, 8. See also HAGEN M. (1985), 'There is no development in art', in FREEMAN and COX (n.6), pp. 59–77.

9 DUBERY F. and J. WILLATS (1972), *Drawing Systems* (London and New York, Studio Vista/VNR). Revised as (1983), *Perspective and Other Drawing Systems* (London, Herbert Press, New York, VNR).

10 WILLATS J. (1977), 'How children learn to draw realistic pictures', *Quarterly Journal of Experimental Psychology*, 29, pp. 367–384.; WILLATS J. (1977), 'How children learn to represent three-dimensional space in drawings', in BUTTERWORTH G. (ed) (1977), *The Child's Representation of the World* (New York, Plenum).

11 The main difference between the scheme described by Dubery and Willats (n.9) and Hagen's version of this scheme (n.8) is that Hagen does not recognise the two categories of 'vertical oblique projection' and 'horizontal oblique projection'.

12 HAGEN (1986) (n.8), pp. 3, 283.

13 *Ibid.*, p. 86.

14 See, for example, WILLATS J. (1984), 'Getting the drawing to look like right as well as to be right: the interaction between production and perception as a mechanism for development', in CROZIER W. and A. CHAPMAN (eds), *Cognitive Processes in the Perception of Art* (Amsterdam, North-Holland), pp. 111–25.

15 LARK-HOROVITZ B. *et al*, quoted in HAGEN (1986) (n.8), p. 273.

16 HAGEN (1985) (n.8), p. 76.

17 For rules of perspective, see DUBERY and WILLATS (n.9). For denotation rules, see HUFFMAN D. (1971), 'Impossible objects as nonsense sentences', in MELTZER B. and D. MITCHIE (eds), *Machine Intelligence*, 6 (Edinburgh University Press), pp. 295–323; KENNEDY J. (1983), 'What can we learn about pictures from the blind?', *Scientific American*, 71, pp. 19–26; WILLATS J. (1985), 'Drawing systems revisited: the role of denotation systems in children's figure drawings', in FREEMAN and COX (n.6), pp. 78–100.

18 LIGHT P. and E. MACINTOSH (1980), 'Depth relationships in young children's drawings', *Journal of Experimental Child Psychology*, 30, pp. 79–87.

19 MOORE V. (1986), 'The use of a colouring task to elucidate children's drawings of a solid cube', *British Journal of Developmental Psychology*, 4, pp. 335–40.

20 MITCHELMORE M. C. (1978), 'Developmental stages in children's representation of regular solid figures', *Journal of Genetic Psychology*, 133, pp. 229–239.

21 Willats J. (1987), 'Marr and pictures: an information processing account of children's drawing', *Archives de Psychologie*, 55, pp. 105–25.

22 For further discussion about T-junctions, see Huffman (n.17); Smith N. R. and C. Fucigna (1988), 'Drawing systems in children's pictures: contour and form', *Visual Arts Research*, 14, 1, pp. 66–76; Willats J. (1988), 'What do the marks stand for in children's drawings of smooth objects? A response to Smith and Fucigna's "Drawing systems in children's pictures: contour and form"', *Visual Arts Research*, 14, 2, pp. 91–5.

23 Willats (1985) (n.17).

24 Stern W. (1914 [30]), *Psychology of Early Childhood* (London, George Allen and Unwin), pp. 369–70.

25 Bloomfield L. (1933 [73]), *Language* (London, George Allen and Unwin), p 31.

26 Moskowitz B. A. (1978), 'The acquisition of language', *Scientific American*, 239, p. 89.

27 *Ibid.*

Acknowledgements

To the Editors of the *Journal of Experimental Child Psychology* for permission to reproduce the drawings shown in Fig. 51; to Dr. Vanessa Moore for lending me the originals of the drawings shown in Fig. 52 and for permission to reproduce them; to Doreen and Frank Hudson for permission to reproduce the drawing by their daughter Joanne shown in Fig. 54 and to Bob Steele of the University of British Columbia for bringing my attention to Joanne's work; and to Paul and Ruth Still for permission to reproduce the drawing by their son Daniel shown in Fig. 55 and to Mrs Christine Hillier and the staff of Lynchetts Nursery School for their help in collecting this drawing.

Chapter Fourteen

DAVID THISTLEWOOD Observational Drawing and the National Curriculum

Throughout much of 1990 and 1991 an Art Working Group appointed by the Secretary of State for Education endeavoured to identify the soundest practices in art and design education in the United Kingdom and to determine the future pattern of provision in the subject for the foreseeable future. This initial stage in defining a National Curriculum in Art therefore had several related aspects. It highlighted the most appropriate existing educational objectives and programmes; it ignored poor practices and thereby eliminated them from the framework of future provision; and it enhanced the core of excellence with a range of advice about how the subject should develop further in primary and secondary education. The result is of substantial significance, not least because it is likely to have career-long ramifications for teachers.

The Working Group's findings of course represented the combined expertise of its membership, comprising art history and criticism, museum education, vocational art and design, and educational management, besides expertise in teaching, training and advising in the subject itself [1]. However, in terms of identifying sound current practices, extending them, and building future policies around them, one of the Group's voices was more distinct than others. This was the contribution of Robert Clement, and its extent will be obvious when the Working Group's published advice [2] is compared with his contribution to this volume. It will be noted that his essay originally took the form of a paper presented at the initiating conference *Drawing Art and Development*, which preceded the National Curriculum prescriptive exercise by one full year. Thus the conference may be claimed to have had some influence at the outset of the Working Group's proceedings, bearing in mind that it provided Robert Clement with a timely platform for his views on the educational value of observational drawing, and a wealth of support from scholars researching discrete aspects of the many roles for drawing in education, besides a range of ideas that would help to modify his arguments in significant details.

This volume, then, in effect completes a circle of relationships. Robert Clement's conference paper provided a focal point for other arguments and research findings. Reported here, these other contributions to a growing corpus give support to his insistence on the prime value of observational drawing within the art and design curriculum. The purposes of this chapter are to identify what precisely the Working Group recommended in this regard, to make connections with some of this volume's other contributions, and to extend the field of argument a little by speculating on the educational issues thus revealed.

There is no doubt that the Working Group's report is an historic

document. It constitutes as accurate a snapshot as may be taken of primary and secondary art and design education, and ambitions for its development, in the early 1990s. It will be consulted as a source of the most accurate information on the realities of art and design education of its day, and on the priorities for art and design education as perceived by those well qualified to recognise them. It not only deals with matters intrinsic to art and design in education, it explores for the first time, in terms of national policy making, a set of responsibilities towards social and environmental education, technology, media education, cross-curricular and multi-cultural dimensions, special educational needs and equality of opportunity. Its collective arguments will no doubt stimulate research enquiry and debate for many years.

But what is captured within its frame? Revealed is a subject, in the later stages of the twentieth century, taught largely through drawing and painting, with ceramics, printmaking, textile work and other two- and three-dimensional study areas having supporting roles. Drawing is the discipline in which highest standards of achievement are realised. These achievements are both central to art and design (graphic recording, investigating, designing, expressing, communicating and experimenting [3]) and tangential – extending into many other subjects of the wider curriculum. This specific excellence marks a distinct era in art and design education, distinguishing the period reviewed by the Working Group from times when, for example, expressive use of paint or constructive use of card and balsawood were dominant classroom activities.

This is a significant observation: the late twentieth century witnessed a revival of drawing excellence in British art and design education, and prepared the ground for systematic research and development initiatives into the numerous roles and purposes of drawing in education, such as those engaged in this volume. From its perspective the Art Working Group foresaw that computer visualisation, virtual reality, and design imaging of all conceivable kinds would become strategically important to the economy, and consequently that there would be an increasing reliance upon what the advocates of visual literacy have termed 'graphicacy' [4].

A further observation of the Working Group was that appreciable levels of drawing excellence had been sustained despite uneven investment in teaching the history of art, or the critical basis of perceiving value in the works of artists, craftworkers and designers. This suggests a host of research issues that demand attention as the National Curriculum is implemented in earnest. Some are identified in this collection of essays, including questions of children's intrinsic drawing abilities, the necessity and nature of teaching at discernible stages of children's development, and the interdependence of drawing standards and knowledge of the rest of the cultural/aesthetic spectrum.

The National Curriculum in Art features discipline-based attainment targets, each having drawing as its anchor discipline. Their introduction marked the end of a period in which uncritical or unstructured practice (in drawing or any other art activity) could be regarded as acceptable.

154

Fundamental to this change has been the belief that while drawing is a natural mode of apprehending the phenomenal world, and while much is achievable because of this (even when children are working apparently aimlessly), drawing becomes most potent as an educational medium when imbued with strong intentionality.

One of the ways chosen to highlight this aspect of drawing within the curriculum has been to suggest a form of graphic 'linguistics'. In this sense art may be said to consist, in part, of a visual language of marks and symbol systems given coherence by certain grammatical and syntactical conventions that may be recognised, understood and used. As in other realms where languages are crucial – literacy and numeracy – the deployment of marks and symbol systems both confirms what is already known and promotes further gains in knowledge. Unlike these other realms, however, art has no single superior language: in a real sense each work of art manifests its own structural logic, or the grammar and syntax of its origination. Whereas each essay in written English is a rehearsal of the standard form of the language (even if its rules are disobeyed) each drawing is a manifestation of an individual logic (even if, paradoxically, it is an attempt to deploy the nearest we have to a standard form – the conventions of classical representation).

Thus while we may generalise about the roles that drawings may fulfil, we cannot specify their ideal form or content. This is why the Working Group's advice to teachers was necessarily non-directive. It recognised that the purposes of drawing may be personal or private, giving the artist a means of communicating perceptions together with the unique structural principles that make them perceptible. Drawing may serve other disciplines – painting, sculpture, design – in preparatory capacities. It may be explanatory, describing perceived relationships or (in design) desired relationships. It may be a profound aesthetic statement in its own right, made from direct observation, memory or imagination. It may be objective and documentary, or imaginative and expressive. It can defer to many generic types, including classical, abstract, figurative and technical, but it cannot promote consistency across these types because of the unique nature of individual percipience. In this latter regard drawing is one of the most direct, intimate and accessible means of expression available to artists, and usually a first recourse in giving form to perceptions, feelings and ideas [5].

The act of drawing may initiate unintended perception and communication, which may arise spontaneously in the act of creative discovery, and connect with the existing experiences of the individual pursuing the creative enquiry and those witnessing it. Art education cannot therefore focus exclusively upon learning a single visual language. But it can focus upon the principle of *intentionality*, and as the National Curriculum sets such store by observational drawing it seems necessary to explore concepts of intentionality attendant upon this paramount feature of the art curriculum.

Observational drawing

What *is* observational drawing? John Willats makes a useful distinction, elsewhere in this volume, between various kinds of geometries which condition children's apprehension of the world around them. Younger children tend to make topological structures of their experience: they use drawing as a means of remote exploration, 'touching' the surfaces of the things they perceive with the marks made by their reflex drawing actions. In addition, however, they seem to conduct an extraordinary circumambulation, 'projecting' their attention around and above the object of their perception as if capable of visualising it from a variety of angles. They do this without changing their viewpoint, and in fact they may not 'look' at anything apart from the paper on which they are working. They are – to paraphrase John Matthews (also in this volume) – drawing not so much what they see as what they know or imagine they know. Their drawings are both confirmations of what they know, and speculative assumptions that are conceptually, if not actually, real and therefore equally well known.

Older children tend towards what John Willats calls projective geometry in their apprehension of phenomena. They adopt the familiar cultural convention of a fixed viewpoint, and their drawings thus locate themselves – and the observers of their images – in precisely definable relationships to the objects of their perception and depiction. They may be no more inclined to look at their subject-matter than when they were younger, but their work bears the hallmark of sight more than empathy.

Topological drawing is individual centred: it is evidence of the young sensibility sorting and sifting experience. The graphic marks that are made in this activity are experience reinforcement – a registering of what is being apprehended. Projective drawing is a socialising of experience, telling others what the individual is capable of perceiving in terms that tend towards conventionalisation for precisely this purpose.

But there is yet another kind of observational drawing that people may engage in if they continue to draw in adult life. It must be acknowledged here that few people continue to draw 'seriously' in maturity. Those who do include the host of artists, designers and other professionals whose special interests are discussed by Steven Garner in this volume. Teachers have professional interests in drawing, but this is not to say that all teachers regard themselves as practising graphic artists or designers. Those individuals who continue to practise drawing throughout their lifetimes are a small proportion of the adult population but they are significant as carriers of drawing culture.

Now is it right to suggest that maturity increases a person's propensity to structure his or her apprehensions of the world within projective geometries? This seems a questionable proposition, given the considerable attempts that many artists make to regain an originality of vision. To see from the fixed viewpoint is to see what others may see; to see topologically is to combine fragments of objective vision with fragments of speculation, invention and supposition. When adults adopt a topological approach they also give rein to opportunism, by recognising fortu-

itous marks and interesting passages of imagery, because of the great value that is placed on spontaneity. There are thus in adult topological drawing the visible results of at least two reflex activities. There are the characteristic evidence of the artist's remote sensing of the subject, and the characteristic evidence of recognising and taking advantage of the visual potential inherent in the medium.

Is the topological vision of the mature artist in other respects similar to that of the younger child? There are sufficient references in the history of modern art to assume that they are comparable. There are many accounts, some possibly apocryphal, of artists like Picasso and Klee striving for the perceptual abilities of children. However, there are significant differences that teachers should be aware of, so that they may distinguish between what they encourage in their pupils' drawings for reasons that are intrinsic to *their pupils'* work, and what they encourage for reasons intrinsic to *their own* work.

One of the most obvious characteristics of adult observational drawing is the length of time that may be spent before the motif. With experience comes increasing ability to sustain visual scrutiny. There is a greater willingness to take whatever time is necessary, and make innumerable fine adjustments to the visual record, in order to achieve a satisfactory outcome. This would appear to be geared to ensuring *projective* accuracy – the perfection of an image of a subject from a fixed viewpoint. But the fact of sustained effort ensures the opposite result. The drawing becomes a recording of events in duration. The sun moves, shadows lengthen and shorten, sharpen and become diffused. The subject may move (however imperceptibly, as in the case of the life model).

The resulting drawing records a perception forming and focusing in time, and the resulting features of this – the erasures and partial erasures, the pentimenti, the contradictions of shadow projection, the simple evidences of wear and tear (which are often valued as proof of 'struggle') – constitute the evidence of prolonged visual effort and attention before the motif. However, there is a secondary value in the incidental marks, the visual 'noise', resulting from this. Those who practise and appreciate drawing may cultivate the often dynamic visual effects of duration for reasons that are purely aesthetic.

Such effects are visually appealing for their own sake, and seem to 'belong' as much to the medium's inherent visual potential as to the act of witnessing a subject over a period of time. There is a largely unresearched equation of apparently contradictory features that are valued in adult topological drawing: evidence of prolonged effort – even struggle – before the motif, yet also evidence that the final image has materialised in apparent spontaneity. Pentimenti and visual 'noise' may therefore be encouraged in the work of pupils for the wrong reasons – that is for effects that please mature appreciation rather than in recognition that they are extending the young person's perceptual range.

Consider the results of an expedition by a father, his sixteen year-old daughter and his fourteen year-old son, to make drawings of a church in the unfamiliar surroundings of a holiday landscape. The fourteen year-old deploys both topological and projective geometries. There is a

tension in his work between the desire to achieve an image that looks 'right' and a natural tendency to draw by exploration, as if sculpting an image within a notional space behind the picture plane (Fig. 56). The sixteen year-old respects a culture of photographic realism, records what she sees with considerable accuracy, but also overlays her drawing with what she knows about projective realism, including the principle that shadows must conform to a specific angle of projection (Fig. 57). The father attempts to draw with an overall consistency, gradually bringing all aspects of the image towards completion simultaneously, but cannot avoid registering the fluctuations that occur in duration (Fig. 58).

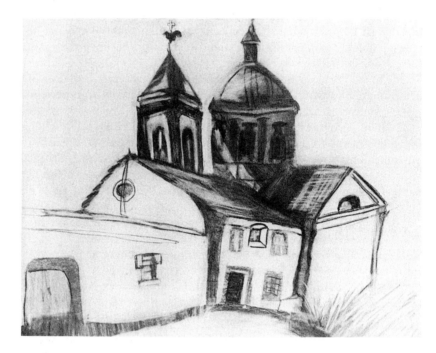

56 JEVON THISTLEWOOD:
*Igreja da Nossa Senhora,
Castro Marim, Portugal.*

In this comparison it is the adult's drawing that bears evidence of compromise. The fourteen year-old does not disguise any apparent 'inconsistencies' resulting from the fact that the earth moves in relation to the sun: he works to record what he senses throughout an *episode*. The sixteen year-old does not disguise her belief that such inconsistencies are to be set aside in the search for a stable reality behind appearances: she works to record an *instant*. The father in fact works discontinuously: satisfactory passages in his work are arrested while others are brought towards comparable states of completion. This does not worry him – it is the tangible evidence of effort in duration, and he has over the years acquired techniques for ensuring continuity between contradictory passages of observational drawing by introducing visual 'noise' that has little purpose other than weaving a satisfactory fabric.

Topological vision is offended by inconsequential marks that do not refer to things seen, experienced or felt. Projective vision is offended by anything in adult drawing that disobeys Cartesian logic. What this illus-

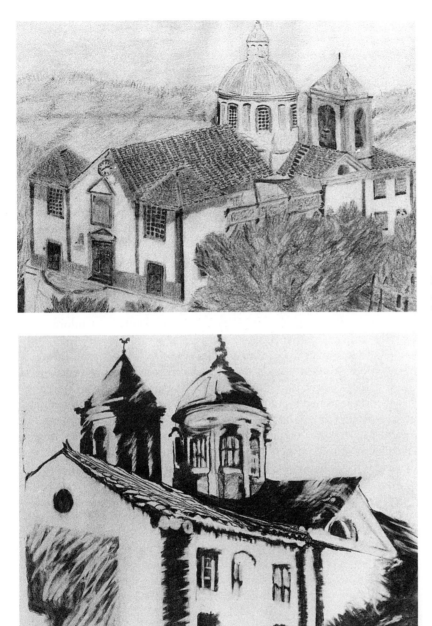

57 DEBORAH THISTLEWOOD:
*Igreja da Nossa Senhora,
Castro Marim, Portugal.*

58 DAVID THISTLEWOOD:
*Igreja da Nossa Senhora,
Castro Marim, Portugal.*

trates is that adult-pupil exchanges may be prone to misunderstandings.
When the teacher does not himself or herself habitually draw, such
misunderstandings are likely to be profound. Now that we have a
curriculum predicated on observational drawing the fundamental differ-
ences between topological and projective vision in childhood and adoles-
cence, and their counterparts in adulthood, require urgent research
attention.

An agenda for drawing research and development

What else does the National Curriculum in Art reveal as an agenda for research? First, there is the evident invitation to engage the essential, distinct but mutually interconnected concepts 'critical appreciation' and 'practice'.

Though much recent work has been undertaken in relation to the first of these [6], a great deal of further research is needed to confirm the roles of drawing within critical and appreciatory activities. It is still more common for pupils to be encouraged to translate their appreciation of, say a painting or a work of sculpture, into words than into drawings.

There is a more readily agreed role for observational drawing in creative practice as the principle of drawing as itself an art form is generally accepted – indeed so ingrained in school art culture as to have produced a number of clichés (sliced cabbage, deformed drink can, impossibly-flexured sports shoe). Preparatory and exploratory functions of drawing are equally well installed in practice. The Working Group endorsed these strongly without, however, identifying potential problems that may arise when intermixing the durational (observational drawings) and instantaneous (photographs) as sources of information, together with such other 'frozen moments' as visual memories.

This rider applies also to investigative and developmental aspects of observational drawing when they feature in experimental processes of the sort that sustain programmes of creative practice. Again, there is a largely unresearched topic here, embracing concepts of the drawing as a unique percept, the suite of drawings as a programmatic development of a percept, and the relationship between topological drawings bearing evidence of duration, and the suite of projective drawings of a subject observed over a period of time and therefore also recording duration.

There is also an obvious invitation to conduct research into the ramifying issues of society, the environment, technology, the media, cross-curricular initiatives, multi-cultural dimensions, special educational needs and equal-opportunities. Arising from some of these issues is the necessity of research prompted by the Working Group's ordering of priorities. Not the least urgent work will be needed on behalf of pupils with visual handicaps and disabilities, and those for whom naturalistic representation offends religious beliefs and cultural practices, for central to this is the principle that while observational drawing empowers a majority of pupils it disadvantages minorities.

However, it is the massive prominence afforded to observational drawing that will most engage the attention of researchers because it will substantially shape the teaching of art, and our thinking about art in education, for as long as the National Curriculum is effective. From this standpoint the following are only the most obvious of issues demanding attention.

The promotion of intentionality

The Working Group questioned the educational value of unstructured expression, but also made efforts to defend the imaginative within a curriculum characterised by purposive enquiry. Deft explanation was therefore required in order to separate 'expression' and 'imagination', and this was effected by maintaining that the most worthwhile imaginative work is prompted by observational skills and their disciplined employment in the cultivation of visual memory.

> Imaginative work of good quality is more likely to arise when
> pupils are able to recall and combine mental images and ideas
> in order to form new ones. To do this, they need a store of
> mental images of their experiences, access to school and class
> collections of visual information such as photographs, and the
> skills of representation which they have developed by working
> from direct observation... [These facilities and attributes
> provide] the solid practical grounding and skills of perception
> needed to help develop imagination [7].

The message is therefore clear: imagination is stirred by representative images and representational abilities, rather than, say, by experimentation with the expressive properties of materials. The cause of imbuing art with intentionality therefore emphasises affinities with design and technology. This is a logic of observational drawing as both fundamental to art and to design: it roots each in environmental awareness and it encourages the disciplined liberation of the imagination. However, in this equation are familiar recurrent contradictions. Observational drawing embodies duration; duration tends towards the topological; the topological accepts fortuitous and irrational mark making; the irrational is therefore prominent within a rational scheme. Such contradictions are only avoided by encouraging pupils to perfect projective abilities, and much informed research is needed to avoid this outcome, clearly identified as undesirable within the National Curriculum [8].

Art as instrumental in design

The National Curriculum locates craft within art, partly in order to confirm the authority of art over considerable aspects of design and technology, and partly to justify the strategic divorcing of art from other 'expressive' arts which appear peripheral to a pragmatic and phenomenal curriculum. Observational drawing is promoted as a preferable substitute for unstructured experimentation with materials. For example, accurate visual analysis of wood in its various states may provide intimate understanding of its appropriateness to different purposes.

In order to maintain this priority the Working Group argued that significant or tangible distinctions between art and craft only occur in mature work and in professional arenas. In education:

> the two are so intimately linked that they are best treated as one
> [9].

This identification requires craft to be subsumed by art. However, it is another predicate of the National Curriculum that:

> one of the principal educational benefits coming from art education is an insight into materials and skills. The sensitive handling of materials and the understanding of their properties ... require much education of the sense of touch, coordinated with that of sight [10].

In this way the National Curriculum binds together an objective art making (founded in observation) and empathy for the craft potential in materials (founded on the coordination of touch and sight). Drawing is the anchor discipline, but it is clearly topological more than projective. The relevant concepts are 'observation', 'touch' and 'sight', rather than 'observation' and 'conventional interpretation'. The range of drawing abilities valued by a representative sample of practising designers, identified by Steven Garner in the research he reports in this volume, confirms exactly the suggestion that it is topological draughting that fuels creative origination in designing.

This must therefore be the basis of contributions art makes to the cross-curricular teaching of design and technology, despite any automatic assumptions that drawing in design should be technical and conventional. The Working Group noted roles for conventional graphic systems besides the observational, but outweighed their importance with other matters: competence (much of which is acquired visually) in handling the materials used in art and design; strategic graphic techniques (observation, speculations and visualisation); intelligent use of information technology (including visual discrimination); and aesthetic (visual) criticism. What is maintained, then, is not only that a visually-directed 'art' subsumes the whole of 'craft' in education, but that it subsumes vital, ability-forming aspects of 'design and technology capability' also.

But while it promoted the virtual identity of art, craft and much of design, and while acknowledging the educational potential in effecting programmes of collaboration with the other arts, the Working Group denied absolutely an educationally-valid *integration* of art with music, dance and drama. The crucial elements that are missing from music, dance and drama are the dual visual disciplines of observing and recording. Though it is recognised that there are concepts of superficial similarity – 'tone, texture, form, scale, colour and rhythm' [11] – it is implied that these are analogies which derive their potency from art, and that in education there is little reciprocation. In rejecting a connectedness with these other art forms, then, the Working Group reinforced an interdependence of art and drawing, and also confirmed the downgrading of emotional expression.

Priorities

The National Curriculum has a very long perspective: priorities are being cast for several generations. In one sense these are strategic and research outcomes may be expected to emerge gradually. It may be anticipated that a new version of old and familiar dualities will become evident. On the one hand topological drawing in art and creative origination in design may cohere in cross-curricular relationship. On the other hand the principles of visual language and 'literacy', which establish the credentials of art as a systematic discipline, and correspondingly pragmatic aspects of designing, may form an alternative alliance. Time will tell.

However, in one fundamental respect a crash programme is needed. The overwhelming emphasis on drawing – in all its forms but particularly the observational – is an acknowledgement of what is desirable for art in education but unavailable for immediate *informed* implementation except patchily. Despite the Working Group's recognition of drawing excellence in current practice, it has a fragile basis. Many of today's teachers of art do not regard themselves as experts in drawing because it did not feature prominently in their own degree programmes. Many more do not consider themselves artists and teach art as non-specialists.

Observational drawing, more than any other facet of art making, is impossible to teach and evaluate if the teacher-evaluator lacks appropriate and practised expertise. Distinctions between the topological and the projective; recognition of their respective values; knowledge of when they are compatible and incompatible in programmatic creativity; discrimination between criteria deriving from childhood and from adult topological drawing; and even comprehension of such fundamental principles as 'duration' and 'intentionality' on which the National Curriculum in Art is predicated – such concepts as these will be meaningless to teachers unprepared to develop and exercise their own drawing repertoires.

It is therefore the most urgent of priorities that all curricular support for observational drawing in schools should contain optional guidance *in their own artistic development* for those teachers who require it. One of the earliest consequences of the National Curriculum in Art might well be a siphoning of crucial expertise away from the classroom and into the environments of research and curricular development. If this is to be avoided, the classroom itself will need to become the research arena [12]. The Art Working Group's most reasonable and apparently innocuous of strategies, then, is likely to initiate as urgent a programme of tactical research and professional development as art education has ever seen.

Notes and References

1 Lord Renfrew of Kaimsthorn (Chair), Giles Auty (art critic), Gilroy Brown (head teacher), Robert Clement (county adviser for art and design), Revd David Derrick (head teacher), Gillian Figg (teacher educator), Toby Jackson (museum educator), Leslie Perry (professor emeritus in education), Peter Riches (head of a faculty of creative studies), Ray Smith (artist), Merrick Taylor (industrialist), Lady Marina Vaizey (historian and critic).

2 DEPARTMENT OF EDUCATION AND SCIENCE/WELSH OFFICE (1991), *Art for Ages 5 to 14* (London, HMSO).

3 *Ibid.*, para. 2.11, p. 6.

4 For a discussion of the visual literacy movement and its various concerns see BOUGHTON D. (1986), 'Visual literacy: implications for cultural understanding through art education', in *Many Cultures; Many Arts*, double volume of the *Journal of Art and Design Education*, 5, 1 & 2, pp. 125–42

5 Working Group report (n.2), para. 3.22, p. 12.

6 Especially by Rod and Dot Taylor. See TAYLOR R. (1986), *Educating for Art* (London, Longman); TAYLOR R. and D. TAYLOR (1990), *Approaching Art and Design; a Guide for Students* (London, Longman).

7 Working Group report (n.2), para. 3.16, p. 11.

8 *Ibid.*, para. 3.3, p. 9.

9 *Ibid.*, para. 3.29, p. 13.

10 *Ibid.*, para. 3.28, p. 13.

11 *Ibid.*, para. 3.43, p. 15.

12 For a number of essays on the classroom as research centre, see *Journal of Art and Design Education*, 10, 3, 1991, especially MASON R. (1991), 'Art teaching and research', pp. 261–69.

Index